INDUSTRIAL
PHOTOGRAPHY

INDUSTRIAL PHOTOGRAPHY

JACK NEUBART

AMPHOTO
An imprint of Watson-Guptill Publications/New York

With love for my Mom,
who would have been proud of this moment.

Obviously, this book reflects the work of more than one person. It also represents years of experience of a number of working corporate/industrial photographers. It is their work that lends an air of credibility and authority to a subject as complex as the one on which this book focuses.

But first I wish to express my thanks to the excellent editorial and design staff at Amphoto, who, as before, have extended themselves to produce a book one could fondly look back upon. I must also thank Elinor Stecker for the excellent work she did in copyediting and technical editing—but mostly for her continued support throughout this project. And I must again acknowledge all the photo magazine editors I've worked with over the years and in particular, Fred Schmidt. And finally, I again express my sincerest gratitude to my close friends Terry Zembowsky and Renee Liberty, who lent an ear whenever I needed it.

My deepest gratitude for the illustrations and techniques, experiences, and advice goes to the twelve photographers who patiently took time from their busy schedules to accommodate my needs in this project. I must first single out Lou Jones, who permitted me to accompany him on assignment in Boston, and the other photographers with whom I visited, namely John Corcoran and Bob Skalkowski in Pennsylvania, Camille Vickers and Greg Beechler in New York, Jeff Smith in New York, Robert Rathe in Virginia, and Ken Graff at Union Carbide in Connecticut; and Jerry Poppenhouse (Phillips Petroleum Co.), Jim Stoots (Lawrence Livermore National Lab), Mark Gubin, and Paul Prosise, all of whom were too far away to visit but who contributed equally to this book. And I must not overlook the staff at Lou Jones's studio, who assisted in various ways, and Jeff Smith's wife, Emily, who proved to be a valuable resource of information.

Copyright © 1989 by Jack Neubart
First published 1989 in New York by AMPHOTO,
an imprint of Watson-Guptill Publications, a division of Billboard Publications, Inc.,
1515 Broadway, New York, NY 10036

Library of Congress Cataloging-in-Publication Data
Neubart, Jack.
 Industrial photography : a complete guide to photographing sites, people, and products / Jack Neubart.

 ISBN 0-8174-4016-X ISBN 0-8174-4017-8 (pbk.)
 1. Photography, Industrial. I. Title
TR706.N485 1989 89-16607
778.9'96—dc20 CIP

Manufactured in Hong Kong

3 3001 00950 3557

1 2 3 4 5 6 7 8 9 / 97 96 95 94 93 92 91 90 89

Jack Neubart is a New York-based freelance photographer and writer. He has worked as Managing Editor at *Industrial Photography* and as Senior Editor of *Photomethods*. Neubart has taught photography at the Olden Photography Workshops and the School of Visual Art's Division of Continuing Education.

Neubart's articles and photographs have been published in *Industrial Photography, Photomethods, The Rangefinder, Studio Photography, Technical Photography, Lens' On Campus, Modern Photography, The New York Times, Popular Photography,* and *The San Francisco Chronicle.* Jack Neubart is also the author of *The Photographer's Guide to Exposure* (AMPHOTO, 1988).

Edited by Philip Clark
Designed by Jay Anning
Graphic Production by Hector Campbell

CONTENTS

DEFINING INDUSTRIAL PHOTOGRAPHY

Industrial photographs encompass a wide range of applications and shooting styles. This image, for a catalog cover, illustrates the use of a studio technique called in-camera masking to produce a photo representative of the high-tech products that some photographers are called upon to shoot.

You arrive at your location, tired from traveling but ready to shoot. You step onto the site and stare out into a black void; you picture it filled with engines purring and awakening everything that depends on those machines. You look for your contact at the plant, the one person who will hit the switch and make the scene spring to life.

And then reality steps in. They expected you tomorrow. Not only that, but what you see are engines that are deadly quiet, lifeless. Even worse, they are filthy and need desperately to be cleaned, the floor needs a paint job, and the area itself is so cluttered with boxes, spare parts, and tools that it all looks hopeless.

Then imagine all you go through to bring order to the chaos you find there, the strangers you must interact with, whose cooperation you need. And then imagine yourself, finally, making those first exposures, and more exposures, and more still—until every nuance of that subject is covered, every exposure possibility explored, every step taken to ensure that you've succeeded in the task at hand.

Later, you return to your studio to have the film processed and hope that an overzealous processing machine doesn't take a particular fancy to your prized, hard-won rolls of film. And after that, the final step. You scrutinize and edit the developed images and finally deliver them to the client, waiting patiently for him to look up at you. And he does—with a smile. Your job is done. A rewarding day in the life of an industrial photographer.

The all-important element in this process is the client. Without him, you have no work. Once you have the work, you have the responsibility, and the process begins again, over and over for each assignment. You experience the challenge of industrial photography each time you accept an assignment.

But what exactly is industrial photography? Each time I mention it to someone, I either get a puzzled expression, or I may hear: "Oh, that's taking pictures of manufacturing plants."

Well, we can try to define industrial photography along those lines, saying that it is principally on-site photography of manufacturing plants, products, processes, corporate executives, and employees, but would we be seeing the entire picture? No. The truth is that industrial photography incorporates a wide range of subject areas.

Even to the industrial photographers who have contributed to this book, industrial photography is many things—many *different* things. Freelance photographers Camille Vickers and Greg Beechler see it as "just about anything you can imagine. We photograph people putting on makeup one day and people working on drilling rigs the next . . . Anything that relates to the workings of a company, whether it be a service company, a product-oriented company, a hospital, or chemical company—any company that might want to publish a product or service brochure, annual report, image piece, or capabilities brochure. The field is extremely wide because of the variety of products and services offered in this and other countries."

"I define it as anything that helps an industry sell or explain their products or business to somebody else," says Mark Gubin. "One of my clients manufactures metal buildings. That's architectural photography, showing what they make. But it also shows the manufacture and construction of those buildings, and my job as an industrial photographer is to try to make them look better than the competition's buildings.

"If you look at the largest industries in the country, the biggest is the construction industry," continues Gubin. "Then there are so many industries that feed around that—all the people who manufacture the machinery and the raw materials and transport it to the construction industry." Each of these industries requires photography to some degree.

Industrial photography, whether it be viewed strictly as such or as corporate photography, location photography, executive portraiture, or photo illustration, still focuses on *industry*. You define it by who will be using the pictures and by what the pictures will be used for.

However you define it, industrial photography may also involve risks and extensive travel, and if there can be said to be a down side, that is it. Not every photographer is cut out for the rigors of location assignments, but the diversity often proves challenging enough to get the creative juices flowing no matter what the assignment nor where you must travel to shoot it.

For many, working in the studio provides the same kind of impetus and results in the same degree of creativity. And a good deal of industrial

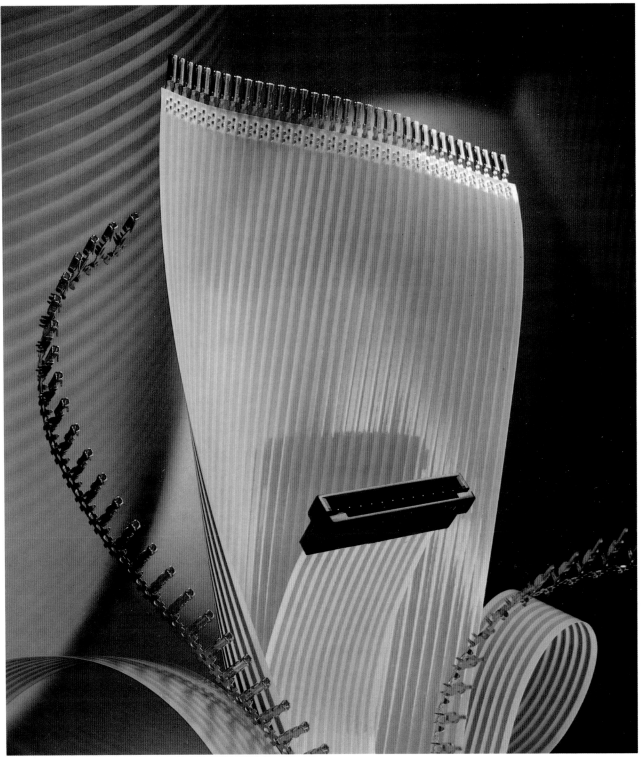

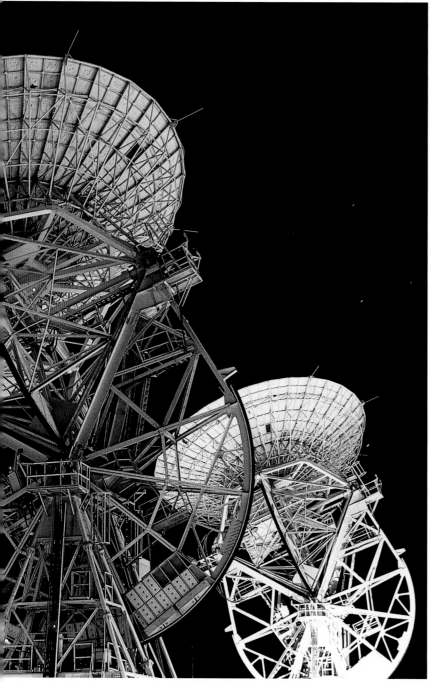

© Camille Vickers.

Editorial illustration for corporate magazines is another use of industrial photographs. These satellite tracking antennas, are responsible for maintaining an open line of communications between Washington and Moscow.

photography takes place in the studio, as well as on location.

The rewards and challenges can best be summed up by Jeff Smith: "It's a very interesting business. You get to shoot a lot of different things, you get to meet a lot of nice people and develop very nice relationships with clients and with people you photograph; you get to travel around. I think it's a very difficult way to make a living, but it's also a very pleasant way to make a living."

To help capture and present the diversity encompassed by industrial photography, I have sought out a number of outstanding photographers working in the field, both freelance and in-house, and have asked them to share their photographs, experiences, techniques, and feelings about their profession. These contributors are freelance photographers Greg Beechler, John Corcoran, Mark Gubin, Lou Jones, Paul Prosise, Robert Rathe, Bob Skalkowski, Jeff Smith, and Camille Vickers, and in-house photographers Ken Graff (Union Carbide), Jerry Poppenhouse (Phillips Petroleum), and James E. Stoots, Jr. (Lawrence Livermore National Lab). Their work and their experiences will make this book a valuable tool in helping you reach the necessary decisions and apply the proper techniques in your industrial photography. The material is presented with the understanding that you are already familiar with the basics of general photography.

Industrial photography has a purpose and that purpose is to communicate. Quite often the most effective industrial photographs are simple and straightforward, with little or no photographic fanfare, no unusual technique, no special effects. But sometimes that extra touch does stand them apart from the rest. The industrial photographs that stand out, that grab our attention and even win competitions are the ones that *communicate*. The professional industrial photographer never loses sight of that key element.

I hope this book succeeds in communicating to you the value and scope of this unique field and that it serves as a useful guide in your career decisions and practical applications in the field. In that endeavor, this book presents industrial photography as an equation, the first part of which centers around the industrial shoot and the applications involved; the second part focuses on the equipment that will deliver the best results and the lighting techniques that make those results shine; and the third part brings you face to face with the difficult career and business choices you must face as an industrial photographer. Component by component, you will see that industrial photography is simply one of the most challenging, multifaceted, and exciting fields in professional photography.

The capabilities brochure is one of the major print media where industrial photographs are used. This image of a plant worker stoking a furnace was used for a Chemetals brochure.

© Jeff Smith.

THE INDUSTRIAL SHOOT

Jerry Poppenhouse, © Phillips Petroleum Co.

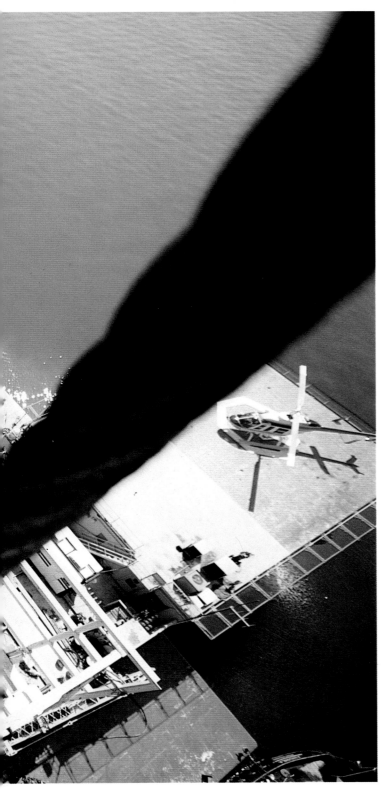

The industrial shoot is a combination of talent, technical mastery, personality, and business acumen—everything you bring to it. For that matter, there is very little of yourself that you do not bring with you. Your client expects it.

Having convinced your client that you're the right person for the job, you now have to handle yourself that way throughout, approaching each assignment with the same care and diligence. You have to know what is and is not safe to do. You have to realize that a major part of your job, in one way or another, puts you in contact with people. It may involve photographing a top executive who gruffly says, "Fifteen minutes," without even looking up at you or saying hello. Or it may put you face to face with a roughneck on an oil rig in a stormy sea who's watching your face turn purple as you acclimate to your new surroundings. You have to be aware of your personal limitations and the limitations placed upon you by the assignment. And no matter what happens, you have to be polite and diplomatic, leaving rudeness and arrogance behind the closed door of your studio. Admittedly, not all your experiences will be pleasurable, but many assuredly will, and you'll find that people will be as nice to you as you are to them.

PREPARING FOR THE ASSIGNMENT

The biggest problems you can expect are that the people at the site either have no idea that you're coming or are completely unprepared when you do.

LOU JONES

Preparing for the assignment goes beyond a simple concern for equipment. It combines the photographer's visual acuity and talent to previsualize the image and his skill in discerning where problems with the site or the subject may lie even before reaching the site or seeing his subject. From the moment he accepts the assignment, everything he does is predicated on his creative instinct and technical experience, topped off with a degree of common sense.

The industrial assignment involves studio time in getting equipment together for a location shoot or, where applicable, shooting in the studio itself. Once at the site, time is spent in scouting, assessing the location and lighting requirements, and finally, in setup and shooting. And when you arrive at the site, you'd better be dressed properly for the occasion, with the right shoes and clothes.

Some of the work you do follows a prescribed layout. It may be an actual sketch or a verbal description that you are expected to follow. Nothing is left to chance, even when the unexpected rears its head and poses some of the ultimate challenges for the industrial photographer. When you first get the assignment, there are questions that must be asked and answered. Both you and your prospective client have expectations about this assignment—and you both have to decide and agree upon what is and is not reasonable.

To produce this image, the photographer had numerous difficulties to overcome and five hours of set-up time for 20 minutes of shooting. A key problem was a lack of available light, requiring him to use flashlights as a focusing aid.

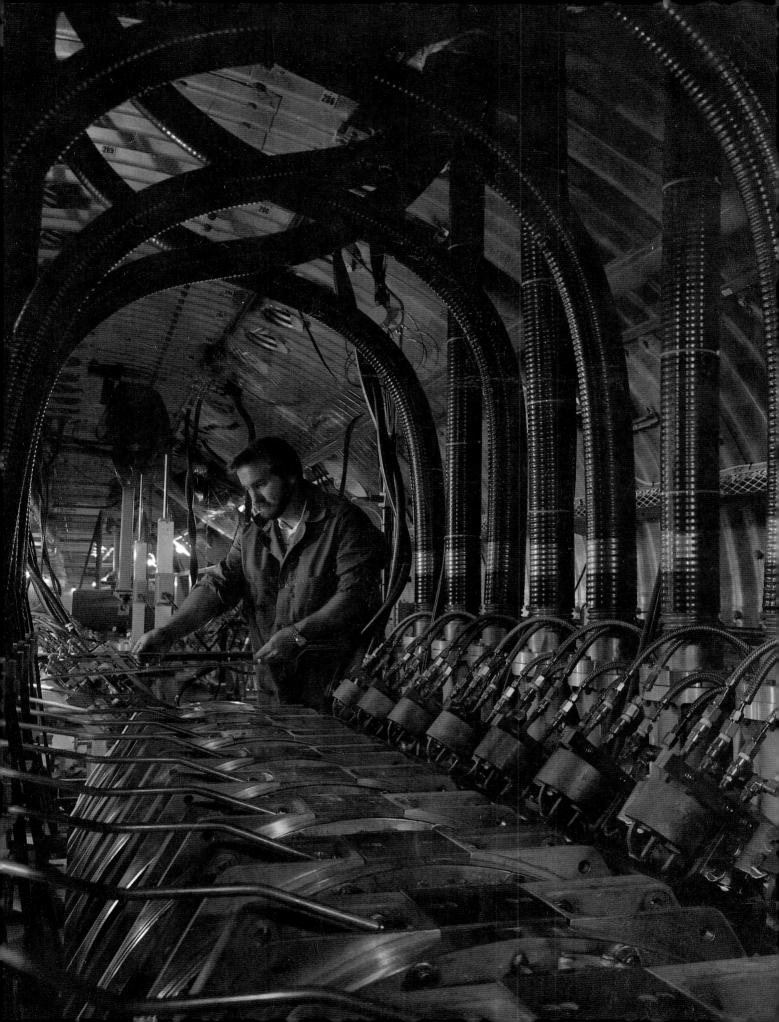

Asking questions is a two-way street: You'll ask questions and so will the client. The client may know your credentials, but he has questions that are as important to him as your questions are to you. And knowing what those questions might be should prove helpful in securing not only the job but your client's confidence in you.

The first question to come from the client may not involve the concept behind the shoot, but whether or not the assignment even interests you. Photographers have been known to turn down jobs because certain assignments offered nothing of interest, no photographic opportunities that would broaden the scope of their portfolios or enhance them in some way.

Of course, the other half of that question revolves around the client's budget. The budget, while it may not be the sole determining factor, may be too small for some well-established photographers to consider. The professional photographer is always factoring in studio overhead, time the assignment would require, and even the time of the year. During peak season, he may be less inclined toward some assignments than at other times of the year; a more lucrative assignment may be waiting in the wings. Experienced industrial photographers already know their clients and their clients' needs and schedules for projects, with some leeway thrown in.

"Most of the time," Camille Vickers notes, "they ask me, 'How much is this going to cost and how long will it take and when can we get the pictures back?'" To answer how long a shoot will take requires some experience. Experience enters into the cost factor as well (for more on pricing your work, see Chapter 10). Turning around the results is something you do as fast as you possibly can—faster, if there's an immediate need for them.

The client's questions may revolve around the concept. "They sometimes ask me, 'Is this concept any good, is this going to work?'" Jeff Smith remarks. "I have a dialogue with the clients, I ask them a lot of questions, and they ask me questions. They might suggest, 'The person is too small,' or 'We need a little more human interaction,' and I figure out how to do it."

Of course, during this dialogue, you must ask your own questions, and you must ask the right questions to guide you through the project. Otherwise, you might come back with a set of beautiful photographs that won't serve anyone's purposes, having failed at a job you thought was a success. That applies whether you're freelance or in-house.

There are any number of questions you can and should ask the client. Here are a few cited by industrial photographers I talked to:

● *What is the concept behind the project?*
What's the client trying to communicate in this photograph? Obviously, the client wants to make a statement about the company, its products or services, or its people—or all of these, and your photographs must make that statement, directly or indirectly. It is up to you to find out exactly what that statement is and how the client wants the statement made.

● *Who is the audience?*
You have to find out if the printed piece is being directed at potential buyers or users of a product or service or at the stockholders.

● *How are the photographs going to be used?*
It is important to know in advance if the pictures will be printed, displayed, or projected, and whether they will be reproduced large or small.

● *Will you have everyone's cooperation when you get there?*
You want to make certain that the people at the site are ready, willing, and able to offer assistance or keep the area clear if necessary.

● *What kind of electricity is available at the site?*
You need to know if you should bring along grounded adaptor plugs and voltage converters.

● *What problems can I expect to find there?*
This question may lead to incomplete answers, but ask it anyway. Simply explain to the client that the more advance information you have, the better and faster you can do your job.

Staffer Jerry Poppenhouse says that he tries to "get on the phone with the client and talk directly to him to find out specific information. Sometimes it's different than what you imagined, so you have to get that information first. Sometimes the client isn't at the location site, so you have to call up the site managers, tell them who you are and when you're going to be there and that you've talked to their boss, and that he wants a photograph depicting this idea or subject. You try to verbally communicate all of this over the phone and get their input, which may be different from their boss's on whether it's ready to be photographed or not and when it's going to be ready and what, in their opinion, is the best way to do it.

"Then, if the client said he wanted people in the photograph," Poppenhouse continues, "you have to tell your contact that there are people involved and you'd like to have people dressed a certain way, the men clean-shaven, and other things like that. Some things may be sensitive. You may want to depict different ethnic groups. You have to discuss all this with your client."

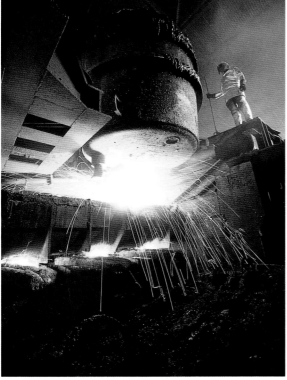

Careful observation led the photographer to this rendering of a steel pour at an industrial facility. To focus on the streak effect in this long exposure, he minimized the visibility of the surrounding area by filling in with blue-filtered strobe.

The client, a design firm, wanted a generic image that spelled "industry." To recreate an industrial setting in his studio, the photographer used a model wearing a mask and gloves, and had two assistants standing on ladders holding sparklers overhead to simulate welding sparks.

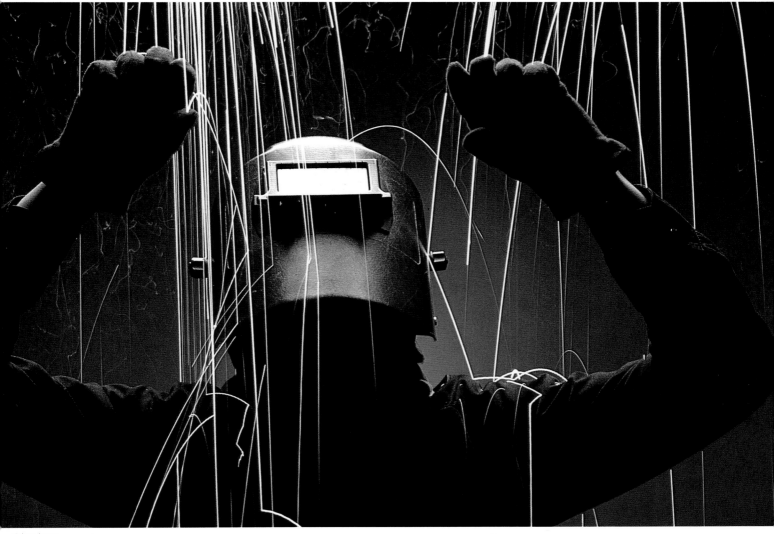

PREPARING FOR THE ASSIGNMENT

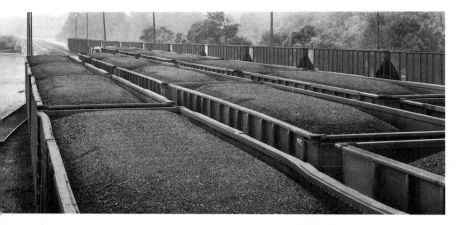

Photographs © John Corcoran.

Some annual reports are shot in black-and-white, often for graphic impact. This assignment, for Emons Industries, required the photographer to build a shooting platform on top of a coal car for his tripod-mounted 4 x 5 camera.

SCOUTING LOCATIONS

The client may give you a layout to work to, a site to work in, and some people as models to work with, but beyond that he expects results within a reasonable amount of time. Of course, what neither you nor your client (though you may wish he did), has any control over are any unexpected events that can befall you as you reach your destination. But a good first step to help you prepare for a shoot is to scout the location.

Location industrial photographers readily admit that location scouting in advance of a shoot is a highly desirable opportunity. Lou Jones' viewpoint is shared by many in his field: "It has to do with the budget. For a lot of work that you do, you go in cold. You fly somewhere, you get there in the morning, you look at the site, and you shoot it. You take an hour or a couple of hours to look at things and then you spend the rest of the day shooting however many shots you have to shoot that day.

"I'm encouraging the practice of advance scouting more with my clients," Jones adds, "to give me scouting location time or to let me see the kinds of things the client wants me to do or to go around and get a feeling for the job before we even think about how we're going to do it. We're doing much more of that nowadays.

"The book (the annual report) that you're shooting for, the piece that you're doing, is directly proportional to the amount of time you can spend previsualizing the work," Jones continues. "If I go in cold, I may get a great shot, but if I get time to see the site well beforehand, I'll make an even better shot." But, he adds, "There's one hard and fast rule: if you see it, shoot it," since things may change that will alter the composition only minutes later.

Camille Vickers notes that there are occasions when a client will pay for days of scouting, to find the right locations and the right people, but such opportunities arise very infrequently. Where scouting must be done on site, Vickers says, "I'll constantly juggle with the schedule to get the best pictures of everything."

Many, if not most, industrial photographers, both freelance and in-house, concur that "expect the unexpected" is a motto to live by. And they all take steps either beforehand or while they are on-site to get around the obstacles that could stand in the way of a successful shoot. "The biggest problem you can expect to encounter," Lou Jones points out, "is that the people at the site either haven't the foggiest idea that you're coming or are completely unprepared for you, or that the situation that should exist doesn't exist. That happens all the time. Things are never the way they say it will be on location."

Being a professional carries with it a certain responsibility. "More often than not, the thing that has to be done is that you're there and you have to make a photograph anyway, regardless of all that," Jones adds.

"For example," Jones cites, "on one assignment in Japan, we had spent days getting permission to get into a facility, a very highly proprietary situation. When we arrived, we found out that whoever was in charge completely misinterpreted the fact that I was supposed to have absolute access to the entire facility and he stuck me in a room that was about 12-by-12 and told me to do the shot there. I told him that the vice president told me that I had full access to this plant. I had just driven through a half mile of some of the most beautiful open-hearth furnaces and materials—the best photo opportunity I had the entire time in Japan that year. They said, 'No, you take the photograph here.' If I had been in the United States, I would have turned around and left right then and there. But this was the only opportunity I had to be at this location for this photograph, so I made a photograph—which turned out to be one of my best that year."

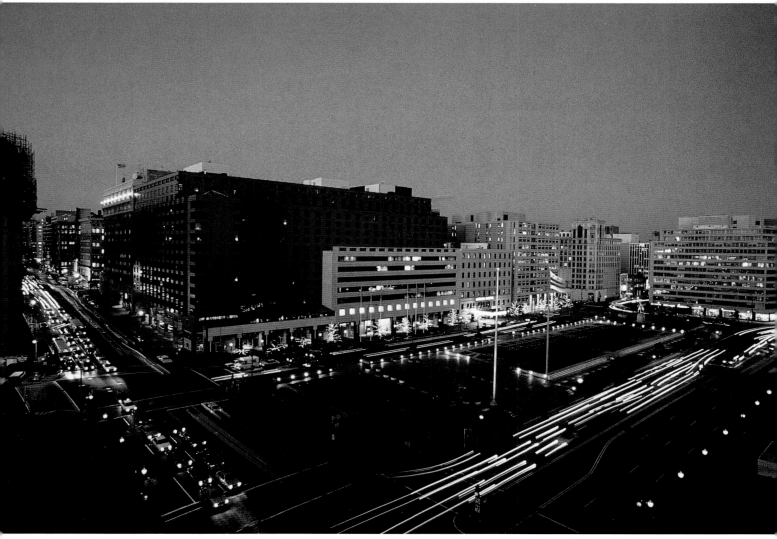

© Robert Rathe.

To capture this moment of a Washington D.C. dusk for Potomac Electric Power Company (PEPCO), the photographer first had to make his way to the roof of a building and then photograph the scene in biting cold weather.

Because the people in charge at the corporate end are so involved with day-to-day matters, not to mention planning for the future growth of the company, they pay less attention to the details that can make or break an assignment. "Very often, they think they have done the job—they'll say, 'There's a photographer coming on Thursday.' That's the end of their responsibility as far as they see it." Jones observes. "That's one of the reasons why we try and take the responsibility of most of the work that we do away from those people. We say, 'You tell us who it is at this plant that we should be getting in contact with and we'll do the groundwork.' The reason is that we want to talk to the shop foreman and ask him if there are any union problems, what can and can't be moved, what can be done at the site, to establish that anything we're going to photograph is in fact going to be there, if it's clean or needs to be cleaned, for example—I can get that information from them."

On location, the problems Jeff Smith has observed focus on "a lack of preparation by the people at the location . . . If they know you're coming and you tell them you're going to need six lines of 15 amps each and they don't have it ready, that can be a problem." Another problem is what Smith calls "dirty electricity," where the current is not voltage stabilized. That can blow out your strobe system. "I've blown up an awful lot of lighting units by having people tell me they've got a perfect electrical system that will transform 240 volts down to 110 volts, but it has so many peaks in it that it blows your equipment." Smith adds, "As long as I have electricity and cooperation, I can shoot."

Sometimes time is wasted at a site because the necessary permits and clearances haven't been obtained. Weather can be a problem, too, principally outdoors. And at times the industrial photographer is up against uncooperative people who feel that your job is cutting into their job. But one way or another, you do it, you solve the problems. You're the professional. That's why they hire you. As Jerry Poppenhouse emphasizes, "You have to adapt to whatever the environment offers you. You have to adapt to any changes. *You have be be adaptable.*"

Poppenhouse's philosophy of adaptability can be seen in this image, at right, which took him to a North Sea facility off the Norwegian coast. The gas at that exploration site was being flared off, because at that point, no storage facilities or pipelines had yet been built. He had to first learn all the safety and evacuation procedures, as well as wear a rubber suit, since a dunking in the sea would leave only precious minutes of survival time. Add to that the fact that Poppenhouse had planned a pleasant night shot but, upon awakening in the dead of night, found to his alarm that it was raining. On top of the gas flare he had to contend with lens flare, as droplets of water hit the protective filter on the lens. But he turned adversity to advantage in this assignment for Phillips Petroleum and produced an often-published photograph.

The photographer had readied himself and his Hasselblad for a night shot, but didn't count on the rain. That made all his safety and evacuation preparation at this North Sea facility all the more important.

Jerry Poppenhouse, © Phillips Petroleum Co.

SHOOTING TO A LAYOUT

Art directors may, in proposing the design for an annual report, brochure, or product piece, prepare a "comp," or composite layout, that you are expected to work from. However, it varies.

"Some jobs are: shoot whatever you see, whether vertical or horizontal, however you want to shoot it," observes Jeff Smith. "Others, I know they're all going to be vertical photographs, or I may know that it's a small photograph and I may execute it differently than a full-page photograph."

An art director may be at the site with you, providing instant feedback if the layout, or any part of the concept, even without a layout, is or isn't working. But that is not always the case. "Often I travel with art directors, that's something that's happening more recently than in the past," Smith adds. "I enjoy it for the input that they can give me, but it's important that you and the art di-

rector have got an understanding," he emphasizes. "In other words, I don't like to be treated as a technician, I like to be treated as part of the creative team." That collaboration, Smith points out, can produce some very positive results.

Put another way, when a photographer is given free reign, the assignment becomes that much more difficult. Camille Vickers recalled one overseas assignment: "I spent three weeks in Japan taking pictures for a corporate magazine and I had absolutely no direction at all. It's overwhelming to realize that you have to decide what to photograph. It's easier to be told that we need this, this, this, and this. Just like when you were given a topic for a term paper in school, the first thing you had to do was narrow your subject down so you could research it and do a good job. But the challenge of it is very exciting."

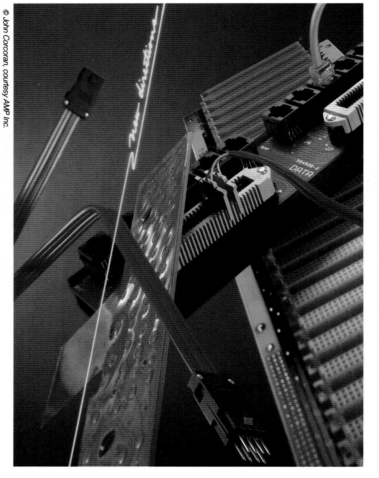

Following the art director's sketch, the photographer created this annual report cover shot. The artist's wide-angle rendering in the drawing proved especially helpful when executing the concept photographically.

Shooting to a layout required the photographer to use an acetate overlay on the groundglass of his 4 x 5 view camera. This was shot for use in a promotional mailer.

VIEWPOINT *Jerry Poppenhouse, Jeff Smith, Camille Vickers, Greg Beechler, Robert Rathe*

THE UNWRITTEN DRESS CODE

There is what Jerry Poppenhouse calls "an unwritten dress code" that both in-house and freelance photographers follow. What you wear is largely a function of whom you're photographing, and where. Poppenhouse points out that "if I'm working in a plant, I'll wear suitable clothing, but the day I'm meeting with the people to discuss the shoot, I'll wear a suit. If I'm talking to a CEO or president, I'll wear a suit. If I'm talking to a manager or somebody else at that level, I'll be comfortable wearing a sport coat."

He also keeps work clothes in his office and often takes along a jump suit that he can easily don over other clothing when the need arises (if the weather is not unbearably hot). "I start the day in a suit, because I never know when I'm going to be called up to the executive offices."

Jeff Smith adds some sensible rationale for following a dress code: "I generally would wear a tie, more often than not, even inside a plant. The people who are really going to make things happen are wearing ties, so if you're wearing a tie, they're going to help you: you're going to be one of them. You've got to remember that the biggest thing you do is to convince people to help you do something they don't want you to do, and if you come in there and alienate them by looking like the artiste, as opposed to another business person who is trying to get something done, you won't get nearly as much cooperation. And, as one of my friends in this business says, if you wear a tie, the secretaries let you use the phone."

"I dress simply," says Camille Vickers, one of the few women working as freelance industrial photographers. "I always wear shirts and slacks and a decent looking jacket. I will wear jeans if I'm sure I won't be coming into contact with executives. I think it's important to have warm hats and gloves with you, because you never know what you're going to run into in outdoor shoots. I try to keep a decent pair of shoes with me, but I'll also have work shoes. I don't dress up, per se. I might dress better if all I'm doing is executive portraits than I would if I'm going to a factory. But I certainly never wear a skirt on a job."

Sneakers and tennis shoes are out, wherever and whatever you shoot. Notes Greg Beechler, "Sneakers can be dangerous in some situations. They're slippery and don't offer any protection against things falling on your feet." Another suggestion for footwear comes from Robert Rathe. He notes that crepe soles on leather shoes help make standing on your feet easier for long days, to combat fatigue. Furthermore, "crepe soles give you a good hold on surfaces. They also serve as a good insulator, so if you happen to touch something electrical, you're not grounded, which is something to consider in a factory."

Assistants generally follow a looser dress code, but as Jeff Smith points out, "I expect my assistants to wear a clean dress shirt, slacks, and leather shoes," adding that "when I wear a tie, they wear a tie." Smith prefers bow-ties, because they don't get caught in the machinery.

PHOTOGRAPHING THE SITE

You have to review safety requirements, because there are a lot of hazardous situations you can get involved in.

JERRY POPPENHOUSE

Industrial photography at industrial sites, and even in corporate offices, is an exciting challenge. No two industrial sites or corporate offices are the same. Some involve elaborate setups; others are more direct. Some may require you to fly in a helicopter or light aircraft—or to shoot from the top of a construction site—while others may require nothing more than a small stepladder, if even that. On the other hand, there are those industrial sites that take you hundreds of feet below the earth's surface.

Conditions at the sites are as variable as the locations themselves. You might find yourself engulfed in dust or ash one day or sprayed with sea water the next, or you may find nothing worse than a little grime. Many locations are quite tame, but even these require a patient, watchful, and creative eye to produce a dynamic portrait of industry at work.

It is easy to be intimidated by a potentially challenging site that requires you to leave terra firma. The mere thought of flying over a plant in a light aircraft or helicopter, climbing to the top of an oil rig, or exploring a mine deep within the bowels of the earth may be less than appetizing, if not downright frightening.

You may never be placed in such situations. Even when you are, safety comes first, which should be some reassurance. It is the prudent photographer who returns from every assignment unscathed, with a case full of exposed film that successfully captures the resources and significance of the site for the client.

At this Pan Am repair facility, the photographer had to position the strobe inside the plane to keep it from appearing in the picture. The girder work required additional lights with light blue filtration, and more lights positioned at ceiling level to illuminate critical areas.

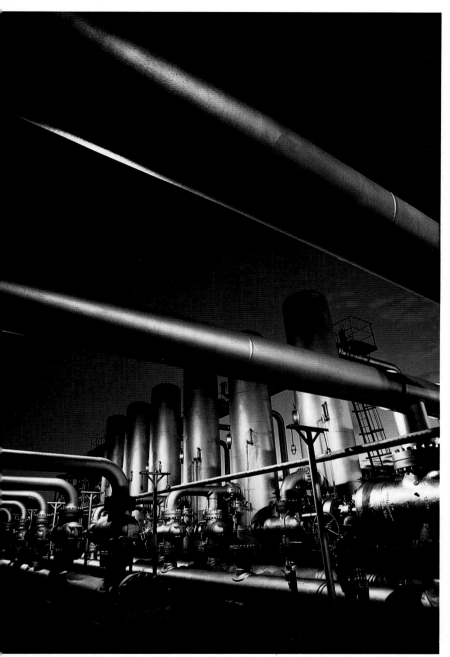

© Camille Vickers.

In this photograph for an annual report for Consolidated Natural Gas Companies, the photographer had to depict the company's largest storage facility. Adding a person for scale, she used an ultra-wideangle lens to emphasize the size of the facility.

"People are always surprised at how much time it takes or at how much gear you have. And you'll always hear jokes about 'Is it going to rain in here?' when you put the the umbrellas up. Always," Camille Vickers comments. "That's simply a part of the job of shooting on location. It goes with the territory."

Getting people involved makes any location assignment more difficult, but often it's a necessity. You may need cleanup crews, you'll often need models, and you may be there with an art director who oversees the shoot.

"The first thing to do is to meet the players, the key personnel that you'll be interacting with," Lou Jones advises. "The second thing is a walk through the plant to look for potential shooting sites."

You also have to make certain that what's been scheduled for you to shoot will be accessible. "One client we were shooting for hadn't found out that the plant closed at two o'clock on Friday, and we arrived at about one," Camille Vickers recalls. Greg Beechler adds: "He'd also scheduled the outdoor shot at noon and the indoor shot for two." Yet, by reshuffling their schedule at the site, Vickers and Beechler were able to complete the assignment. Flexibility was the key there.

Describing one part of an involved shoot, Lou Jones related how deceptively simple, yet truly complicated the setup could be. The shot involved the new glass facade of a newspaper complex. "We had to do the first shoot, which was supposed to be at dawn with the sun coming up right in front of the building," the intent being to catch the morning glow in the glass facade. "We had a crane lifting us up about 25 feet. We had the road in front blocked off and we were shooting 4x5. We got a beautiful dawn, we were all set up, we had the union people bring out the crane, and we shot two Polaroids just as the morning light broke—and then the clouds moved in. We had to quit the shoot." Fortunately, a subsequent try two weekends later proved successful. (For more on this assignment, see the sidebar, "On Location," on page 27).

SITE MAKEOVERS

One of the problems at industrial sites, even corporate offices, is that the place is either filthy or cluttered with everything imaginable that will work against you in a picture. Photographers often find themselves or their assistants cleaning up. Where people's offices have to be rearranged, it helps to shoot Polaroids, even with a simple point-and-shoot instant camera, as a reference, to help restore the space to its original condition.

Cleanup takes time, and there may not be enough time to do it. However, there are solutions. "Generally, you try to find an area that's a little bit cleaner," Jeff Smith recommends. Failing that, "you can hide a tremendous amount through lighting—keeping unsightly areas in shadow—and by cropping."

There's a practical course that Smith outlines: "In my scouting tour, if I find a very messy area that I want to shoot in, I'll make it the last shot of the day and ask if it can be cleaned up by then. Or I may use a forklift to move a bunch of cases or products in to form a wall that can cover up an unsightly area."

The cleanup requirements may be more than just cleanup. "At an automotive plant," Camille Vickers recalls, "we asked them to repaint a floor. We came back the next day to do the shot."

A heavy manufacturing facility involves people, equipment, and processes. In this photo for a Blount Inc. annual report, the photographer used available light, shooting from a scaffolding at a safe distance.

© Camille Vickers.

SHOOTING THE BOSTON GLOBE PRESS ROOM

9:00 AM: Jones and assistants complete studio prep.

11:00 AM: Jones arrives at site with two assistants.

Jones meets with client and is told that the scissor lift would not be there for a couple of hours. The client gets approval from the press union people for Jones to begin setup. It was not an ideal situation, since the scissor lift would have given Jones the camera viewpoint from which to direct the setup, but Jones takes the initiative to save time and directs assistants where to begin setting up lights.

"This is for an annual report. They want two photographs; one of the new facade of the building, the other of the new press room, which is a multimillion dollar state-of-the-art facility. Today's shot involves putting a scissor lift at the edge of the press room (toward the windows) up 10–12 feet. We're lighting one side of this room, where there are brand new presses.

"Now, the pressmen are cleaning up. My assistants are hanging lights behind the poles, so they won't show in the picture. We're shooting with several Balcar 2400 W/S units. They're all going to be umbrellaed, since bare lights would leave heavy shadows. What happens here is that we're trying to get a slight bit of strobe and ambient light. The ambient light is partially daylight and partially sodium vapor lamps, which is an awful color for this situation. We have to blow that out, and yet we have to take advantage of the ambient daylight that's coming in to give some of the feeling in the shadow areas."

"We use a Minolta flash meter, but metering is essentially done with Polaroid. We can tweak our lights and the Polaroids tell us what we need to know. The Polaroid tells us if we have enough depth of field."

Jones is concerned with some highly visible dust on a window in the "quiet room" (a soundproof area), that may show in the picture, but someone is attending to it. "It's all about the photograph," he comments, emphasizing the attention to detail.

Jones does visual check of the lighting.

1:00 PM: Scissor lift arrives, test Polaroids shot.

First assistant takes a meter reading. With the arrival of the scissor lift, Jones goes up on the lift and makes test Polaroids—used to judge where the lights would be needed and also to make sure that the area that would be visible in the picture would be as spotless as it was supposed to be, they're also an aid in composition; strobes were not popped for initial Polaroids. Great attention is paid to making sure that there are no unsightly areas.

2:45 PM: Light setup completed.

Now it's just a matter of double-checking their placement. Everything is being checked to the *n*th degree. Jones checks against Polaroid.

Just when you think you have everything under con-

trol, something crops up. Someone decides to hang a Halloween decoration inside a window in the quiet room. It has to be taken down.

3:50 PM: Flash meter test of each flash setup.

Incident metering used, in cordless mode, to ensure fairly uniform lighting ratios. A Quantum Radio Slave II remotely triggers each strobe.

Adding to the complexity of the shot is the addition of models in the foreground—and the need to light them as well—and models in the quiet room where soundproofing makes it extremely difficult to direct the person from outside. All models are employees.

4:00 PM: Polaroid test for the lighting, to see how the lights affect the presses and the people.

The remote transmitter is connected directly to the 4 x 5 camera. Once the shutter snaps closed, it sends a pulse to the receiver at the end of one power pack. There are four power packs set off by the remote, but all four packs are hardwired together, set off by one signal from the radio remote. Now a black-and-white Polaroid test is made.

Lights: 11 large-capacity flash heads with umbrellas; 5 small 25 W/S Morris strobes. Morris strobes are not umbrellaed. Morris strobes are used to fill in areas that would otherwise be in deep shadow. These strobes are self-contained and screw directly into any light socket.

Exposure determined to be f/11. First exposure measurement was made for the Morris strobes. All other strobes were brought up or down to match that Morris strobe exposure. Slaves could not be used for the big power packs because of walls or other obstacles. That was the reason for hardwiring.

4:30 PM: Shoot commences on 4 x 5, in black and white.

Shoot begins with two models.

Assistant helps time recycling of strobes to coordinate correct flash syncing.

5:00 PM: Switch to 35mm.

Color film used for the 35mm shots. One model added. Tripods changed as well. Exposures are one second and everyone is holding still. (4 x 5 exposures with two models had the models engaged in conversation.)

5:10 PM: Shoot concludes; cleanup commences.

Models sign releases.

6:30 PM: Gear packed away; the day ends.

Studio time: (9 to 11 a.m.) 2 hr; setup time: (11 a.m. to 4:30 p.m.) 5 hr. 30 min; shooting time: (4:30 to 5:10 p.m.) 40 min cleanup time: 1 hr 20 min; total elapsed time: 9 hr 30 min (excluding return trip to studio). Note: these figures do not include studio time that was involved prior to and after the day of the shoot.

© Lou Jones.

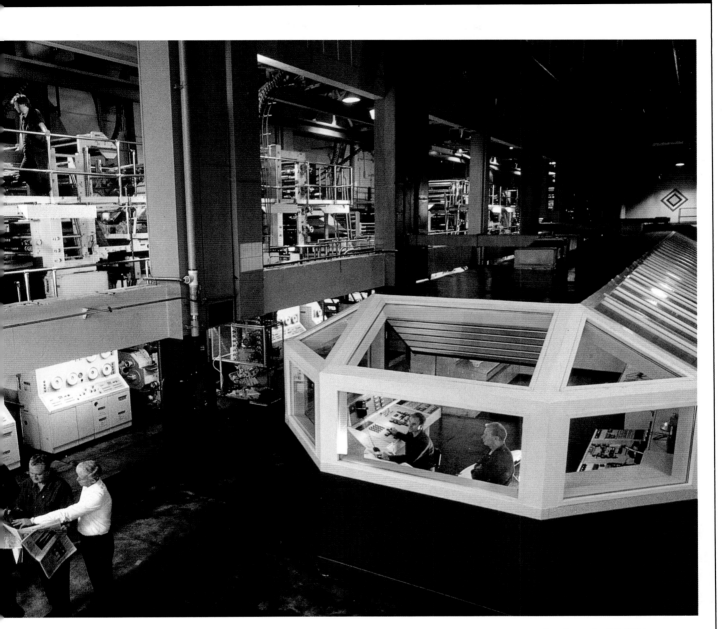

Lou Jones tackled the challenge of photographing the Boston Globe's press room through a combination of his own photographic vision, years of experience with lighting, countless hours of preparation, the cooperation of the client and the press room staff, his two assistants, and the aid of a scissor lift.

The photographer had to show the helipad and a helicopter coming in for a landing at a "jack-up" rig. He had to coordinate the two helicopters, his and the one below, choosing to shoot late in the afternoon to render the ocean black.

By and large, the consensus runs in favor of helicopters when it comes to shooting from the air. "We prefer helicopters, mainly because they give you more maneuverability," says Camille Vickers, reasoning that helicopters can hover and provide a larger open area for the photographer to shoot through.

The biggest advantage is that, unlike many light aircraft, a helicopter has no wings and struts to get in the way. Moreover, on a helicopter, you can take a door off. An airplane usually only gives you a small open window to shoot through. Helicopters also let you get closer to the ground. Local regulations, however, govern how low that altitude is, and no responsible pilot will violate those regulations. (And you wouldn't want to fly with him if he did.) On the other hand, light aircraft do have one advantage: They're often cheaper to rent.

Whichever craft you use, you may find the going easy most of the time, but there is that occasional frightening experience no one wants to think about. "We've had some pretty hairy experiences shooting out of helicopters in bad weather, fog, hail, snow," relates Jerry Poppenhouse. Hairy experiences are not the domain of helicopters alone. "In Alaska, it was so cold—minus 85 degrees—that the tire on the single engine aircraft broke on takeoff. As a result, the landing was not as smooth as it might otherwise have been."

While this may not technically fall under the category of shooting industrial sites, it is one example of the perils of aerial photography. One assignment called for Poppenhouse to shoot a mail-delivery plane from another light aircraft. (The subject plane uses Phillips fuel, which was the reason for the assignment in the first place: to show an application of the product.) But there was one catch: The client wanted the plane photographed in a thunderstorm. "They wanted big thunderheads. It was pretty dark out, the weather was just absolutely terrible—the way we wanted it. But there was so much wind that our plane got in front of the mail plane for a brief second. I'm shooting away and I see this plane coming right at us." The photograph, to Poppenhouse's experienced eye, was on target, but, after all that, the agency didn't even use it.

Of course, shooting from the air has its own set of technical problems. Vibration can be a problem if you lean up against the sides of the craft, so you avoid that. A bigger problem, perhaps, than vibration is that the camera is buffeted by the wind.

One consideration that might be a problem really is not. "You usually don't need great depth of field when shooting from the air," observes Jeff Smith, "and I will generally open up to a stop and a half under maximum, unless it's very low light, in which case I'll go to maximum lens aperture. I try to get the highest shutter speed I can."

Photographers differ on their use of filters from the air. Smith notes that he's usually not up high enough for a UV filter to be necessary. "I believe in getting as low as you *safely* can and using as wide a lens as you can. I prefer shooting at dawn and dusk, using an 81B or 81C to warm things up a bit and make it look even more like dawn and dusk." Robert Rathe uses UV and skylight filters, even a polarizer when it won't cut down on the shutter speed necessary against the effect of vibrations. Camille Vickers and Greg Beechler also use polarizers when they need to cut through haze, using these filters with 35mm cameras and Kodachrome film.

But just for the record, if you thought that photographers only used 35mm cameras for aerial photography, you're mistaken. "We've taken cameras as big as 8x10 out in a helicopter and mounted it to a gyro stabilizer. We got some outstanding results, but it's more trouble than it's worth," Jerry Poppenhouse recalls.

And one final safety note, from Robert Rathe, who recommends that the number of passengers be limited to the photographer and his assistant (who's largely responsible for film loading and lens changing) if they intend to hover in a helicopter. If the client goes along, slow fly-bys are the safer alternative.

© Camille Vickers.

The train was scheduled but the fog was not, which required the light aircraft to circle until some of the fog lifted, when the photographer made this exposure.

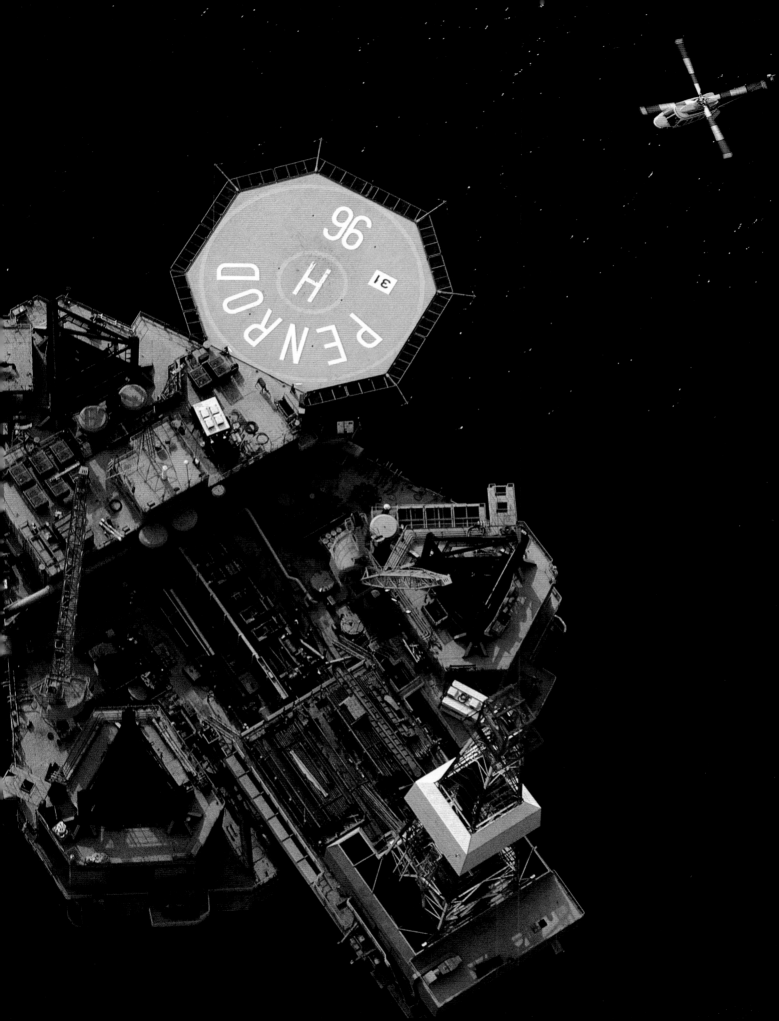

SAFETY FIRST

Once you've talked to people at the site and made your presence known, you need to discuss the parameters of the assignment and the safety regulations. "You have to review safety requirements, because there are a lot of hazardous situations that you can get involved in," Jerry Poppenhouse advises. "At a lot of locations, you need a safety person with you, and that has to be arranged in advance. You walk through the location, which can take several hours. Then you get your lights set up in accordance with Occupational Safety and Health Administration (OSHA) standards and do your job.

"Sometimes you're in an area that requires the use of explosion-proof equipment," Poppenhouse cautions, "and you have to make sure your lights will not be a source of ignition of flammable vapors. You also have to make sure that your electrical equipment has the proper rating for use in hazardous areas. Some places have twist-lock electrical sockets, so you need an adapter for that. You may get adapters from operations or maintenance personnel in the area. If you're in a high noise level environment, you need protective devices for your ears. You may need safety glasses, hard-toed shoes, and a helmet. If you're in a hydrogen sulphide gas area, you need somebody along with a gas-monitoring device. You need a proper safety harness if you have to walk on a four-inch beam at a construction site.

"At one site," Poppenhouse relates, "I was up on top of a tall tower in Kansas City, shooting the work they were doing. They started shouting and motioning to me, but of course I couldn't hear or understand them. I had gotten approval to use my equipment and photograph from the elevation of the tower. Once I got up there, they realized I had not been briefed on the need for protective clothing required to work near equipment that was processing potentially harmful materials. Luckily, I hadn't exposed myself to any of it. From that day on, I always ask what material is in the tower.

"Another time," he continues, "again where I had prior approval, I went up a tower in one part of the plant, not knowing that in another part they had just released some gases as part of a controlled emission. Luckily, I had a railing for support and was standing on a platform when the release occurred. I hung on and came out okay when the cloud passed." Those are the kinds of situations where good communication is critical.

Similar incidents occur with freelance photographers as well. The prudent move, as Jeff Smith convincingly states, is to control and organize these situations to maximize safety. "I don't believe that any photograph is worth getting injured for."

But no assignment has to be dangerous, regardless of the site, if you follow some basic precautions. "It's a question of general awareness of what you're doing and where you are," says Robert Rathe. "There are a lot of very dangerous situations out there, in factories, on construction sites. Sometimes you can get so involved in looking through the viewfinder that your sense of where you are in relation to something that might be dangerous is distorted." In other words, keep everything in front of and behind the camera in proper perspective.

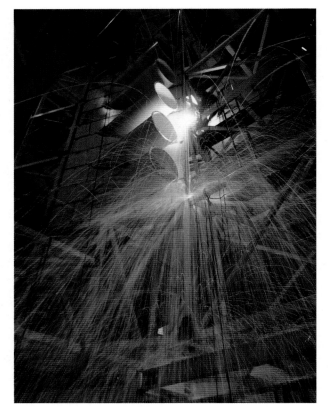

James E. Stoots, © LLNL.

To photograph this welding process on a space frame required the photographer to remotely trip the shutter from another room and to set the 4 x 5 camera up under heavy canvas, with an 8 x 10-inch sheet of glass fastened over the front to protect the lens. On cue the welder tipped the container of molten metal onto the frame below, creating a shower of sparks.

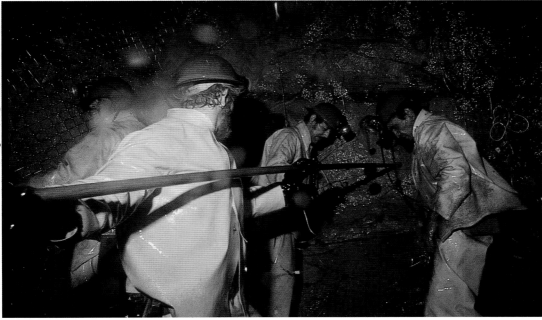

Complicating matters in this uranium mine was the combination of mist, rain, darkness, and underground explosions. Here mine workers are loading a charge as they prepared to blow the rock.

SHOOTING UNDERGROUND

One of the less glamorous assignments you can have is to go down in a damp, dark, dust-laden mine. You can refuse the assignment if you're a freelancer, or you can tackle the challenge. As a staff photographer, it may be part of what you're *expected* to do.

Going down into a coal mine in this country requires a federal inspector on the property. It will also mean no electronic flash lights. You wear a jumpsuit, safety equipment, and a self-respirator (in the use of which you have been trained), steel-toed shoes, and a hard hat with built-in light, which may have to be your sole or principal light source for photography. This was one situation that Camille Vickers found herself in shooting at a mining site in Wyoming. She used the hat light to illuminate her subjects for a long exposure and a tripod to keep the camera steady.

Another situation placed Vickers in a trona mine, also in Wyoming. Trona, which is soda ash, is, Vickers noted, probably the worst mineral you can get on your camera, since it is highly corrosive. If you're not careful, you can spend an entire evening cleaning your cameras to remove any residue of this material.

Jerry Poppenhouse found himself in a uranium mine on assignment for Phillips Petroleum. The workers were loading a charge, getting ready to blow up the rock. Because the ore hadn't been processed at that point, it was not at a level where it would have any adverse effect on people or film. Poppenhouse took two handlemount strobes that were inside waterproof containers. He put his 35 mm SLR in a watertight housing as well. "I had one person at each strobe, so I could tell these people

to move around—the strobes, in a sense, had legs on them. The problem was with the steam and the rain, preventing me from focusing and from seeing my *f*/stops or the distance scale on the lens. I had to go back up to the surface and put tape on the aperture ring, in a sort of braille system, so that the thicker the tape the wider the aperture. The same with the focusing ring, marking the 35mm lens at infinity. Once back down below and shooting, it was just a matter of taking a handkerchief to wipe off the waterproof housing, when necessary. As soon as I did that, I would take a picture.

"This was probably the most difficult assignment I've every had," continues Poppenhouse. "That was down 2,100 feet. I'd never been down in a mine before, let alone a uranium mine. Once in a while they set off an explosion. You had water and air being blown in for the people to breathe, which was cooler than the air down there, and when it hit the hot water from the aquifers, it turned to steam. So it was constantly raining, which is why they were wearing raincoats. It was dark. The only light is the one you supply." At one point the drainage pumps stopped working, leaving Poppenhouse in water up to his neck—and he's 6'4". And the elevator, which was an oar bucket, was out of commission. But, fortunately, that was only a temporary setback.

"The closest thing to compare this to," he went on, "would be to stand in a hot shower with your camera, turn off the lights, have somebody throw sand on you every once in a while, and blow in some cold air on you so it would turn to steam when it hits the hot water. Then try to take a photograph in those conditions."

PHOTOGRAPHING PRODUCTS AND PROCESSES

Ask whether a product does something special, and how that product relates to the industry.

JOHN CORCORAN

When you arrive at an industrial site, you may find yourself photographing more than just the site or individual aspects of it. The assignment may call for you to photograph any variety of products and complex processes, such as furnaces and metal pours, welding, and lasers, to name a few.

There are many reasons for shooting a product at the site itself, aside from the fact that the client may simply want the shot done that way. One principal reason is that it enables you to show a product in the context of other elements that relate to it. And then there is the obvious one: You can't move much of what you photograph out of the factory and into your studio.

On the other hand, there are certain advantages to working in the studio. Here you can show, without any embellishments, what the product is or does, or you can recreate an industrial setting with sets especially built for the occasion or even fabricate a scenario out of your own imagination. Everything here is fully under your control, and you don't have to worry about production schedules that may be interrupted by your presence at a facility.

On the surface, it might appear that several of the processes described here have no application to the freelancer. But you couldn't be further from the truth. If you are familiar with these processes and the photographic means to record them, you'd be one step ahead of your competition when a client calls and asks, "Can you do this?" Besides, there is always the possibility that you may find yourself working as an in-house photographer where such processes are commonplace. Having advance knowledge of what's required couldn't hurt the next time you're up for a job review or applying for the job in the first place.

This studio shot took more than studio work to perfect. The physically perfect sectioned cables had to be cosmetically cleaned up, as did the background, both requiring extensive retouching.

Photographed for a Kennecott Copper annual report, this red hot refractory mold is immediately dumped into a vat of sand and left there to cool for two weeks. A 180mm lens allowed the photographer to shoot at a comfortable distance, unaffected by the heat, for this available-light exposure.

As with industrial sites, many processes can prove hazardous if you don't follow the safety rules laid down at the facility. As Jim Stoots, an in-house photographer at Lawrence Livermore National Lab, relates concerning one series of photographs involving an experimental project: "We had an explosion and only lost a camera lens. Had we not complied with all the strict safety regulations, we would have been engulfed by flames, chemicals, and molten ceramics."

Of course, things may not prove that disastrous, but circumstances may still be totally beyond your control, as Camille Vickers relates. At a copper smelting site, there was a spill. "I didn't know what was going on. I was taking pictures and somebody grabbed me from behind and yanked me about 20 feet just before this molten copper reached my feet."

And there was another incident, which happened to Vickers at a chemical plant. She put her camera bag down to photograph a small truck. There was no place to put the bag to ensure its safety, which didn't appear to be an issue at the time. "And while I was busy photographing this truck, a tractor-trailer pulls through and runs right over my camera bag." But the story did not prove as disastrous in its consequences as might at first appear. Her Nikon cameras and lenses made it through with only minor damage. The camera bag, on the other hand, was totally destroyed.

It's impossible to see into the future and to anticipate every potential hazard. All you can do is take reasonable precautions. This happened while Mark Gubin was photographing on assignment: The client's tractor was pulling 50 freight cars across a bridge, in an area of Colorado where the tracks stretched across a perfectly flat grade. Those cars are so well bearinged that you could push one right along, but, once set in motion, you couldn't stop it yourself.

"The tractor started pulling the cars along the tracks across that small bridge, and once we got the shots, we told the driver to stop. The driver put on the brakes, and, in doing so, set off a chain reaction: The last car hit the one before it and each did the same thing in turn. The tractor driver saw it coming and he leaped out of the tractor just in time— and into the water. The tractor lurched forward, but it didn't get derailed and no one was hurt."

Keep a watchful eye!

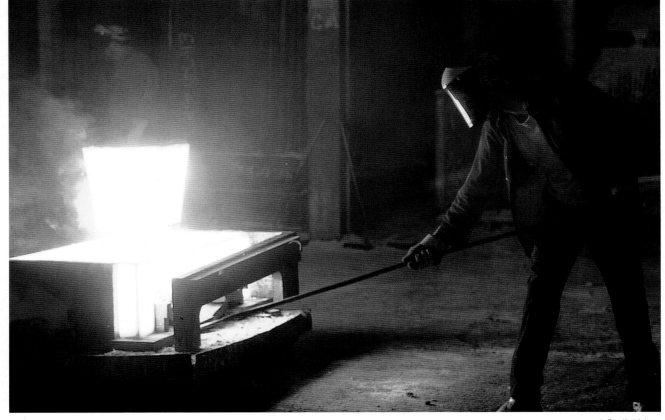

© Camille Vickers.

PRODUCTS LARGE AND SMALL

Industrial photographers are required to photograph any number of both large and small products, whether on location or in the studio. Here are just two examples, the first on location, involving large products, the second—small-product photography in the studio. Interestingly enough, the purpose of the assignment may not necessarily be to promote or sell the product as much as to promote the capabilities of the company. Or it may be to promote a product—but indirectly, by showing what the product is used for, and this too may be shown more by inference than by direct application.

As he was scouting the location with his client, on assignment for Raytheon, Jeff Smith was impressed by the pristine appearance of the airplane hangar floor and decided to use it as a backdrop. That decision, however, required that a special perch be built and hung from the overhead girders, about 20 to 25 feet above the ground. This perch was built overnight. Smith intentionally used three planes with red accent coloration, which were pulled into camera range and arranged for a dramatic composition.

One of the elements that Jeff Smith felt would add to this shot was a strong shadow, so he used a bitube strobe head mounted on a Bogen light stand, adding a stand extender to get the light to a height of 15 feet. Smith added other lights, bouncing them off the white ceiling as fill for the lower left-hand corner.

In contrast, Mark Gubin's assignment involved a degreasing product that required an in-studio set-up with gears. Shot for Johnson's Wax, the assignment gave Gubin carte blanche to design the picture any way he wanted to present the client's statement about the efficacy of the product, a cleaning fluid that removes grease from industrial products without causing them to rust. Being given this information and directed to "go ahead and make us a very pretty picture," Gubin created a set using a painted background made by airbrushing, colored flood light on the background, with a colored spot to simulate the sun. He had to find his own gears and he made them look greasy by applying different kinds of oil and adding water to them and on the set to make the oil bead up. Blue-gelled lights were reflected off white boards for the foreground subject lighting.

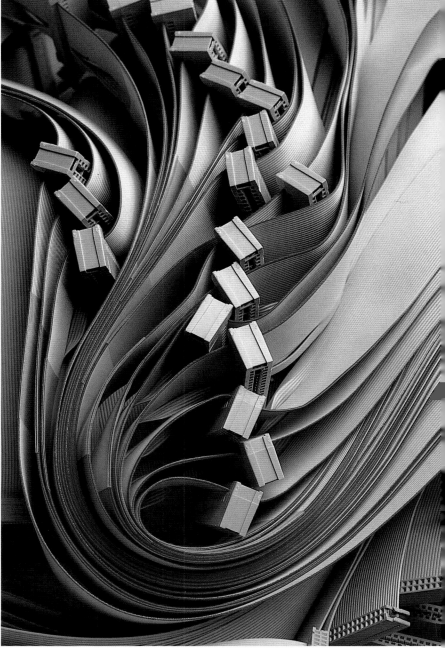

© Lou Jones.

This photograph of computer cables was shot on location for a Price Waterhouse brochure. The photographer used a macro lens and umbrella lighting, kicking some light into the shadows with a reflector.

© Mark Gubin

In this studio shot for Johnson's Wax, the photographer was given carte blanche to create a visual statement about a product that removes grease from industrial products. Supplying his own gears, he created the set, applying oil and water to the foreground and props.

INDUSTRIAL PHOTOGRAPHY

There are two basic approaches to shooting computer and other screen images. One involves stripping in the screen image after the initial exposure is made, and sometimes that's the only possibility. More often, however, what will work best is a time exposure involving several seconds for the screen and another exposure for the surrounding area. The second exposure can be made by available light or with added light sources, whichever proves most efficient.

There is one problem with many color computer images and that is that the image is overly cyan—about 40CC cyan, according to Jeff Smith's experience. To counter that, he places a 40CC red gel filter on the camera lens when exposing daylight-balanced color film. That renders the screen fairly accurately. However, that now leaves you with the problem of correcting for the rest of the scene, which will appear too red as a result of overall filtration. Assuming that you're strobing the

shot, the trick here is to balance the red with the equivalent on the strobes. Smith has worked out a formula that involves a combination of filters that will render the rest of the scene in their original colors, while still correcting for the CRT. That strobe filter pack involves two Lee 191 and two 05C filters. Why not use camera-quality CC40C (cyan) gels on the lights instead? Their cost would be prohibitive, at least to your client's way of thinking when he sees the bill. The less expensive lighting filters are an easier tab to swallow.

Robert Rathe has observed that computer screens require different exposure on color Polaroid film than they do on Kodak Ektachrome. That could result in exposure error if you base your exposure strictly on the Polaroid test print. He finds that black and white type 55 on 4x5 and type 665 in 2¼ is more accurate for computer screens—actually for a lot of things—in terms of determining the Ektachrome exposure.

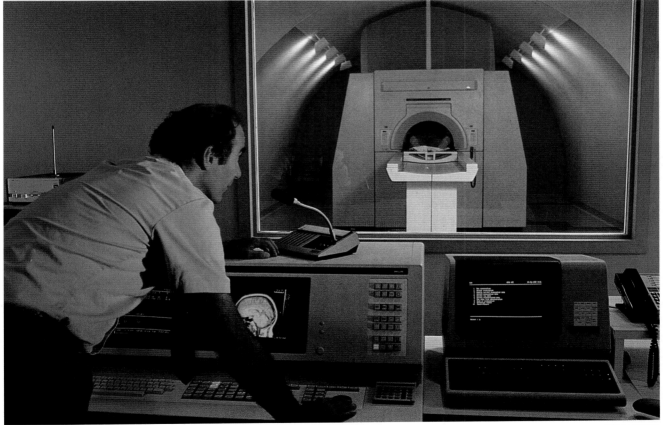

© Robert Rathe.

The trick to successfully photographing magnetic resonance imaging (MRI) equipment is to use lights that are not easily affected by the high magnetic fields generated by the device. In this image, aluminum lights and stands were used for the MRI equipment in the outer room; the control room was also lit to balance the illumination.

WORKING AROUND HIGH MAGNETIC FIELDS

Not every magnetic device is a problem, but some are. And one that several contributors to this book have had experience with is magnetic resonance imaging equipment, used for nondestructive testing in research-and-development facilities and in medical applications.

"I did a job in Alabama, in a magnetic resonance imaging facility," Ken Graff tells us. "They have to cool off the magnets with liquid helium, which Union Carbide supplies. I was in the room with the machine and my shutters went bananas, and I cooked a flash unit because of the high magnetic field. Walking past the machine, I actually felt it pulling at the camera I was holding. The job turned out all right, but the flash doesn't work anymore."

Robert Rathe's own experience around magnetic resonance imaging equipment thankfully proved more pleasant. "The problem with photographing something like this is that it's a huge magnet that can't be turned off. When you walk into the room, you have to take your credit cards out of your pocket, because the machine will erase the magnetic data on them. You can't put anything made with iron in the room where the big magnet is. My strobe heads are aluminum, as are the stands, so we were able to place them in the room." Consequently, the shot that time went off without a hitch.

PHOTOGRAPHING LASERS

Lasers are generally photographed by the light they generate. The apparatus producing the laser beams, however, requires an external light source, or it will remain largely in shadow. Since this constitutes an in-camera double exposure, put the lens cap on the camera after making the initial strobe (or tungsten light) exposure if all lights, other than the lasers, are not turned off. That's the easy part.

There are several proven techniques for photographing laser beams themselves. Because most laser beams are not visible by themselves, as you can see from smoke-filled laser light shows, some medium must be placed in the light path to render the laser beam visible.

One technique Jeff Smith has found useful involves taking a can of freon-propelled canned air (such as Dust-Off) and spraying it while the can is turned upside down, without shaking the can. Different nozzles produce different spray patterns. Run this spray through the beam, with all the lights in the room turned off, and with the shutter on Bulb or Time. The beam becomes visible in the long exposure, which varies considerably with the intensity of the beam and the beam image you want to capture on film. By running the canned air either three or four times along the beam path, or doing it more slowly, you can build up and control the exposure of different beams.

This is very time-consuming, taking the better part of a day, considering the many times the procedure must be followed to assure usable photographs, but it yields very good results in the end. The amount of time required depends on the number of laser beams. You should of course shoot Polaroid tests, and it may be prudent to bracket your exposures. *Caution: Do not spray the canned air too close to the optics, since a freon coating may cause the glass to shatter.*

Cigarette and cigar smoke are generally frowned upon when applied to expensive laser systems. Smoke and fog machines leave an oily residue on the optics, but may be used with low-grade laser systems. Before using this machine, make sure any automatic smoke detector or sprinkler systems are turned off and take care to avoid the use of excess smoke/fog to prevent the laser optics from being heavily coated with smoke particles.

Where individual beams are concerned, you can use a matte black card as a trace card. Set up the camera to record the image as you continuously run the card in the beam's path. You can also use a sheet of acetate supported in a rigid frame, which would then allow you to record the beam path coming toward the camera, so long as the beam is too weak to do damage to the camera, or your eye, should it fall directly on either.

Jim Stoots's experience with lasers has revealed that some lasers, such as argon lasers, need only be photographed by the effect they have on an object. Copper vapor lasers, on the other hand, are so powerful and bright that they need no medium whatever to make them visible. For other lasers he may use an inert aerosol material, Aervoe Precision Instrument Cleaner (Aervoe/Pacific Co., San Leandro, California). His experience with this material has shown that all he need do is spray it from overhead, without turning the can upside down. No cloud is formed to soften the image of the laser. But he does warn against spraying this aerosol near the optics, or they may shatter on contact, as with other aerosol materials.

One series of photographs produced by Jim Stoots shows an argon laser. Here a broadband high-reflector mirror was used to pump a tunable liquid dye in front of the laser to produce colors from green through yellow to red. By tilting the mirror, its transmission frequencies, or colors, can be changed. The output power of this laser can reach a maximum of about 10W and is enough to

burn through some solid objects. Stoots photographed this laser for Lawrence Livermore National Lab's Atomic Vapor Laser Isotope Separation Program. This series of photographs was used variously in an annual report, for wall decor, and in publications.

As many as 10 multiple exposures and as much as one hour were required per sheet of film. First, Stoots exposed for the research scientist, who then left the scene. Subsequent exposures were made for the optics table, the apparatus, and each laser beam. Stoots used an inert spray for the first beam exposure. He notes that each beam had to be recorded separately because the lens had to be closed and the beam redirected to a predesignated spot on a ruler, which he used as a spacing guide. Subsequent beams were recorded with the help of clear acetate supported on a piece of black wood, to avoid ghost images on the film and to keep the photographer out of the direct line of the lasers.

It's always best to check with someone at the site or with your client before using any of these approaches. Only people working with this type of apparatus know what will and will not affect them adversely. The glass elements for some laser systems can cost as much as one and a half million dollars, Stoots points out, referring to systems he photographs.

By a fortuitous accident, John Corcoran discovered a completely different approach to making a laser beam visible. This involved a laser pointer beam and it happened when an art director visited his studio with an award made of acrylic plastic. "We were playing with it on the set of the cityscape we were working on and I started shining the laser I was using through the acrylic. Strangely enough, the red beam of the laser light was clearly visible through the clear acrylic material. Until this discovery, I was unhappily resigned to using smoke to make the beam visible in the photograph, but I didn't think the placement of the beam and its subsequent exposures could be made repeatedly and consistently in that fashion. I went to a plastics supplier in town and bought some acrylic rods, and we built a sort of long laser gun to lay across the streets of our model city. The light was not only visible but it could be accurately placed. I could move it anywhere I wanted, to different areas, and even expose for different lengths of time. It was far more controllable than would have been possible had we used smoke."

Caution: A laser beam, especially a strong one, can do considerable damage to your retina. You should follow all safety regulations concerning the viewing of lasers, which may include wearing safety goggles or masks or shielding the laser from direct view. When in doubt, ask someone at the facility or the laser manufacturer.

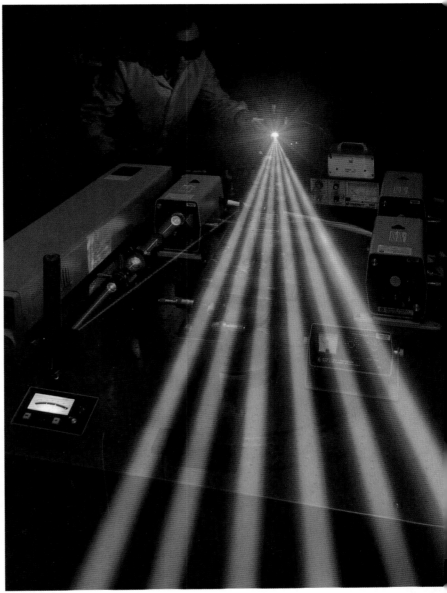

James E. Stoots, Jr., © LLNL.

This photograph for Livermore Lab's Atomic Vapor Laser Isotope Separation Program shows an argon laser with a broadband high-reflector mirror. The mirror was used to pump a tunable liquid dye in front of the laser to produce different colors.

PHOTOGRAPHING NEON

It's one thing to photograph neon displays in New York's Times Square or in Las Vegas but quite another to do it in a studio situation—close up. Lou Jones once sought to simulate a laser beam and he found that a neon tube could do the job best, as long as he prevented light from spilling onto the tube surface, revealing its true character.

Robert Rathe, on the other hand, had to photograph neon tubes that appeared to be ink flowing from bottles. He didn't want the neon to look simply like a colored tube, so he enhanced the effect by double-exposing, using diffusion for his second shot. The image successfully simulated the spread of light from the neon tubes.

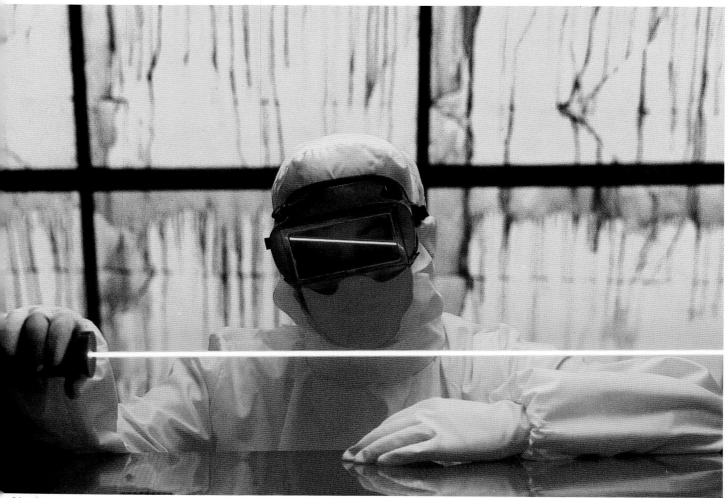

© Lou Jones.

There's more than one way to represent a laser. Choosing to build an entire set for this shot, which substituted a neon tube for the laser beam, the photographer carefully lighted the set to avoid light hitting the tube and producing specular reflections off the neon housing.

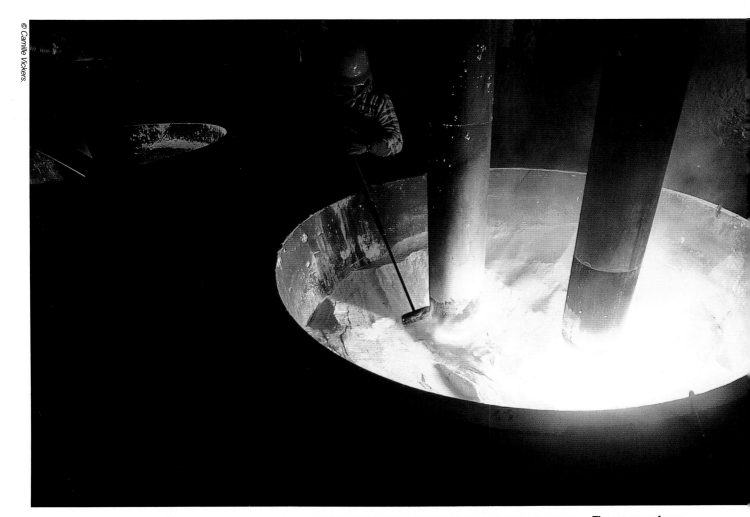

PHOTOGRAPHING WELDING AND HEAT-RADIATING PROCESSES

When the sparks start flying, metal pours or burns red hot, or when a furnace belches fire, you know to be careful. But how do you approach these subjects with your camera?

In some cases, it is the camera, much more so than the photographer, that is in some danger. Facilities such as those involving an electro-mineral open furnace kick up clouds of abrasive powder, and, short of using an underwater housing, which one does not normally carry on location, it may be impossible to keep the camera free of the unwanted materials. The next best thing is to take your licks and thoroughly clean out the camera at the end of the day or have it professionally cleaned when you return to your studio.

Other situations may involve such searing temperatures as to require you to periodically leave the immediate area for several minutes. Whether or not the heat will affect the camera somehow seems secondary to personal comfort under these situations, although it's best to take the camera with you for a cooling period.

Exposures are generally long for these processes, made by the light of the heat-radiating material or the welding torch, whichever applies. If any of the surrounding area is required in the shot, studio or even handheld strobes can provide a kicker light to bring out more detail in these particular areas. If people are in the picture, they should hold still during the long exposures.

The process shown is used to create abrasives that are incorporated in the making of grinding wheels and related products. Clouds of abrasive dust made it necessary for the photographer to go outside in sub-zero temperatures to reload the camera.

PAYING ATTENTION TO DETAIL

A few pieces of advance information are always helpful in producing the best image possible. For example, in creating his photographs, John Corcoran tries to establish all the parameters that will direct him toward a finished product. He'll ask whether a product does anything special, how it relates to the industry; he looks for any visual ties that could work in a photograph. It's even helpful to know what colors the art director doesn't like, he points out.

There are also proprietary obstacles to overcome. Jerry Poppenhouse relates how on one assignment to photograph a Phillips product in use, there were obstacles even for the in-house photographer. He went out to a canoe manufacturer that was using Phillips plastics. That company devised a proprietary method to produce canoes and didn't want this to be photographed. "So when I photographed the canoe from our standpoint, showing that it was our plastics in use, I had to shoot Polaroids in advance to show the canoe manufacturer that the thing they didn't want seen wasn't visible in the photographs. Everything had to be cleared during the shoot. I didn't have to go back and show them the final shots because they saw that I had the camera on a tripod and didn't change the viewpoint."

There are little details to watch out for as well and one is that you should make sure that the logo on the product is correct. Many times a new product undergoes design changes in its logo, or the company may have recently changed its corporate logo, a change that may not be reflected on all the packaging or products waiting to be photographed. The wrong logo and the picture will be rejected.

And then there are the few minor "cosmetic" accessories, such as those Robert Rathe carries with him: crayons of suitable color to fix nicks in furniture and colored markers to cover paint chips in equipment.

John Corcoran has a number of tips for small-product photography. One involves making your own reflectors from the foil film wrappers or bags

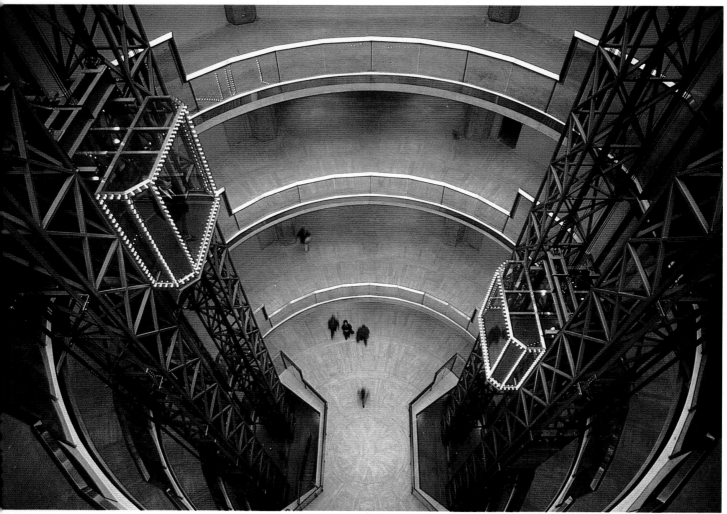

© Camille Vickers.

© Jeff Smith.

The high viewpoint that the photographer chose for this shot, on assignment for Raytheon, required that a special perch be built about 20 to 25 feet up and hung from the overhead girders. He arranged three Beech craft for a dramatic composition.

On assignment for International Paper, the photographer chose to work with the corporate logo as a graphic element. Shooting from an overhead catwalk, he arranged the key elements, and even had the assembly line worker wear a yellow shirt for contrast.

© Jeff Smith.

On assignment for Westinghouse Elevator Company, the photographer captured the existing symmetry of the interior with a high viewpoint. CC30M filtration was used with daylight film to correct for the fluorescent lighting indoors.

The work of some in-house photographers may involve photographing research and development projects. This image of a synthetically-grown potassium dihydrogen phosphate crystal was displayed at a crystallography convention.

found inside sheet film boxes. Simply use spray adhesive to mount them onto cardboard. Another is matte black Con-Tact Brand Cushion-All that, like contact paper, is available in paint and hardware stores and can be affixed to any surface that you need to serve as a black backdrop. With this material, as with black velvet or felt, use a lint brush or lint-removing roller to keep dust off it.

There is, of course, the problem of objects that appear too shiny, with highly reflective hot spots. One corrective measure is to use dulling spray, but many photographers frown on this approach because the effect looks artificial and, worse, may gum up the works as a result of the residue that remains on the product. At best, they may apply it to selective areas, such as on a shiny screw head.

With any small products, you'll need some way of securing them to the background. Modeling clay is one way, but clay leaves a residue that may ruin an otherwise perfectly reusable backdrop. The best alternative is a material that is similar in consistency to clay but leaves nothing behind. Several plastic adhesive products are available in art-sup-

ply stores and specialty photographic supply shops.

With any product, but especially with small products, you will have to consider the background, which should relate to the subject or to the concept behind the shot and support that subject or concept visually. Suitable backgrounds are often found at the site, but you may have no choice but to create your own. In this case, the means at your disposal are virtually endless and range from seamless paper and posterboard to artfully arranged litho materials.

Frequently, gelled lights are the simple yet effective means to creating both subtle and stark backgrounds. Gelling lights may be used as the only means or may be used in combination with various background materials. Plexiglas or other acrylic plastic materials can be used as desktop supports or as transilluminated background shapes of varying definition (sometimes they're more effective when their edges are blurred). Beyond that, you can add any number of elements to support the concept.

REPAIRING SURFACES ON SMALL PRODUCTS

John Corcoran has found that there are a number of ways to make surfaces on the small products he photographs look better than new. ("New" does not necessarily mean perfect.) "I use a variety of things to change the surfaces of some of the products I photograph. Dulling spray works for some objects. When the objects are very small, it's difficult to move them around on the set after they have been sprayed, without damaging the sprayed surfaces. So if they are suspended on wires or supported off of a flat surface, I'll try dulling spray first, because it's easy to wipe off. The spray I use leaves a beautiful matte surface and because it's like wax, it wipes off easily." The dulling sprays Corcoran uses are K-Line Matt and Semi-Matt. Another product, which acts as a neutral-density filter on shiny surfaces, is K-Line 4X Neutral Grey Filter Spray.

"A problem that can occur, however, with this type of spray is that the waxy surface can catch dust and hold it on the product's surfaces and with very small parts, the dust is often visible. To solve this problem I sometimes use McDonald Pro-Tecta-Cote Matte or Lustre lacquer instead. The products can be dusted between exposures.

"Another method of cleaning off a surface is to blast it with glass beads. We do this with a conventional sandblaster, substituting glass for the sand. It works great, except it does permanently alter the surfaces of the object and will remove paint, plating, and just about everything else, so it's done with care.

"A very simple way to clean and soften a surface is to carefully use an eraser—the kind that is made for both pencil and ink. I always start with the softer, pencil side, because the harder side cuts a little deeper and may scratch too much.

"Although it's not terribly practical, I have had a couple of small objects airbrushed prior to photographing them. This has worked fairly well with plated strips of connectors, for example, where the plating is a sort of matte gray but which, through the stamping process, become scratched. A retoucher can match the color of the plating and blow a nice smooth surface over the scratched one. The paint, usually water soluble, is quite perishable and must be handled carefully.

"All of these methods, plus the use of effective lighting, really help to reduce, and in many cases eliminate, retouching on the final image."

© John Corcoran.

A catalog cover for Motorola Semiconductor Division required the photographer to apply the in-camera masking technique to small-signal components 2.5mm long and 1mm high. He used an eraser to remove surface blemishes on the knobby parts of the larger components and to reduce sheen.

IN-CAMERA MASKING

In-camera masking is a method of combining two images on one sheet of film using a special double-exposure technique. Here is the principle, as outlined by John Corcoran, who has adapted this technique to his small-product photography with 4 x 5 cameras:

"A transparency, to be used for the background of the fabricated final image, is mounted on a special adapter made specifically for this process and placed in a view camera. The one I use with a 4 x 5 camera—and will be referring to—is the ICM Adapter made by Professional Photographic Products, Hammonton, New Jersey (see diagrams, opposite page). The device consists of a hinged frame and occupies the position where the film holder is normally located between the camera back and the groundglass. Because the adapter is only about a 1/2-inch thick, a film holder will then slide easily between the adapter and the groundglass.

"The movable frame of the ICM, holding the background transparency, may be rotated from Position A (completely out of the way of the camera's film plane) to Position B (completely covering and in contact with the film plane). An actuating lever on the ICM, outside the camera, moves the frame back and forth.

"The concept of in-camera masking is pretty straightforward. However, to actually accomplish a well-masked image, it takes a little practice and planning. The trick to the technique is the change of lighting, particularly on the background behind the subject being photographed.

"In Position A (Fig. 2), the subject is illuminated to satisfy the photographer's standards. This illumination should create the illusion that the lighting affecting the subject and the lighting used for the background transparency are the same. It has to enhance the subject as well as conform to the direction and mood that the background image has already established. It is of utmost importance that the background behind the subject in Position A is kept as black as possible. When the lighting and background are ready, load a film holder with unexposed film between the groundglass and the back of the masking adapter, and make an exposure with the masking frame in Position A.

"Without moving the subject or replacing the dark slide, change the masking frame to Position B, by rotating the actuating lever. This places the background transparency directly in front of and in contact with the film in the film holder. The lights illuminating the subject should be turned off and the background changed from black to white. The background can either be illuminated from the front (copyboard lighting) or transilluminated (via a lightbox). In either case, no light should strike the subject except from directly behind it.

"From the camera position, the backlighting effect makes the subject a silhouette. Because the ICM frame is now in contact with the film in the camera (Position B), when the second exposure is made, the image on the background transparency will be contact-printed onto the film. If the subject and camera have not moved, the silhouetting effect will work to mask the subject image from the background image, protecting the first exposure from overprinting by the second exposure.

"The combined exposures will produce one image of the subject with the image of the background masked around it. If the process is done carefully, the registration should be perfect.

"Like any process, however, there are a few things to watch for that can create problems. One of the first areas of concern is the black background behind the subject for the Position A exposure (Fig. 2). This background must be kept completely black. This can be achieved with a card painted matte black, with a piece of black velvet, or any matte black background material. No light must be allowed to spill over from the subject lighting. A gobo might be necessary to prevent any spill. If the background is far enough behind the foreground subject, the problem of spill light can be significantly reduced.

"Because the final transparency from the masking process is a combination of a live image (first generation—made of the object in front of the camera) and a second generation copy of the background transparency, a build-up of contrast from the original background to the copy will be evident. This can cause problems in the color saturation of the background, and the additional contrast could make the tonal range of the background unreproducible. Whenever possible, I like to shoot my background transparencies on duping film. Images shot on duping film will almost always look too flat, but in the copy generation the contrast will increase and look very natural in the final image. Another technique I've used to control the contrast of the background is to "flash" the film in the camera, using the white background from Position B." He makes this flash exposure in between the foreground exposure and the background exposure. It works to reduce the contrast of the background, but does not affect the subject contrast. Roughly figure out the flash exposure based on two- to three-percent of the exposure required for the background transparency, using neutral-density filters for the flash exposure. The ND filters make the equivalent two-or-three percent flash exposure last more than one second, which helps you avoid changing shutter speed midstream, until the exposure is completed (to avoid camera shake). Some testing will be helpful.

Beyond that, Corcoran points out that an important concern is the believability of the final image. The illustration should appear as if the subject or product and its background environment exist together. You simply have to keep the subject in mind when the background image is produced. The main lighting should appear to be coming from the same direction for both the subject and background and any major color or brightness from the background should carry through to the subject.

For example, if the background has a substantial amount of red light, the foreground subject should reflect some of that light source. One way Corcoran creates this continuity is to cut small pieces of colored gels and tape them to the light banks that illuminate the edges of the product. Testing will show how much the gels affect the color of the subject. It should be just enough to convince the viewer that the image existed in reality exactly as it is seen on the transparency.

The IN-CAMERA Masking System

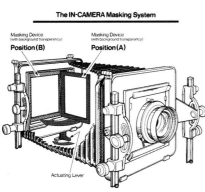

Masking Device
(with background transparency)
Position (B)

Masking Device
(with background transparency)
Position (A)

Actuating Lever

Masking Device and Lighting Positions

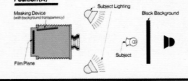

Position (A)

Masking Device
(with background transparency)

Subject Lighting

Black Background

Film Plane

Subject

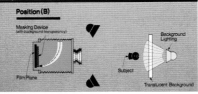

Position (B)

Masking Device
(with background transparency)

Background Lighting

Film Plane

Subject

Translucent Background

The diagram at far left illustrates the position of an ICM masking device as it is rotated toward the film plane. At left, the lighting preparation and setup for creating a background mask are shown.

The transparency made from two lithos, combined with color gels added.

The central black stripe is a matte black area designated for the star field.

The star field was created by spreading glitter on a large piece of black velvet.

The silicon wafer is shown in position against a matte black background.

A card held in front of the lens matted off an area at the lower right.

The final components in place, fitted into the area in the previous image.

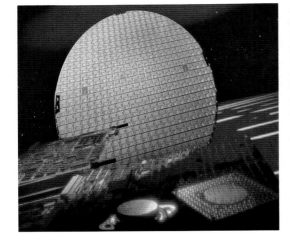

John Corcoran used in-camera masking for this unique view of a silicon wafer. He projected the first two images shown onto a piece of film in an enlarger, and removed the holder with this piece of undeveloped film to the camera set up to photograph the star field. This produced a composite image (not shown), which served as the background transparency (the first mask). The second mask was produced by exposing the wafer onto the first mask, and this image was put in another camera at the circuit-board set, for a double exposure with the circuit boards. The unprocessed film was moved to a third 4 x 5 camera and the last components were added to yield a final double exposure. Each stage shown represents the setup for the composites.

PHOTOGRAPHING MANAGEMENT AND LABOR

If you tell someone that all you'll need is ten minutes, you then can't tell them later you need five or ten minutes more.

ROBERT RATHE

As a portrait photographer, the industrial specialist must project the same confidence and develop the same rapport with his subjects that any photographer specializing in portrait photography must do. Only here the person in front of the camera is often a corporate executive taking time out of a busy schedule or it may be someone just trying to do the job he's been doing for years and wanting to get back to it. Either way, the demands upon the photographer in this situation must match the demands of the subject: Make it good but make it fast.

Well, the plant or office worker may not be as forthright about demands on his time as the chief executive officer (CEO), but he may harbor an unseen resentment that work is not being done. So, it is up to the photographer to make this time as enjoyable and as painless as possible—and as efficient.

Industrial portraits take place in a variety of locations. They may be straight head-and-shoulder or full-length portraits of an executive of a company in his office or boardroom, but they may just as easily be shot in some seemingly exotic atrium in the corporation's own building or outside it—or on location, wherever that executive would like to be photographed. Office and plant personnel may not be pictured in a seemingly exotic setting, but the workplace is often a challenge just the same.

Whether the picture depicts the CEO posed for a formal portrait or shows a worker in the factory, the photographer must overcome similar obstacles and he must gain acceptance and cooperation.

Having selected a buttress that was under construction at the mining site as the shooting location, the photographer still had to convince the executives that it was a safe place to climb on to for this portrait.

DEVELOPING RAPPORT WITH YOUR SUBJECT

There are many ways to instill a sense of working together, which lies at the heart of developing rapport with a portrait subject. You don't want to be viewed as working at cross purposes. And experience will teach you that different approaches work with different people, but that each approach builds upon common ground. There is no universally accepted formula for establishing rapport, and every photographer must find a personal approach that is comfortable.

"You have to be pleasant and cooperative," emphasizes Robert Rathe, "and you have to have a couple of humorous stories at hand." Simply, the key is to get people to relax. "That's a skill that you develop."

Camille Vickers' viewpoint on the subject is generally in agreement, but she adds: "We are often in such a hurry that we don't really have time to break the ice with people. We just have to be extremely businesslike, and come in and say, 'You have to help us out, we've got to do this, this, and this.' I think when they see how serious you are, that they respect that and they help you out. I try to make people understand that this is going to take some time, and I'm really sorry that this is interfering with their day, but it's really important and we want this to look the best that it can look. I'm sincere and serious with people. I don't tell jokes—that's not part of my personality."

Jeff Smith's approach to people is analogous to those mentioned above. "I talk to them, introduce myself, explain what the project is and how I think it's going to work. Basically, I just try to show the person I'm a serious person with a job to do and that I would appreciate his help. I get cooperation from everybody by making sure that everyone has a lot of fun. I treat everybody with respect. It works like a charm."

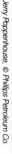
Jerry Poppenhouse, © Phillips Petroleum Co.

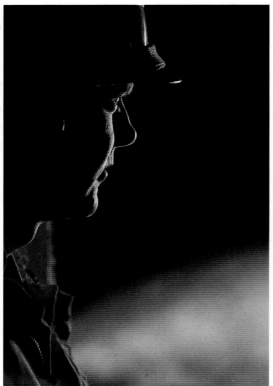

Camille Vickers photographed workers on a rig in silhouette (right), in contrast with Jerry Poppenhouse's portrait (above) made by the light of a rig flaring. In both cases, rapport was an indirect result of the photographer staying back to observe people at work.

© Camille Vickers

MAINTAINING A POSITIVE ATTITUDE

Photographers don't generally see people as obstacles, but there are times when people are not cooperative. Each situation calls for tact and diplomacy. And sometimes cooperation comes along when you least expect it.

"You have to have a positive attitude," advises Jerry Poppenhouse, giving us the in-house photographer's point of view, but one that can be applied in all situations. "With a positive attitude, no matter what the conditions are or who the people are or how hostile or difficult they might be to work with, treat them the way you would want to be treated and deal with them as human beings. Don't deal with them as 'I'm the guy from the home office, so you better do as I say, or you'll be in trouble.' You can't treat them like that and expect their cooperation. We're out there to do them a service, because by our promoting them, they are going to look better. However, it's hard to explain that to them. They may have their doubts about why we're there—they may think we're photographing the installation because we plan to sell it. There may be rumors floating around." In this day and age of corporate takeovers and leveraged buyouts, there are always rumors about things like that in any corporate environment, and the right attitude can go a long way toward easing tensions.

There are related reasons for people being less than cooperative. "There are some people who come in to a shoot with a predisposed negative attitude," observes Robert Rathe. "You have to remember that they may have been through this before, and unfortunately may have had bad experiences with other photographers. Another photographer may have kept them an hour longer than he was supposed to or was rude or looked unkempt or dressed improperly and acted very unprofessional—sometimes you have to overcome that impression."

The problems may center around people not directly associated with the company. As is the case with many in-house photographers, though certainly not all, they occasionally have the opportunity to travel or to photograph celebrities. Two of Poppenhouse's experiences reveal how this philosophy has stood him in good stead in his profession. "I may have to compromise somewhat, because I won't shove a camera in somebody's face and take a photograph if a person doesn't want it."

For example, he related one situation in Africa, where he was assigned to photograph the local flavor around the installations where Phillips Petroleum employees were being transferred to. "There was one village with an outdoor market,

The map at this AT&T long-distance switching station provided the key illumination, which required CC40M filtration for the cool white fluorescents. A 30-sec. exposure meant that the people had to hold their positions and look as natural as possible. Additional lighting came from appropriately filtered light banks.

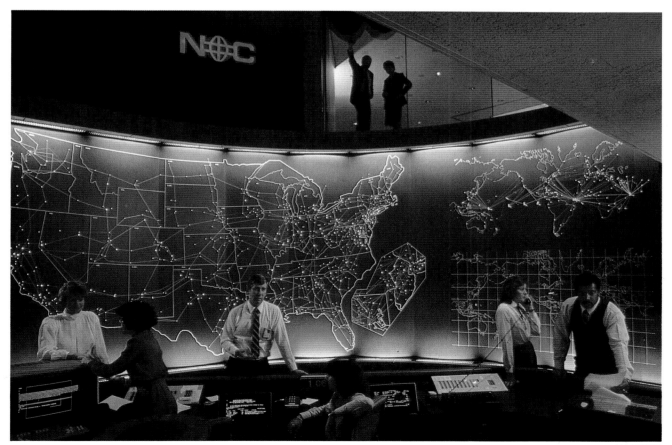

© Jeff Smith.

© Jeff Smith.

In this shot for a Union Carbide capabilities brochure, the photographer focused on both the woman and the distillation column. He added water of different colors to the column, canting it at a 45-degree angle. A bank light provided the key illumination, with a hair light added to separate the woman's hair from the black backdrop.

where a Moslem woman was selling fish. I asked her if I could photograph her and the fish, and she said no. Well, I wasn't about to take the shot in that situation, so I held the camera away from her and began to talk to her with the few words I knew in her language and, being a fisherman myself, showed an interest in the fish. And all of a sudden she grabbed these fish and held them up, showing that she was proud of the fish we were talking about—and so I pointed to my camera and she nodded her head and I took the photograph. It's a photograph that's been used a lot since." It happened because of Poppenhouse's willingness to communicate and the respect that he showed this woman and the business she took pride in.

Poppenhouse related another incident, this one where he was supposed to photograph a well-known actor. He visited the actor's winter retreat to document an environmenal board meeting in which both a Phillips executive and the actor were taking part. Apologetic, the actor refused to be photographed, and Poppenhouse decided to make the best of the situation by walking around the retreat. His walk took him to a group of handicapped people who were sledding down the slope, and he observed that they were organizing for a group photograph. Introducing himself as a photographer, Poppenhouse offered not only to take the picture but to send them the prints, which he'd have processed in the corporate photo lab. "Apparently that actor saw this, and he came over to us and got into the photograph with them. And after this, he told me to feel free to photograph him."

Thankfully, people are not inflexible, and truly uncooperative people are more the exception than the rule. "A bigger problem is a very unattractive worker, somebody who is terribly overweight or unshaven or very poorly dressed," says Jeff Smith. His solution is to try to replace that person with someone else. No one said solutions couldn't be as simple as that, and often, though not always, they are.

Sometimes, it's not the person specifically that can prove to be the obstacle to the shot. As far as the photograph itself is concerned, everything may fall into place, but the graphic impact, however, may suffer from some loose ends. The color scheme may not be the best it could be in the photographer's eyes—and it could simply revolve around the shirt a man is wearing or even a hard hat. To overcome design obstacles, photographers carry a variety of shirts to a shoot and various hard hats of different colors to make the most dynamic visual statement possible.

PEOPLE AT WORK

Photographing people in their everyday work environments may prove immeasurably difficult, especially when those people are crammed into tight quarters or situated in an area that, quite the contrary, is fairly expansive. A number of outdoor situations readily lend themselves to available-light photography, but shooting indoors may require that the photographer use studio lighting, often as an adjunct to the existing indoor lighting.

One assignment required Jeff Smith to photograph a Boeing 747 simulator training session for Pan Am. The problem here was that this was a pretty fancy simulator with computer-generated graphics on the windows and Smith had to mask off any reflections that could be mirrored in the various glass surfaces. He positioned the lights to illuminate the faces, with a blue-gelled backlight, using a long exposure to burn in the cockpit instruments. The lights were placed outside of the picture frame. The reddish light on the crew members came from the instrumentation panels.

On another assignment, Smith had to portray an AT&T long-distance switching station for his client, Mellon Bank. The room featured a wall-sized, illuminated map, which was essentially the light source. That required CC40M (magenta) filtration on the lens for the cool-white fluorescent illumination. The ambient tungsten lights in the room were inadequate, especially since they couldn't be filtered to balance the filters on the lens, so they were turned off and strobes used in their place, with the appropriate filtration. The map required a 30-second exposure, which meant that the people had to look as natural as possible while holding their positions. Light banks were positioned left and right and hidden by overhangs, with additional lighting for the upper level.

© Jeff Smith.

In this Boeing 747 simulator training session photographed for Pan Am, the photographer had to mask off any reflections that could be mirrored in the various glass surfaces. He positioned the lights out of camera range to illuminate the faces, adding a blue-gelled backlight.

You never know what has been weighing on an executive's mind when he walks into the shoot. Some executives may be pleasant regardless of any surrounding circumstances; others may be irritable. "You walk in there and think you're going to meet someone pleasant," Lou Jones comments. "Most of the time, the art director or someone will cue you in to that person's temperament.

"You have to show that you're in control," Jones emphasizes. "If you lose control, you've lost it." But the troublesome executive appears to be more the exception than the norm.

The corporate executive will say, " 'I've got only two minutes to give you.' " Rathe notes. He explains that it's going to require more time than that, saying, " 'I'm sure, since this is your annual report that is going to tens of thousands of stockholders, you don't want to look any less than your best and I certainly don't think you want me back here a week from now spending more time to get the picture right; so let's try and work together on this and we'll get it done as soon as we can.' "

"On the other hand, if you tell someone that all you'll need is ten minutes," Rathe adds, "you can't tell him you'll need five or even ten minutes more. With corporate executives you're given a block of time, and you have to use that time very efficiently. You have to recognize when continuing to shoot is counterproductive. You may get more frames of film exposed, but you're going to get someone who's not cooperative, not smiling, not happy that you're there and wishing you would leave. There's a really fine line between being firm about what you need and being cooperative and accommodating to your client's needs. You do have to recognize that as important as what you are doing is to you, it may not be the other person's highest priority."

You have to constantly keep your senses attuned to the person in front of the camera and you're always trying to be at your best. "I only have a very few minutes to do the portrait," says Jones of photographing executives. "You·have to get the subject relaxed in the first few minutes. Usually I try to find out something about the person in advance or during those first few minutes. In addition, I make whomever I'm photographing feel special or important." Making people in front of the camera "feel special or important" is an approach that works with anyone you're photographing, not just executives, and is instinctively followed by the practiced professional.

Poppenhouse points out that being in-house does have its advantages when photographing corporate people. "When you photograph an executive you know what to talk about. If you're freelance, you should take the time to get some kind of portfolio about that executive so you know

a little bit about him, how long he's been with the company, what his likes and dislikes are, what are his hobbies. If you can't find that out, pick up the *Wall Street Journal* and find out what that company's stock is doing. And you can always talk to him about the stock market or about what the company's latest acquisitions are. Get him interested in something other than you and how he's going to look in the photograph. If you can talk to him in a language he understands, he'll become more relaxed. But if you go in and say, 'Oh yeah, man, just one more, man, that's cool,' " you're not going to get what you want."

There's another advantage to being an in-house photographer. "I had an assistant that didn't load the camera back one time," Poppenhouse recalls. "Of course you can't say that in front of an executive, so make up an excuse why you need to shoot another roll. One thing you can say is that the executive looks more relaxed now than before. If it's somebody you know pretty well, you can tell him the truth. In this case, I knew the executive really well and I said, 'We're going to shoot another roll.' He asked why and I told him, 'Because we didn't have any film in the camera.' He got a big charge out of it. It depends on the individual."

Getting people animated and talking is the key, according to Jeff Smith. The photographer should not do all the talking. He should "shoot around the person's talking. He should encourage hand gesturing. The star is the subject of the portrait, not the photographer. The photographer is there doing a job, and he's got to do whatever it takes to bring the person out."

There are other considerations centering around "hangers-on," those people who look and listen—and play a role that could be either supportive or counterproductive. "I try to get rid of as many hangers-on as possible," Robert Rathe says. "I try not to have too many people around kibitzing with the people that we're photographing, because people will then act differently—the group dynamic is very different from that obtained in one-on-one situations."

These people can, however, be of some help too. It takes experience to determine when they're helpful and when they're not. "The hangers-on may be the person's secretary or coworkers. Sometimes the secretary is the person an executive trusts to straighten his tie, clip a couple of stray hairs, or trim his moustache. If you sense that this is the relationship that exists, then this secretary becomes one of your most valuable tools (and whose aid you immediately enlist). On the other hand, if you sense that you've got the subject looking just right, and then the secretary comes in and says, 'That's not really his best side,' you know this is someone you want to get rid of right away."

Making use of the doorways to frame these two oil-exploration company executives, the photographer also enhanced the composition by arranging the maps on the table in a graphic pattern.

THE EXECUTIVE PORTRAIT

The time that it takes to set up an executive portrait depends on any number of variables. You may first have to scout around to find the right office or other location, if one has not already been suggested or recommended. You may also have to track down various props to provide the proper executive or boardroom atmosphere.

You also have to know how many people are going to be in the shot. Then comes the actual setting of lights and camera. That can take an hour and a half to two hours for one or two executives, but it can easily be double that for an entire board of directors or a conference meeting. But, again, variables come into play that can extend these setup times considerably more than that, whereas the client's request for available light portraits, to retain an unobtrusive air, will cut that time.

When it comes to working with a number of executives, each potential problem is magnified substantially. As Jerry Poppenhouse points out, any time more than one person is in the shot, you get the problems of eyeglasses, varying heights, people with thinning hair, people that tend to blink a lot, people that don't look at the camera. "So each individual is a separate problem. He is only looking at himself in the finished picture and wants to look the best he can."

An executive, and certainly an entire board of directors, will give you only a few minutes of their time to get the shot and get it right. As Smith again notes, "You do get into a situation where, say you're tying up seven or eight people. You may only have them for 15 minutes, when what you'd like is an hour to work with them. So you modify your shooting schedule to the conditions."

DO'S AND DON'TS

There are other things to look for when photographing executives. The photographer "should make sure that the garments look good, that the tie's centered, that the cuffs are showing; if the subject has a nice wristwatch, show it," Smith advises. Camille Vickers reemphasizes that you should pay attention to detail. A tie slipping loose can make a picture unusable; some lint on a dark jacket can contribute to a heavy—and, in the client's eyes, unnecessary—retouching bill.

Photographers have their own guidelines on the portrait itself. Camille Vickers, for example, cites that she doesn't like pictures showing only one ear. "I like to at least see a little bit of the other ear. I think most people look better at a three-quarter angle if it's a more or less straight-on portrait.

"I also don't like the ear that's facing the camera to be overlit. I like the lighting to come from the other direction, so that the ear that you see fully is not bright."

EXECUTIVE GROUP PORTRAITURE

Photographing two or more executives together is quite different from photographing just one person. Positioning, lighting, camera angles, and facial expression are critical variables. "One of the real secrets of successful group portraiture is to have the people positioned in such a way that they're not squarely facing into the camera. You're not doing a mug shot, where you need to see full face. I almost always try to arrange the people so they are turned a little to the right or left and are looking slightly over their shoulder, generally with their hands clasped in front—hands in the pocket are totally acceptable and add to a very relaxed look.

"I shoot as fast as my strobes will allow me and I keep up a running patter—'Look over here, gentlemen, you look great; okay, that's terrific; okay, let's have the third gentleman with the red tie...' And I generally try to learn their first names, which is an awful lot easier than last names, I sometimes write their names in the positions they're in, on a little card that I'll tape to the back of the camera. So I'll say, 'Okay, George, move a little bit to your left; okay, turn your body a little bit more toward the wall.'

"In any portrait, but especially a group portrait, I also like to have objects around that people can lean on. I find that a person just standing in front of a backdrop becomes very self-conscious without something, besides the floor, to anchor his body to. So, having them partially sitting on a desk, or leaning against a bannister, or putting their hand on the back of a tall chair adds very much to their comfort. It makes them more relaxed than if they're standing in a certain place and don't know what to do with their hands.

"I did a shot for one client where the two top executives were standing and talking to each other. There were no props that could be put into the shot and still make it look good. I wanted them to look relaxed, so I just made sure that they were talking with their hands. In my stream of patter I inject some humor, to get them involved and get some feedback. Examples would be: 'Okay, Bob, let me have your right hand in your pocket.' If he puts his left hand in his pocket, which actually happens more times than you think, I'd say, 'Okay, Bob, the other right hand.' That generally gets a laugh. Or I'll say, 'Bob, put your right hand in your pocket...No, Bob, in your pocket, not your boss's pocket.' You'd be surprised at how well that works, even though it sounds corny. If you establish a good mood with these people, they appreciate it.

"One of the things you do run into is that a lot of times, you'll use a stand-in—secretaries, cafeteria personnel, or what have you—and I always try to do that. If there are ten people in a photograph, I'll get ten stand-ins, especially for lighting, so when I do my Polaroids I know that no one will be blocked, that someone won't have a shadow across his face, that the hair lights are

set up properly. Once the executives come in, there are usually only one or two who need individual attention and have to be featured in the foreground, let's say, or seated." To ensure that there are enough stand-ins, Smith talks to the client ahead of time, specifying how many people he needs and when he needs them.

"Basically, you look for a power position to put the top one or two executives in. Once you do that, you arrange for complexion tonality—in other words, you put the darker-complexioned people toward the lights and the paler ones away from the lights; you try to keep the bald men from being directly underneath the hair light, so that you don't get a lot of nasty reflections." But Smith additionally points out that some retouching to remove jowls, or age spots, or hot spots on the forehead "is only natural for virtually any board of directors', chairman of the board's, or president's portrait."

There are, of course, power positions that reflect the relative importance of each executive in group shots: "It depends on the composition. Generally, forward is better, taller is better; in some cases, seated is more powerful. That's a thing you develop with experience.

"Say you're photographing a relatively small chairman and a big president. You want to make sure that the chairman is given prominence in the composition. You can achieve that effect, for example, by sitting him at the edge of a table and seating the president slightly behind him. It varies from picture to picture.

"Know the people. Know whether they're heavy, or thin, or bald, or well-dressed. You can find this out from looking at past annual reports or by talking to the public relations contact you've got. And you can determine the problems you're going to run into before you lay eyes on the person.

"I had a situation where I had a couple of executives seated on a car—their company made one of the products that went into the car. The chairman is a slight, somewhat short but good-looking, distinguished man. But the president is a big, hearty man with a thick thatch of white hair—an executive straight out of central casting. So I had the chairman leaning on the fender of the car, while the president was leaning up against the roof behind. That's the picture they wanted: They wanted the chairman to have precedence and that's what I gave them.

"Basically, I light for the chairman, with the expectation that everybody else will look good. If he looks good, my main job has been done. Even in a group portrait. And if there's somebody in the back who's bald and has a hot spot on his head, I figure that can easily be retouched out. The person I want to be happy in all of these pictures is, of course, the senior executive. He's the one who's got the clout and who says that you come again next year to work for the company or not."

© Jeff Smith.

In this group portrait, the photographer positioned the men so that the key executive is given prominence by virtue of his size, the red tie he's wearing, and by squarely facing the camera.

Bringing professional talent into a shoot is an accepted, though certainly not rampant, practice in industrial photography. When the question of hiring models comes up, Lou Jones responds, "I'm always looking at friends—I tend to use a lot of people I know who react well in front of the camera and yet are not professionals. I want rapport with people, but when things are not working as smoothly as they should, I don't want to worry that it's costing me a fortune. Professional models are paid by the hour and you usually have them for an hour or two. Very often the kinds of photograph we're taking will take hours to do, and we don't know when things are going to come together.

"Very often," Jones continues, "the person we're photographing is the actual person doing the job, so they need to be real. What we'll do is substitute people from other parts of the office—they may be more photogenic, more flexible. Sometimes I photograph the person that's not photogenic and use that picture as a sketch and substitute someone else later."

As Jones states, there may be a need to find substitutes. Photographers regularly use their assistants as models. But where professional models are needed, the reason is simple: "The main reason," notes Jeff Smith, "is that you can't take people who are working and tie them up on a shot that is going to take a long time or you can't get clients or friends to fill in. I find that professional models for this kind of work are not always suitable . . . and often that's the last resort. I've had models come to a site half an hour or an hour late when the direction of the light was crucial."

Where do you find these models? The town or city you're in may have an agency. It's extremely rare that a client will opt for a high-priced model to be flown in especially for the shoot.

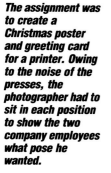

The assignment was to create a Christmas poster and greeting card for a printer. Owing to the noise of the presses, the photographer had to sit in each position to show the two company employees what pose he wanted.

ADDING FINISHING TOUCHES

At times, even the photogenic subject may need a few finishing touches. Facial blemishes, five o'clock shadow on a male executive, wrinkles and age spots, stains on clothing—each may seem like a small detail, but to a portrait, especially of the CEO or chairman of the board, it's the proverbial molehill that becomes the mountain.

Each photographer treats each situation as he sees it best. "When they need a shave, we usually try and get them to go in and shave," Lou Jones comments. "For an annual report that focused on portraits, we used a makeup artist. I've had women assistants apply pancake. We let the people go and wash the powder off right away, which executives do, since they hate the stuff. If it's a really bad situation, like someone who had red wine stains on his clothing, we photographed him from the other side, where there were no stains." And Jones's approach with someone who is not very attractive but who must be in the picture is to use heavy shadow on one side, with the lighting dramatically contoured.

© Jeff Smith.

Proper lighting often helps eliminate or reduce the amount of retouching required afterwards.

© Lou Jones.

The assignment was to produce a series of photographs for a number of promotional brochures aimed at major business sectors. This photograph was directed at the oil industry.

When confronted with the executive who needs a shave, Jerry Poppenhouse has a solution immediately at hand, at least when the portraits are done at corporate headquarters. There's a barber there who does double duty as a makeup artist. Jeff Smith brings along disposable razors and shaving cream, making sure to carry unopened packages of razors to assure the executive that the blades are indeed fresh. He also offers the executive the option of an electric razor, if necessary. "I'll just say, 'Excuse me, sir, I think you need a shave,' and most of them say, 'Okay, I'm glad you mentioned it.' It saves a thousand bucks in retouching costs." Another solution is to try to schedule the portrait session early in the day. However, what works on paper may not work in real-life situations, and portrait shoots are often planned around someone else's schedule, not yours.

That doesn't mean that retouching is never done. Quite the contrary, as Smith points out, "retouching is part of the modern era. I think that most good art directors do retouch these days. It depends on the budget." As a matter of fact, when asked about his use of makeup artists, Smith replies, "I haven't. Sometimes I'll powder a person lightly if he looks a little shiny. I'm not opposed to it or anything, but I haven't found it really necessary so far. It can be done in retouching almost as cheaply, except for the light powdering. I like to keep my subjects comfortable, and I think the makeup artist can intrude on that."

Camille Vickers offers a different viewpoint: "We quite often work with a hair and makeup artist, especially if there are a lot of people or executives to photograph. It helps to have someone who's professional, even if it's just to powder people's noses ahead of time. I do it myself if there's nobody available. Sometimes we'll hire a makeup artist from the area were shooting in, and the client sometimes hires people directly. We've taken our makeup artist on cross-country trips where she was needed every day of the shoot, but we've never flown her out to the West Coast for one day, then flown her right back." Budgetary constraints are on every photographer's mind.

If you're the least bit intimidated about applying powder to an executive's face, follow Robert Rathe's advice. "We're very straightforward, matter-of-fact but low key. We say, 'In order to cut down on any hot spots, we just want to put some powder on your face.' And most people are more than willing to cooperate. Maintaining a professional attitude, making it appear that it's nothing out of the ordinary, makes a big difference."

REWARD HAS ITS OWN VIRTUE

People that you photograph will always appreciate a copy of the picture in which they are featured. Unfortunately, that is just one more demand on you. You're there to do a job, not to engage in public relations for your client. Yet, a part of you would like to be as accommodating as possible. There are several solutions.

One is to make good use of the Polaroid test prints, once the client or art director on the scene decides that these pictures are no longer needed. Under the pressures of the situation, you don't really have time to shoot duplicates and triplicates of test Polaroids. Besides, each test shot is coming out of the client's pocket, and Polaroids cost the client in time and money. But, aside from the one or few test prints that the art director wants to take back to show to *his* client or boss, others are sure to remain behind, unwanted, with no further use. (In case you're wondering, to keep track of these test shots you simply keep the peeled off backings and take a count at the end of the shoot or back in the studio.) Jeff Smith, in addition to giving people Polaroids, encourages his clients to send everybody prints, although not all clients will acquiesce to that request. "One of the things I do is carry a small point-and-shoot camera with me and ask the art director to shoot candids of the people. We'll process the color negs and send those to the people."

Lou Jones takes a Polaroid SX-70 on foreign shoots, giving prints shot with that camera to the people he photographs. In other situations, he'll give people test prints when they ask for them.

Being an in-house photographer with a full-service lab does have its advantages. Notes Jerry Poppenhouse, "We'll give people a good color print. We're sending two crates of framed photographs to two of our offices. They're redecorating and I convinced them to hang up some framed photographs of both the facility and the people working there."

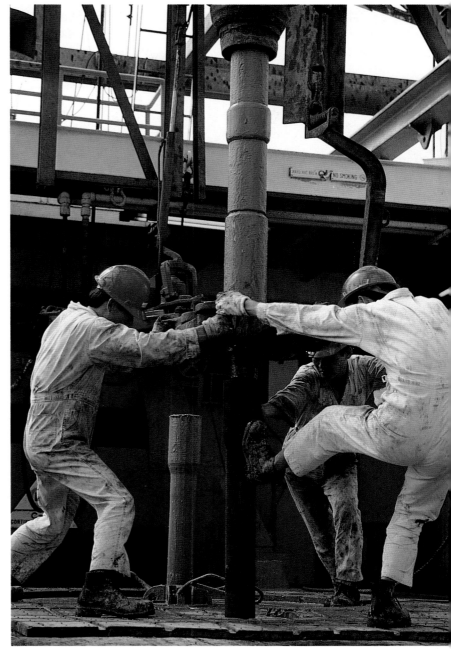

Jerry Poppenhouse, © Phillips Petroleum Co.

In foreign countries, language may not be your only problem. At an oil rig in China, it took patience to wait until these workers became indifferent to having their picture taken for this "working" portrait.

EQUIPMENT AND LIGHTING

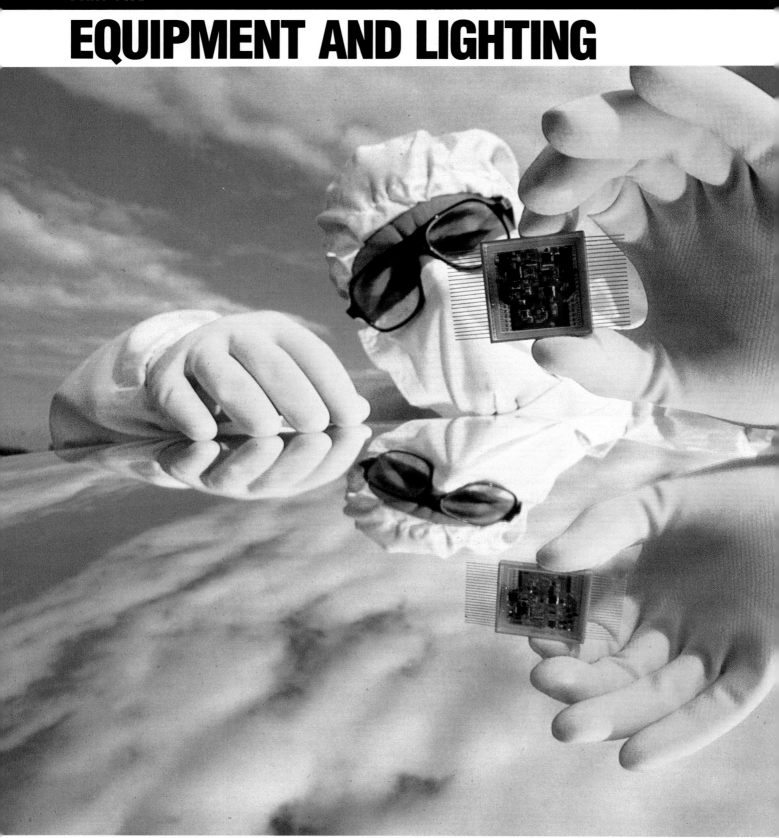

© Lou Jones.

As we all know, it's not the equipment that makes the photographer but the way that photographer handles and controls that equipment to produce the best image possible. Cameras, lenses, lights, exposure meters—they're all tools put in the hands of what a client expects to be a competent photographer—and the client couldn't care less, or shouldn't, what name is etched onto the front of your cameras or how expensive or fancy your light meter is. What that client is looking for is *results.*

To achieve good results you have to begin the shoot on firm footing. You've got to have your equipment ready and organized, in full working order, with sufficient backups to ensure success. You've got to be fully aware of what is involved in transporting your equipment to the shooting site, what problems you may encounter, and how to overcome those problems. You've got to arrange for assistants, lodging, car rentals—or you have to have someone in your studio do that for you. You also have to know when to apply which lens to which situation and know what film works best.

Lighting, often your most crucial element, may be simple or complex, and you have to know how to set up lights so that they serve your purposes and don't interfere with others or prove hazardous. All of these concerns are factors we will take a look at in this next section.

EQUIPMENT FOR THE SHOOT

It's important to know where everything is, and every time we leave the studio, we know exactly what equipment we have.

ROBERT RATHE

Attaching a 2X teleconverter to a 600mm lens enhanced the forced perspective that added impact to this shot made for Raytheon. The photographer lighted the pilot and the nose of the plane, adding an 85B filter to his lens for an even warmer sunset. The strobe lights were appropriately filtered.

There are countless details involving equipment that must be attended to before embarking on an assignment. Preparations begin in the studio, but sometimes details follow details, especially if the shoot is long and involved, encompassing several days and various locations.

To make the proper preparations, you have to pack all the necessary equipment in the most suitable photo luggage. Airline regulations must be considered as well, and that is information you had better get well in advance of packing your gear, especially with the changing face of the airline industry. Remember that aircraft to out-of-the-way areas are often smaller and accommodate less luggage than jetliners. There is another alternative open to you, which is to ship a major part of the equipment by United Parcel Service or other insured carrier for overnight delivery. Admittedly, this is the means of last resort for someone working without an assistant, but photographers have used it successfully.

There are additional restrictions involved and they focus on the transfer of your equipment between countries. The procedures may sometimes be unnecessarily complex, but often they are straightforward, once you've followed prudent steps to ensure a smooth transition.

Choosing the right gear is no easy matter. Essentially, the pro looks for proven reliability, a true system camera that will accept every major accessory, including a Polaroid back, and a solid foundation of customer support. These are points that cannot be compromised by price. The investment in essential equipment need not be overwhelming, but that investment should be in the best equipment you can afford. And always think toward expanding your system. Reinvest profits into your location outfit and into your studio as well.

As with everything else, the photo luggage that the working pro uses must meet the demands of the job by offering the necessary protection and organization of packed items that keeps equipment safe and readily accessible.

Photo luggage comes in a vast array of shapes and sizes. The principal consideration must be: What is your means of transportation? If everything gets thrown into the baggage compartment of a commercial jetliner, then that luggage had better be hard and sturdy, since countless other items will be piled on top of it.

Photographers are largely in agreement that soft bags are no place for metal reflectors for lights, which can easily get bent out of shape. If these reflectors are not removable, I strongly recommend you stick to the hard case for their portage.

There are impact-resistant, watertight molded space-age plastic cases and metal-reinforced plywood-bonded-to-plastic cases that are available either off the shelf or custom ordered for photo gear. Equipment that goes in here includes powerpacks, metal reflectors, and related accessories. The high-tensile strength molded plastic cases are also useful for cameras.

"I carry two Fiberbilt cases that I call 'coffins,' which are about 38 x 10 x 14 inches, and are made of highly durable plastic," says Jeff Smith. "They're great for tripods, light stands, boom stands, stand extensions, velvet . . . the big stuff. I hate the tubes: they're extremely awkward to pack, they're not modular. I've got a whole modular system that I put on a cart, and that includes some heavy-duty molded plastic cases."

Robert Rathe has incorporated different designs of luggage cases in his location outfits, the result being a very workable combination that takes advantage of the latest luggage technology. "I use Lightware cases for my powerpacks. I save a lot of weight without sacrificing protection. I've never had a problem with damage to the packs. They're also nice because they don't tear up the inside of your car. I use a large plywood and metal case for strobe heads and other fragile equipment; fiber cases for stands, because of the weight, and several other assorted cases for cables, gels, filters, etc."

Cameras are another matter. Few photographers will entrust their cameras to the baggage compartment, opting instead to take them on a plane as carry-on luggage. Unfortunately, as airlines become increasingly security conscious, putting these bags through security checks could involve considerable time, which means you'd better get to the airport early. Yet, no matter how early you get there for your flight, chances are you'll be getting in line in front of someone who has just enough time to board his flight.

Aside from the remote possibility of stowed baggage getting lost or misplaced, the reason for carrying cameras on board revolves even more strongly on the fact that it just makes photographers more comfortable to fly that way. It's much harder to replace cameras, lenses, and exposure meters that one has put one's faith and trust in. Besides, these items are much more delicate than anything that normally goes through as checked baggage.

Obviously, shoulder bags are the most popular camera bags, but there are some very good hand-carry cases. The hard cases are often small enough so as not to be too heavy, and they do have the added advantage that, should the absolute need arise to transfer this case to stowed baggage, its well-padded interior combined with the strong, rigid exterior shell should protect the equipment inside.

"I use Rimowa (hard-shell) cases—the smaller ones that fit under an airplane seat, and I carry a Tenba (soft) shoulder bag for meters, filters, and odds and ends," says Jeff Smith. He points to the fact that both types of cases, hard-shell and soft, have their place as photo luggage for fragile camera gear and, when of the proper size, can meet carry-on luggage specifications.

The interiors of soft-sided and hard-sided equipment bags and cases may be customized with padded walls and partitions or cut from foam. If you opt for foam inserts, use only precut foam, as this stuff gets messy to customize. Some photographers find hard cases useful to stand on when small stepladders or stools may not be available or practical.

Without going into greater detail, I strongly recommend that you stick to major brands of bags and cases and not look for bargains. You're entrusting not only your photo gear but also your reputation to the safe arrival of this equipment in fully usable condition to do the job. Photo luggage is probably the cheapest link in your photo equipment chain, and cheap luggage becomes your weakest link.

Theft of equipment is also a concern. The cases you use can play a vital role here. "My assistants and I are very security-conscious," emphasizes Jeff Smith. "We don't leave our cases open with the gear lying around. We keep an eye on things. I don't leave a camera on a tripod when I go out for lunch. I put everything in its case. The cameras come with me, but the lighting equipment stays there at the site, cases closed, if not locked."

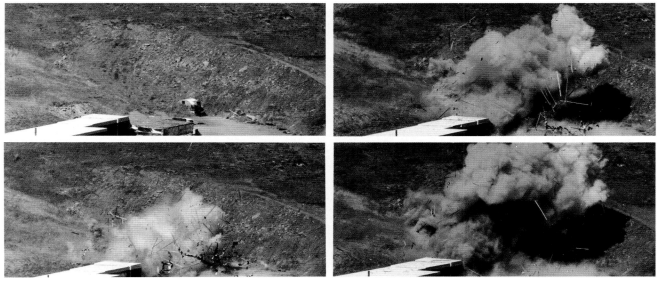

EQUIPMENT TO GO

Studio preparation varies depending on the scope of the shoot and the geographical location relative to the photographer's studio. In-house industrial photographers may be called to an executive's office at a moment's notice, and they may have a special kit ready for such eventualities. More often than not, they will be given sufficient notice, but even then, they have a location kit all ready to go. It may require some last-minute adjustments to the checklist of what goes and what stays, but it's ready.

"It depends on the assignment," notes Phillips Petroleum's Jerry Poppenhouse. "Some assignments can take as long as one or two days to set up the studio for, others can be set up in a matter of minutes. When going on location, it will take longer, and you make some compromises in the equipment you take. You can't take all the lighting you'd like, so you have to refrain from photographing the Taj Mahal with studio lights. You have to know your limitations and don't try to do anything beyond them, and then you're okay."

In-house photographers don't always travel light. Lawrence Livermore National Lab photographer Jim Stoots had to document debris scattering after a *non-nuclear* explosion for the Nuclear Weapons Engineering Division. He had to set up several cameras, both special-purpose high-speed cameras and two similarly equipped Nikons. The shot was to go off at 9 A.M., with Stoots located a mile away from the test site. A number of failed count-downs and one hour later, with the temperature soaring to 112° F, word went out for "someone go out there and hit the thing with a hammer!" Five seconds later, the device exploded, but during that first five seconds, three of the four cameras were operational—photographing nothing. It was the fourth camera, a Nikon equipped with motor drive and mirror lens, that saved the day, capturing the event on the last 25 frames.

Generally speaking, though, freelance photographers will often go on location with more equipment than would an in-house photographer. Many location photographers feel that it's the one item you just happen to leave behind that day that will stand in the way of doing a better job. Not only do they prefer to carry as much as they can, but they back up a good many essentials in case something is damaged or lost.

To ensure that both studio and location time is kept at an efficient level, Robert Rathe has recommendations of his own that he follows regularly: "We check out and clean equipment when we come back from a shoot and keep a really careful watch when we're traveling, looking for indicators that something might be approaching a malfunction point—funny noises from a strobe head, for example.

"On location, it's important that you know absolutely where everything is," Rathe adds. "Usually, when you travel, there's not a lot of flexibility in your schedule. So it's really crucial that you don't spend 10 minutes looking for this and 10 minutes looking for that. So at the end of a trip, my assistant will go through all the equipment and make sure that everything is back exactly where it goes, because sometimes in the haste of packing up with 20 minutes to get to the airport, things get thrown in—even by a client trying to be helpful—and get misplaced. Every time we leave the studio, we know exactly what we have."

It goes without saying that the more years you're in the business, the more equipment you gather, which means that there's more for you to take along. Some industrial photographers take only as much as they alone can handle comfortably, but more often than not, an industrial photographer,

Research and development documentation of debris scattering after a non-nuclear explosion was the purpose of this series of photographs taken for Livermore Lab's Nuclear Weapons Engineering Division. With the temperature soaring to 112°F, the photographer remained a safe distance away, with four cameras set up for the event.

often with at least one assistant, will be burdened with several hundred pounds of gear, taking into consideration heavy duty lighting stands, tripods —and shipping and carrying cases, which may add considerably to the load.

"I travel with a very heavy kit," Jeff Smith notes, "about 1,200 pounds of gear, 600 feet of electrical extension cord, hair dryers to keep my Polaroids warm . . . I travel heavy. There are jobs where you need three times that much to do the job. I've got to know before I leave, and organize that equipment, get it transported, hire extra assistants if necessary.

"It depends on the shot as to the amount of work that has to be done," Smith continues. "Luckily, I've got a very good organization behind me, and they're doing most of that work while I'm on the road."

Your equipment requirements on any location assignment will vary, depending on your shooting style, the subject, and the client's needs, not necessarily in that order. It will also vary depending on whether you travel alone or with an assistant. And a large part of the location kit consists of your lights and all the paraphernalia that goes with it.

To give you a better idea of the equipment carried on location, Union Carbide's Ken Graff has a location outfit that he can readily carry onto a plane and which fits comfortably into the overhead bin. This kit includes 2,000 W/S of strobe power (Dynalites), each pack at 1,000 W/S; one bitube head which outputs 2,000 W/S, with each other head supplying up to 1,000 W/S. Graff uses a Lightware case that also carries stands, tripods, cords, umbrellas, and light banks, as well as gobos and flags

that can conveniently be packed away. In addition, he carries a separate case for camera equipment.

Specializing in location assignments, free-lancers Camille Vickers and Greg Beechler "travel with the same equipment most of the time. Sometimes we may need seamless paper and some way of hanging it, things like that. It can take a few hours getting everything together, properly packed and organized. For example, on our most recent trip, we took three big cases of lights, one tube with stands and tripods, three cases of cameras, one case of film, a cart, and a soft duffel with umbrellas, gels, pieces of velvet, white sheets, and all kinds of extras. We don't check the cameras and the film." The weight of their location kit is around 750 to 850 pounds.

The Tables on industrial photographer location kits (page 72) outline starting points for outfits you can build up from or to, depending on what you use as your starting points. You can use this as a checklist, modifying it to suit your needs and checking against it each time you go out on assignment and return to your studio. You might even want to break the list down into parts, to define what goes in which cases. After a while, of course, this all becomes routine, but these steps may be helpful to your new assistants. You might also consider shooting a Polaroid of the contents of each case, to be used as a reference and as a further check.

These Tables are presented here to help you prepare for your shoot. If you need a rationale for any piece of equipment, those reasons can be found in these chapters. Some things, however, should be self-explanatory.

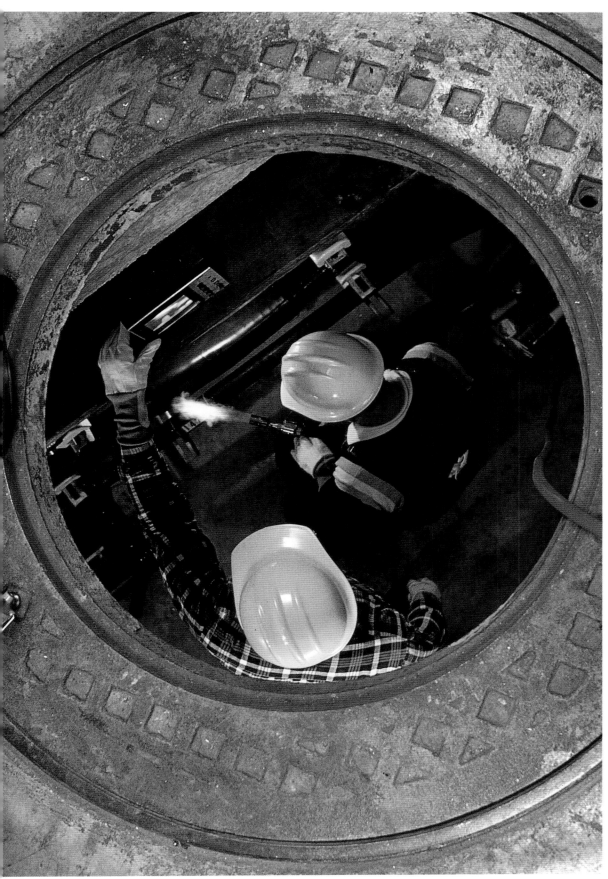

This image depicts an on-the-job video training manhole for a PEPCO annual report. The 250W bulbs used for lighting inside (together with strobe from above) were brought along from the studio for situations such as this one.

© Robert Rathe.

© Jeff Smith.

The mixed available lighting, a car driving away on cue in the background, and lighting for the people in the foreground, the airplane, and the pilot inside the cockpit were all factors to consider in this assignment for Raytheon. Success relied on having all necessary equipment on hand.

"MUST-HAVES" ON LOCATION

On location, there are of course the basic pieces of equipment—the cameras, meters, lighting, tripods, Polaroid backs—that photographers will never leave their studio without. But there are additional items without which things would not run smoothly, or perhaps not at all.

"The first thing that comes to mind is the job envelope," cites Camille Vickers, "with all the directions, instructions, contacts, phone numbers—all that sort of thing. If you go out without that, forget it." Robert Rathe uses his computer to produce that list: "I'll try to get names of local suppliers from photographers in that city. Then I print out a couple of copies of all this information and carry one and give the other to my assistant."

In addition, there are other items that help photographers on location. Vickers also carries a compass. "If we arrive somewhere at night and we have to shoot the sunrise, we know which direction to aim the camera at and where to position ourselves." At a remote location, that's much easier than trying to find a stranger who will give you funny looks when you ask that question of him or, in a foreign country, attempting to communicate at all. And of course a flashlight helps on many occasions where ambient light is inadequate, to let you check camera controls or reconnoiter a dark area to make sure nothing was left behind.

Communication is often the lifeblood of the location photographer. If people are beyond normal hearing range, it could require people to shout to each other or to use a "runner" to carry messages back and forth between the photographer and his client, assistants, and models—not an efficient system. Jeff Smith finds walkie-talkies to be a tremendous help in setting up big industrial shoots. They're also useful to facilitate communications when several vehicles are caravanning in unfamiliar locations.

Walkie-talkies are not the only communications devices photographers find helpful. In this day and age of increasing electronic sophistication, cellular mobile phones will be finding their way into more and more location kits. Camille Vickers and Greg Beechler observed that a cellular telephone makes it so much easier to communicate with clients and locations while on the road or from a specific location. And it also means that they don't have to concern themselves about whether or not there would be a telephone where they were going or that it would be an encumbrance for them to use the client's phone on location.

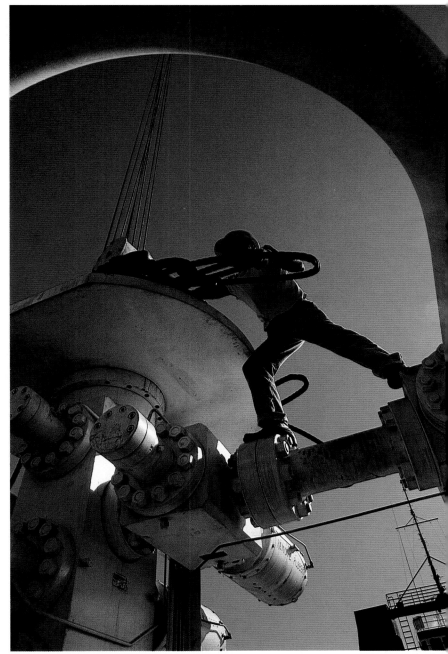

Jerry Poppenhouse, © Phillips Petroleum Co.

Photographing from a relatively high elevation on an oil rig requires you to know what you need and to have it on hand when you make the ascent.

Starter Kit 1 (35mm)
35mm camera bodies (2)
Lenses (24mm, 50mm, 100mm, 300mm)
Polaroid back (35mm format)
Flash powerpack
Flash heads (2 or 3)
Spare flash tubes and modeling lamps
Flash head reflectors, barndoors, snoots, honeycomb grids; lighting filters
Flash meter
PC cords; extension cords
Tripod (full light)
Lighting stands (standard, background)
Umbrellas (silvered, white, shoot-through)
Accessories: filters; filter holder (for gels); lens shades; plus-diopter lenses; step-up/step-down rings; spare lens/body caps; cable releases
Lens care kit; jeweler's screwdrivers
Heavy-duty electrical extension cords
Batteries
Gaffer tape
Camera bag/lighting case
Carry cart/hand truck

Starter Kit II (35mm + 2¼)
35mm camera bodies (2)
Lenses (24mm, 50mm, 100mm, 300mm, macro/micro, PC)
Polaroid back (35mm format)
35mm accessories: filters; filter holder (for gels); lens shades; step-up/step-down rings; spare lens/body caps
Medium-format camera body w/finder
120 film magazines (2 minimum)
Medium-format lenses (wideangle, normal)
Polaroid back (medium format)
Medium-format accessories: filters; filter holder (for gels); extension tubes; lens shades; step-up/step-down rings; spare lens/body caps
Flash powerpacks (2)
Flash heads (4)
Spare flash tubes and modeling lamps
Flash head reflectors, barndoors, snoots, honeycomb grids; lighting filters
Flash meter
Color temperature meter
Photo slave
Radio remote
Infrared remote
Tripod (full height)
Lighting stands (standard, background)
Umbrellas (silvered, white, shoot-through)
Light banks (various sizes)
Strip light bank (optional)
Bounce panels
PC cords; extension cords
Lens care kit; jeweler's screwdrivers
Heavy-duty electrical extension cords
Batteries
Gaffer tape
Camera bag
Lighting cases
Carry cart/hand truck

Advanced Kit I (35mm + 2¼ + 4 x 5)
35mm camera bodies (2 to 3)
Lenses (20mm, 24mm, 50mm, 85mm, 100mm, 200mm, 300mm, PC, macro/micro—include fast optics)
Polaroid back (35mm format)
35mm accessories: filters, filter holder (for gels); lens shades; plus-diopter lenses; step-up/step-down rings; spare lens/body caps
Medium-format camera bodies (2) w/finder
120 film magazines (3 or 4)
Lenses (wideangle, normal, telephoto)
Polaroid back (medium format)
Medium-format accessories: filters; filter holder (for gels); extension tubes; lens shades; step-up/step-down rings; spare lens/body caps
4 x 5 view camera w/wideangle lens; Polaroid back; sheet film holders; rollfilm magazine
Flash powerpacks (2 or 3)
Flash heads (4 to 6)
Bitube head
Spare flash tubes and modeling lamps
Flash head reflectors, barndooors, snoots, honeycomb grids; lighting filters
Flash meter
Color temperature meter
Tripods (full height, ceiling height)
Photo slave
Radio remote
Infrared remote
PC cords; extension cords
Umbrellas (silvered, white, shoot-through; various sizes, shapes)
Light banks (various sizes)
Strip light banks (various sizes)
Diffusion panels; bounce panels; scrims; flags, gobos
Lighting stands (standard, background, boom)
Clamps
Lens care kit; jeweler's screwdrivers
All-purpose tool kit
Gaffer tape
Batteries
Heavy-duty electrical extension cords
Sandbags
Seamless background hardware
White (background) sheets
Optional: Walkie-talkies (1 per person); Cellular telephone
Optional: Stepladder
Optional: Seamless (background) paper
Camera bags
Lighting cases
Carry cart/hand truck

Advanced Kit II (35mm + 2¼ + 4 x 5)
35mm camera bodies (3)
Lenses (fisheye, 20mm, 24mm, 28mm, 35mm, 50mm, 85mm, 100mm, 200mm, 300mm, PC, macro/micro—include fast optics)
Polaroid back (35mm format)
35mm accessories: filters; filter holder (for gels); lens shades; extension tubes: step-up/step-down rings; spare lens/body caps
Medium-format camera bodies (2) w/finder
120 film magazines (3 or 4)
Medium-format lenses (wideangle, normal, telephoto, PC lens—if available)
Polaroid back (medium format)
Medium-format accessories: filters; filter holder (for gels); lens shades; plus-diopter lenses; step-up/step-down rings; spare lens/body caps
4 x 5 view camera, w/wideangle/normal/tele lenses; Polaroid back; sheet film holders; rollfilm magazine
Flash powerpacks (2 or 3)
Flash heads (6 to 9)
Pencil light
Bitube head
Quad head
Spare flash tubes and modeling lamps
Flash head reflectors, barndoors, snoots, honeycomb grids; lighting filters
Flash meter
Color temperature meter
Cable releases
Photo slave
Radio remote
Infrared remote
PC cords; extension cords
Umbrellas (silvered, white, shoot-through: various sizes, shapes)
Light banks (various sizes)
Strip light banks (various sizes)
Diffusion panels; bounce panels; scrims; flags; gobos
Lighting stands (standard, background, boom)
Tripods (full height, ceiling height)
Clamps
Lens care kit
Jeweler's screwdrivers
All-purpose tool kit
Gaffer tape
Batteries
Electrical extension cords
Camera bags
Lighting cases
Sandbags
Seamless background hardware
White (background) sheets
Optional: Walkie-talkies (1 per person); Cellular telephone
Optional: Stepladders (varying heights)
Optional: Seamless (background) paper
Carry cart/hand truck

IMPORT RESTRICTIONS ON EQUIPMENT

When traveling outside the United States, you have to consider foreign restrictions on bringing in professional photographic gear. The "carnet"—a semi-official document produced by the United States Council for International Business, with the cooperation of most industrialized nations—allows untaxed transfers of professional equipment into and among its member countries. This document is not as yet accepted in newly industrialized countries. Oddly enough, it is recognized in Canada but often not accepted, at least from U.S. citizens. A government that does not accept the carnet sets its own restrictions and may impose a hefty tax on equipment—to the point that it may pay to rent the necessary photo gear when you reach a major city within your destination. Should you opt to bypass the tax after having crossed a border with all your equipment in hand, it may be necessary to leave your gear with the customs agent, supposedly in good hands. New trade agreements may revise Canadian policies, but you'd be wise to get all this information up front.

When visiting countries that do not accept the carnet and to avoid the possibility of having your equipment impounded by Customs, make sure your client's representatives in that country have utilized all their connections and filed the proper papers. They should inform the government bureaus involved of your intentions, outlining what's being brought in and for how long. One in-house photographer recalled traveling to a country in South America on assignment, where he was subjected to an item-by-item documentation by the agents there to establish resale potential. It's an obstacle, but not one you can't overcome with prudent handling.

The carnet is not a blanket release to freely come and go as you please. Customs in each country must review and approve the documents, and the agent does have the right to inspect your equipment. The carnet itself includes a detailed list of the equipment you're carrying, with dollar values and serial numbers. It pays to categorize the list, grouping cameras together, then lights, and so on, and if you do extensive traveling with much of the same gear from trip to trip, it is simpler to use the same list and record what specifically applies on a separate form.

The application for a carnet is good for one year from date of issue. It's not totally free, as you do have to post a bond in the amount of 40 percent of the value of your equipment, which guarantees that you won't sell your equipment while in a member country. There is also a nominal fee, based on the value of the equipment as well, that must be paid to the U.S. Council. For more information and applications, write to the U.S. Council for International Business, 1212 Sixth Avenue, New York, NY 10036.

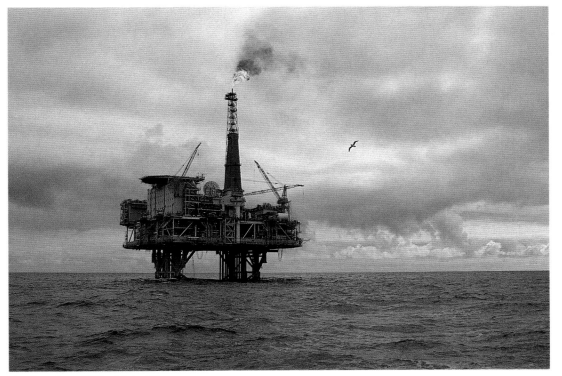

Jerry Poppenhouse, © Philips Petroleum Co.

Shooting a site does not always offer the photographer a comfortable land-based vantage point. This oil rig was shot from a supply boat in a stormy North Sea, off the coast of Scotland.

No photographer working today restricts himself to the same equipment he started with. Often the gear is expanded to meet current and prospective needs, and, perhaps not as often, equipment is replaced with newer equipment that can handle an even wider variety of tasks with greater ease and facility. One thing is for certain: Photo equipment weighs more and more heavily on photographers' minds and shoulders today.

"I started out with a basic kit," Jeff Smith tells us, "lenses from 20 to 200mm, in most of the increments, a couple of camera bodies, a tripod or two, a Graflex strobe for on-camera flash. Now, I've got everything from 15 to 600mm f/4, and all the steps in between, and two Polaroid backs, all kinds of Nikons, and a full Pentax 6 x 7 system with 45 to 600mm lenses, and all kinds of tripods, and a lot of lights and light stands—I wouldn't go back to the other way of shooting. I think that one of the things that differentiates me from other people is the amount of equipment I carry to a job in order to handle virtually any situation. But I think you can start out with a pretty minimal kit if you're really creative and you know your technical stuff."

"I started off with a Nikon and Mamiya RB67," comments Camille Vickers, "because at that time a lot of things were expected to be shot on 2¼ format. 35mm was not used nearly as much as it is to-

day. And then gradually, over the years, people stopped asking for the 2¼ and asked me to shoot 35mm. So I built up my 35mm system with more Nikons and Nikon lenses. I used to travel around with one big Balcar strobe and a large Gitzo tripod. Now I carry four or five different powerpacks with lots of heads and pencil lights and portable strobes and hot lights and stands. I started with a few basic lenses: a wide angle, normal, and telephoto. Every year, I seem to add a little bit more."

When Jerry Poppenhouse began his career as an in-house photographer over 20 years ago, he introduced the 35mm camera to the staff photographers, who were former photojournalists using 4 x 5 Graflexes. As the department progressed, so did the scope of the equipment, encompassing both 35mm and 2¼ systems, as well as larger formats. "Anything we purchase we have to justify. If you can't justify it, you don't get it. Simple as that." His workhorse cameras are Nikons and Hasselblads.

But what if you're just starting out and on a tight budget? How much equipment would suffice to make you competitive? "You don't need much," advises Lou Jones. "You can be very creative without a lot of equipment. And there are a lot of very good photographers that shoot almost everything with available light."

VIEWPOINT *Jeff Smith, Jerry Poppenhouse, Camille Vickers, Ken Graff*

AUTOFOCUS: YES OR NO?

The pros were mixed in their feelings about autofocus cameras. Here are selected responses to the question, "If you don't already, would you ever work with an autofocus camera?"

Jeff Smith: "I'm sure that the next cameras I buy are going to be the autofocusing Nikon F4s. There's no reason not to use the modern technology. I guess the thing I've got most against autofocus cameras is that I think they're going to lead to more center-weighted compositions, and I don't do a lot of centerweighted compositions. But I'll figure out a way around that. I think that it's a product of today's technology and that it's going to be extremely helpful for most photographers."

Jerry Poppenhouse: "We're asked to cover functions, what I call 'run-and-gun' photography, and for that automatic focusing works well. For that you can't spend a whole lot of time creating compositions. We have the Nikon N2020. We've also ordered two F4s.

I've taken ground-to-air shots, where an autofocus camera certainly is a help in shooting a plane that's flying a hundred-something miles an hour, zooming over your head. You can continuously stay in focus. Now that I'm wearing glasses, autofocusing is a real help."

Camille Vickers: "I'm sure there would be some application where it would be extremely useful, but I've gotten along all these years without it. A lot of times we'll have a group of people and we'll want them moving toward us while we're moving backwards and that's hard—keeping people in focus and shooting. So if it works, I might use it."

Ken Graff: "As far as autofocus is concerned, after using it for awhile (working with the Nikon N8008) and then going back to manual focus, especially with a long lens and racking the focus back and forth with that lens, you can't beat the speed that autofocus provides."

PRO CHOICES IN CAMERAS AND FORMATS

I conducted a small survey among the photographers contributing to this book, using only one representative per studio where more than one was involved. This survey did not reveal anything too surprising. Freelancers shot mostly 35mm, with 6 x 6 and 4 x 5 coming in a tight second. The in-house photographers favored the 6 x 6 format over the leading contender, 35mm; 4 x 5 trailed, followed slightly by 6 x 7 and even further behind by 8 x 10. Among freelancers, both 6 x 7 and 8 x 10 were in the minority.

You have to keep in mind that what industrial photographers need in a location camera is a machine that will stand up to the rigors of the site. Dust and moisture are common problems at a number of these locations and the camera must be well sealed against these elements. Pros want a camera that will not be obsolete a month after they take it out of the box. They also like the camera to work with the lenses and accessories they've acquired over time. They care less about fancy exposure metering systems and more about reliability and durability and consistency.

Some products, much more so than others, come with a user-support interface that virtually guarantees that, should something go wrong, the company will back the product to the photographer's satisfaction. In some cases, a loaner camera or lens might be made available. For that matter, there are even loaner programs for professional photographers who have registered with major manufacturers or distributors. These are factors that enter into the equipment equation.

Another factor pros weigh in choosing a working 35mm SLR is the range of accessories and the availability of rentals. Some cameras are better for that than are others. You need the assurance that you can rent a PC lens, or any lens or accessory, when you need it. The 35mm SLR favored by the majority of photographers in this book is the Nikon, but there are also Canon and Minolta users. One in-house photographer even listed a Leica rangefinder among the equipment he uses.

Beyond 35mm there are the 6 x 6 cm and 6 x 7 cm formats. (I don't know of industrial photographers using the smaller 6 x 4.5 design, which is popular with wedding photographers.) Generally referred to as medium format or simply "2¼," these cameras may not be as universally used in this field as they once were. This is due largely to the popularity of Kodachrome film for the 35mm camera, but as pointed out, that may change with the introduction of Kodachrome in the 120 film size. (With accessory backs, some of these cameras can shoot in a variety of formats.)

Among 2¼ cameras, the Hasselblad was rated most popular. What was said about 35mm systems applies equally to this format. No pro wants to feel insecure about his investment, and knowing that the integrity of the system will be kept virtually intact as newer models are introduced is an assurance that the pro takes with him on assignment each day. If he loses his favorite lens to an accident, he knows another one will be available to replace it. It may cost more now, and it might not be identical, but it will fit his camera and operate as well as the first one did.

The Hasselblad, as you well know, produces a square image with the standard 6 x 6 cm (also commonly referred to as 2¼ x 2¼-in.) format. The advantage to a square picture is that the image can be cropped to a vertical or horizontal to meet a client's needs. Unlike the 35mm image, there is plenty left after cropping to be usable, without excess graininess.

On the other hand, you can opt for an even larger negative or transparency with the 6 x 7 cm (2¼ x 2¾-in.) format, such as the Mamiya RB67 and the Pentax 6 x 7. The RB67 is larger and heavier than the Hasselblad, but it, too, is a solid workhorse of a camera. The Pentax, on the other hand, looks like a 35mm SLR, only larger, and unlike the RB67, features a focal plane shutter. (That is also true of the Hasselblad FC design.)

The next step up is the large format, or view, camera. Here Sinar is mentioned most, with Linhof second, and a couple of others trailing in the survey. The 4 x 5 format appears to take precedence over 8 x 10 (5 x 7 has gotten lost in the shuffle, it seems) principally because it's considerably cheaper to operate. Buying a modular view camera will let you convert from one format to another, but I haven't heard mention that a client was unhappy with a 4 x 5 and wanted an 8 x 10 image. Don't forget, these photographs are not being posted as billboards, so that a film size larger than 4 x 5 is not really necessary.

To sum up, don't pick a camera for the image you think it creates when seen but for the image it creates unseen. Choose it because it fits your shooting style and the diversity of subjects you expect to shoot. *Choose it because it will deliver the kind of results with the same consistency that your client expects of you.*

© Mark Gubin

© John Corcoran

The choice of camera format reflects a client's request or your own preference—or both. Mark Gubin used an 8 x 10 view camera for the generator (opposite page), whereas John Corcoran preferred the 4 x 5 format (left) for these small components. A 6 x 6 cm format was ideal for Jerry Poppenhouse in an Alaskan oil rig (below left), while I photographed this scene of a train yard for stock on 35mm.

© Jack Neubart

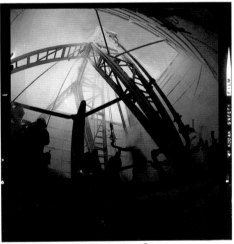

Jerry Poppenhouse, © Phillips Petroleum Co.

The one thing you don't want to do is leave your-self short on assignment, unable to capture the best viewpoint for your client because you didn't own the right lens. Focal lengths from ultrawide to long telephoto come into play at one time or another. It's only those special lenses, such as the ultrafast, ultralow-dispersion glass or fluorite-element optics, that find their way least—or last—into photographers' camera bags. Mirror lenses, or if you want to be more technical, catadioptric ("cat") lenses, unlike the others mentioned, are rarely used. They are often lighter than comparable lenses but generally slower than what's available in refractive optics, and there's no practical way to stop down a mirror lens to a smaller working aperture. However, the image quality of a good cat lens is rivaled only by a lens that incorporates special glass. And the mirror lens is more compact and much less expensive, a consideration for any photographer on a budget.

Macro/Micro lenses (depending on what the manufacturer of your camera system calls them) are used, but not widely, which is true also of perspective control/shift (PC) lenses. But keep in mind that such lenses prove invaluable in the right situations.

The macro/micro lens is not a difficult lens to work with, under most circumstances, so long as you don't have an unwieldy bellows attached to it. A PC lens is a different animal. Many, if not most, PC lenses must be used stopped down. It's preferable that a tripod support the camera, to ensure that you don't unwittingly throw lines out of alignment. And to further ensure that the lines go perfectly straight, or at least as straight as you can get them (perfect perspective control is not always achievable), you should use a spirit level on the tripod head and an "architectural" grid screen in the viewfinder. Of course, a view camera with the right front and rear standard movements makes PC lenses superfluous—but only when you're shooting in large format. A PC lens will never replace a view camera, but it comes close enough for many practical applications.

The one lens that you may hear pros arguing for and against is the zoom. On the one side are those photographers who find it useful not only as a cropping and visualization tool but almost indis-pensable when they're put into a tight spot or where quick reflexes are necessary. On the other side are those who claim that these lenses do not deliver the necessary image quality.

Both groups are right. The zoom lens is a versa-tile tool, but there are many zooms that produce inferior images. The problem with zooms comes as a result of what's good about them. To offer so many focal lengths in one lens often requires some compromises. There is more glass (technically, a greater number of air-to-glass interfaces), which makes the lens more prone to flare and lower contrast. Lower contrast contributes to a flat-looking picture, which, even if sharp, lacks punch. Multi-coating helps, of course, but it is not a panacea.

Further, these lenses are often somewhat slower than their fixed-focal-length counterparts. Take an 80-200mm zoom and put that up against an 85mm optic. Maximum aperture on the zoom may be $f/4.5$, $f/2.8$ if you're willing to spend more. The fixed focal length 85mm, already reasonably priced, is often $f/2$ or faster. Another example: a 24-50mm lens. While many 24mm lenses are $f/2.8$, most 50s are $f/1.7$ and faster. The 24-50mm zoom will be an $f/2.8$ lens if you're lucky. Not very good in low-light situations.

Another consideration is the minimum focusing distance of the zoom. At some positions, that may be closer than you could get with a standard lens, especially if the zoom offers a "macro" mode, but then again it could be greater for others. Besides, macro in a zoom is a gross misnomer. Even "closeup" would be an exaggeration by normal standards for closeup photography, and, judging by reproduction ratios (to be more technical), no "macro-focusing" zoom can provide true closeup magnification or produce images as sharp as a true macro/micro lens of fixed focal length.

Now, with all that said, don't overlook one important consideration: There are some very high-quality zoom lenses out there, and such a lens can make the difference between what is a good composition and what is a great one by virtue of a few degrees in the angle of view. Simply, the most important unknown quantity here is you, first in how you use the lens and second in whether or not you took the time to thoroughly test it out before staking your reputation on it.

A shift lens on a Pentax 6x7 enabled the photographer to keep the verticals from converging in this group portrait made for Mellon Bank. Both frontal and back illumination were used.

We can fill a book about accessories that are used by the pro—and some people have done just that—so let's look at it from a practical perspective.

First on the list would be a Polaroid back. These backs are available for just about any camera today. The advantages to using Polaroid prints have already been described. Unfortunately, these backs are not cheap. In the 35mm format, they also practically require a camera dedicated to shooting instant prints, because it's much more convenient

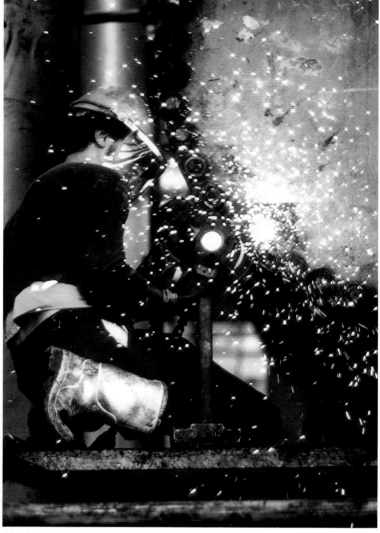

© Lou Jones.

Walking around this oil refinery on assignment for Gulf, the photographer saw this worker cutting a bolt off a tank. Shooting wide open, and using a monopod in this low-light situation, he zoomed in with a Minolta 80–200mm lens.

and aster to use one body for Polaroids and a second for the actual shoot. Other camera formats are designed for fairly convenient, if not rapid, changing of the film holder, magazine, or back, whichever term you prefer. Technically speaking, I would say that film holder applies more correctly to sheet film, a film magazine to rollfilm (which is usually thought of as 120/220), and a back for 35mm. Usage does vary with mileage, however, and the terms are often interchangeable.

Next on the purchasing agenda would be photo luggage, which we've already addressed, and a sturdy tripod. Sooner or later you'll need one of those tripods that reach all the way to the ceiling, if not higher, and you may need your own stepladder to go with that.

Don't skimp on your tripod. Cheap tripods have poorly made leg-locking mechanisms that come loose with little wear. They are often wobbly, and if you don't feel safe putting all your weight on a fully extended tripod, look for something else.

Another consideration is the pan/tilt head, which you should buy separately from the tripod. It should come equipped with at least one, but preferably two or three, spirit levels to ensure horizontal and vertical alignment of the camera. But don't fret if a good tripod head has no spirit level: you can always buy one at a photo or hardware store.

More important, perhaps, is the way the head handles. Check for smoothness of movement, handles that are comfortable to grasp, and a camera platform that is of the proper size to hold the cameras you plan to use most often. You can always buy a second head with a larger platform, later, when needed for larger formats.

The final consideration involves the legs themselves. Tubular legs, in my book, are the best, but there are many excellent tripods that feature closed U-channel legs, and not all tubular-leg tripods are of equal quality. The least favored are the open U-channel designs. Also, a center brace helps ensure that the tripod will be sturdy in use.

Next in order of preference would be a motor drive. Many of the newer 35mm and medium format cameras feature built-in power winders. In some cases, these winders are arguably considered motor drives, but avoiding semantics for now, they offer one distinct advantage, possibly two: One, they advance film to the next frame automatically (some even wind the film to the first frame automatically), and two, they may also automatically rewind your film.

Other necessary accessories are outlined in the table of location outfits outlined earlier, and should be self-explanatory. Items such as exposure meters and lights are key equipment and will be considered in a later chapter.

SPECIAL-PURPOSE CAMERAS

The panoramic or wide-field camera is not your everyday camera. It delivers an image that is wider than that from a conventional camera. These cameras may use 120 or 35mm film and, either way, may yield fewer exposures to a roll than a typical camera, by virtue of exposing a greater length of film with each exposure. Generally speaking, the panoramic camera produces an image with a greater aspect ratio than a wide-field design.

Some of the better known designs are the Hasselblad SWC-series, which are the only Hasselblads with a fixed lens for a 90° field of view, the Linhof Technorama, and the Fuji G617 designs. If you're interested in stretching the limits of your imagination, you might consider something like the Globuscope, with its 360° perspective.

The advantage to cameras like these is that, when used judiciously, they produce images that give the client something different, something unusual—a way of seeing a plant or oil rig that he hasn't seen before. You might say they "stretch" one's imagination. (Of course, no one said you couldn't crop an image tightly to give the appearance of panoramic perspective or use a panoramic pan head on your tripod to produce images that can be butted together in printing. You'll have to explore these creative options yourself as particular photographic situations arise.)

While it may be rare, panoramic cameras are used to effect, as in this interior shot made with a Widelux camera in available light.

RENTING VS. BUYING EQUIPMENT

Pros don't buy every camera and lens made just on the assumption that they may use it someday. No, they rent equipment they don't own, and that can include 35mm lenses or an entire 2¼ or 4 x 5 system. Here's why: "There are many pieces of very expensive, specialized equipment that you'd be crazy to own. Why tie up thousands of dollars in something that you only use once or twice a year, when you can rent it and bill the rental to your client?

On the other hand," Rathe adds, "I don't like renting equipment if I can avoid it. If I have to rent something too many times, then I'd rather just go out and buy it. I don't like the feeling of having to depend on someone having it in stock just when I need it."

Of course, the experienced pro limits rentals to those odd items, as Rathe emphasized. If you rent equipment left and right, however, it may reflect poorly on your ability to handle the job. So keep it to reasonable levels. And if you expect the rental tab to be a hefty one, make sure to discuss it with your client first. For that matter, a prudent move would be to outline all rentals and get the client's approval when you estimate or quote the cost of the prospective job.

FILM AND EXPOSURE

Clients like Polaroid prints as a reference point they can return to, sometimes for evaluation, sometimes for reassurance.

Industrial photographers have their favorite films and their preferred exposure techniques, but they tailor these preferences to the subject, the situation at hand, and most of all, to their client's needs.

There is a reason for faithfully using one film type: You develop a feel for what the film can do, how it will react under different conditions, how it reproduces color and contrast. That's important for delivering consistent results to a client. Unfortunately, film manufacturers don't produce their films with the consistency the pro would like and for some pros the inconsistencies are enough to convince them to try something else.

Just as there are variables in films, there are variables in exposure. But unlike film, which is manufactured to tight tolerances, exposure is relative. No one determines what exposure is correct until you see the final image, unless you subscribe to some exposure techniques that make claims toward greater precision. Realistically, there are no specifications that are laid down, except to make the exposure the best it can be. The tools and techniques used in achieving that goal may vary, but there are some common denominators.

Handheld meters are often a determining factor in making an exposure, but are by far not the sole determinants. Industrial photography relies heavily on the use of Polaroid print film for tests that are used as indicators to exposure and composition. These test prints are as much a tool as any exposure meter.

Sometimes it's possible to manipulate available light, as with this tracking antenna at Goddard Space Center, Maryland, photographed for a corporate trade magazine. Gelling the ground flood lights for a one-second exposure on daylight film produced this result.

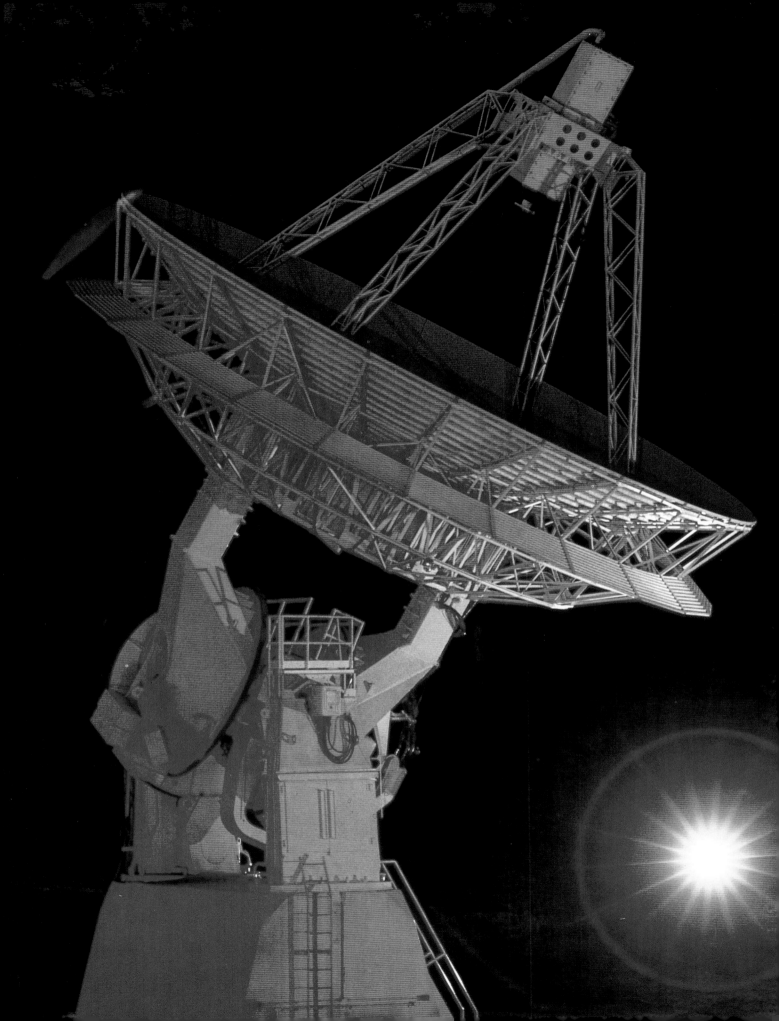

© Lou Jones.

The color cast that resulted from mercury-vapor light added impact to this photograph. The photographer had proposed the concept to the client, who then had to find a suitable telephone pole with a craning mercury vapor light.

The photographer took advantage of a daylight film's response to sodium vapor lights by not filtering for the yellow color cast. He bracketed a reflected-light exposure, basing it around f/5.6 at 1 sec.

Ken Graff, © Union Carbide Corp.

CHOOSING FILMS WITH A PURPOSE

For the working industrial photographer, choosing a film type is often a matter of ensuring that detail and color or, in black-and-white, subject tonalities are reproduced to their best advantage. That practically, though not completely, eliminates fast, grainy films. Pros are divided principally along the lines of freelancers having one set of preferences, in-house photographers another.

Freelancers choose principally between Kodachrome and Fujichrome in the slower speed color transparency films for 35mm and 2¼. They favor films in the ISO 25 to 64 range, with a small minority markedly preferring films in the ISO 100 to 200 range in all film formats. The in-house participants in this survey, however, lean strongest toward Ektachrome among transparency films. These people were divided as to shooting transparency or negative films, whereas freelancers' responses were heavily weighted toward chromes.

There are also personal preferences involved between shooting color transparency or negative film, but mostly you shoot the type of film the client needs, or you deliver the results in the form—chrome or print—the client not only prefers but is used to seeing.

On the other hand, it may be your practice to deliver prints because you may do your own custom printing, dodging and burning-in where necessary, or fine-tuning the print in any number of ways that go beyond what was achievable in the original chrome or negative. And your clients may feel this medium suits their purposes.

Further consideration comes down to the use of daylight-balanced or tungsten-balanced film, and generally that depends on the light source used, unless you're purposely looking to add impact with the "wrong" film type. You also have the choice, among some color negative materials, between Type S and Type L, "S" being relegated to shorter exposure times and "L" longer ones. Type S films may have a softer edge to them, while Type L produces crisper results with a harder edge. Again, these are generalizations and you should do your own tests and judge the results for yourself.

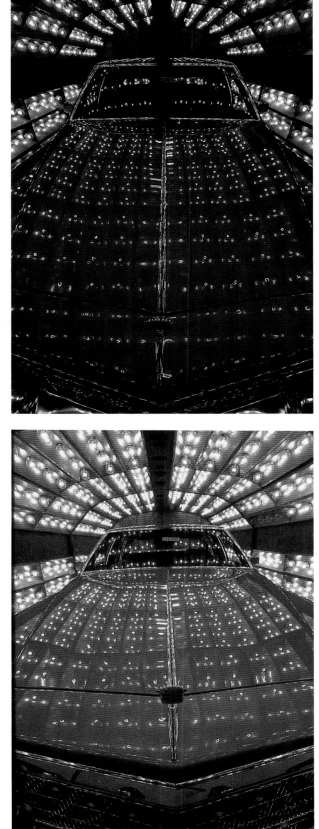

The warmer image (top), shot with daylight-balanced film by available tungsten illumination, renders the heat of the paint being baked onto the car surface in an oven. The subject was also photographed on tungsten film to offer the client a choice between the two.

© Jeff Smith.

FILM AND EXPOSURE







BATCH-TESTING FILM

Industrial photographers who batch-test film for speed appear to be in the minority, according to my survey. The problem with film is that it's never the same twice. Not only that, variations that you probably don't know about in the processing will affect the final image produced. And it's often much easier to leave minor variations to sophisticated printing technologies that can correct for the smallest of idiosyncrasies.

That's not to say that exposure is not important. It certainly is, but exposure is not an exact science. All you can do is try to produce the best exposure you can that will reproduce important subject detail, and trust that you've satisfied the client.

Testing for color balance is another matter. Though not unequivocally, it is the freelancer who batch-tests for color balance, while in-house photographers are divided on this matter. The same holds true for using a color temperature meter, with freelancers sharply in favor of it. In-house photographer Jerry Poppenhouse states that he uses one "occasionally. It really doesn't help me too much, because some of our plants have such a mixture of lighting. I'd have to have a kit full of filters, and I don't carry that much stuff along."

Jeff Smith recommends a simple and straightforward approach to balance-testing films when you find it necessary to switch emulsion batches. Once you've established color balance for the films you usually work with, save one roll from the old batch as a test roll, shoot and mark the roll, then shoot with the new emulsion, and compare the two. A practiced eye will see where the differences lie, or you can hold CC filters over the print or chrome to visualize the results to the degree that corrections are needed.

Using Type A color slide film added impact by producing a blue color cast to this photograph of an arc welder. The exposure was f/5.6 at 1/8 sec., under available factory lighting.

To make this image more dramatic, the photographer used red filtration on the light behind the camera to highlight the water and a small unfiltered bank for the drill bit itself. The flash was set to the slowest duration to blur the drops of water.

POLAROID TESTING

Virtually every industrial photographer will have made at least one Polaroid test to verify some technical aspect of a shot. Polaroid tests are necessary and helpful. You can, after a time, feel confident from your own experience that certain lighting adjustments require either this or that much tweaking in exposure without doing additional Polaroid tests, but it's the most ready source of information at your disposal. And, even if you feel comfortable without shooting that extra sheet of film, the client may request it.

The photographer and client both will look at a Polaroid print and express their criticism or approval. Clients like it because they use these prints as a reference point that they return to periodically, sometimes for evaluation, sometimes for reassurance. And the photographer may refer back to them as well. I've observed art directors go back to the Polaroids time and again, put them down, look at them again, compare old Polaroids with new ones. And models, where there are any, appreciate the opportunity for some visual feedback.

Unlike clip tests, which require the accessibility of a lab to test for film density and exposure, Polaroids can be exposed on the spot in virtually any professional format, with 35mm to 4 x 5 being the most popular range. Black-and-white Polaroid prints are often the best indicators for exposure, while color Polaroids are useful to help judge composition and, within reason, color balance. Neither medium is perfect, but then again, no film medium is. It does make sense to test your shooting film against the Polaroids when changing film batches of either medium and even periodically as a check against aging effects in either film.

Oddly enough, the only Polaroid materials the pros use are the print films. With the advent of 35mm Polaroid slide film, one might suspect that this material would be welcomed by the pro. There are several major problems with this material, however, as a replacement for the traditional Polaroid print film.

Polaroid slides range from acceptable to exceptional. I prefer the black-and-white materials. But for you to use the Polaroid slide films as an on-site test would mean shooting an entire roll of film when only one exposure is needed. You can't vary subject placement and lighting setups for each exposure and then try to duplicate the arrangement that proved best after you've processed the roll of film. And if you were to shoot and process only one exposure, you'd be spending a lot more money and time for one slide than for one Polaroid print. Of course, you could simply expose the entire roll as plus/minus brackets, but that means keeping a running tab of each exposure, when it's much easier to set your exposure, expose an instant print, examine the print, and adjust the exposure.

Another consideration is the extra step required to process these slide films, which require their own processor and a sum total of several minutes to process the roll. Print films often develop in under one minute. Besides, looking down at a print is a lot easier than craning your neck to look at a slide against an overhead light source. And it's also easier for more eyes to view a print. There are other reasons why the print material is preferable. Your clients will be used to doing things the old-fashioned way, and once people are used to something, it's very difficult to get them used to something they may not regard as being any better. And if that's not reason enough, Polaroid prints are what your client takes back to *his* client or boss. Further, the print offers a ready surface to mark areas that need greater attention.

The Polaroid print can also play a vital role for studio shots when the client is not at the studio. John Corcoran may send Polaroids when he's working on a concept that requires input from a client hundreds or thousands of miles away. Along with that, he'll send an audio-cassette tape with details about the picture. The combination gives the photographer and the client a reference point they can use as a springboard to work off.

To add impact to this image of a chemical complex, the photographer shot the moon with a long lens and double-exposed that frame with a shot of the plant, using a wide-angle lens. He added a light amber filter to enhance the color. For the best vantage point, he had to stand on a tall mound of industrial waste.

USES OF PUSH/PULL-PROCESSING

One factor that affects exposure and color balance both is push- and pull-processing. The almost overwhelming response in my survey to whether or not photographers availed themselves of that processing option was "seldom," with one "sometimes." Among freelancers, pull-processing rated an isolated "sometimes" vote, but among in-house staff, pull-processing pulled a much stronger "never" vote. I should point out that one in-house photographer indicated that he did neither push nor pull film.

Push-processing can benefit an image that is flat, by bringing up the contrast, whereas pull-processing can have the reverse effect, reducing contrast where too much exists. The one negative side-effect with color films is that color balance can shift and will certainly do so with any appreciable degree of push/pull processing. One-quarter, or less, to one-half EV is probably the safest range, but you should test the film you're working with to see how well—or poorly—it tolerates deviations in processing time.

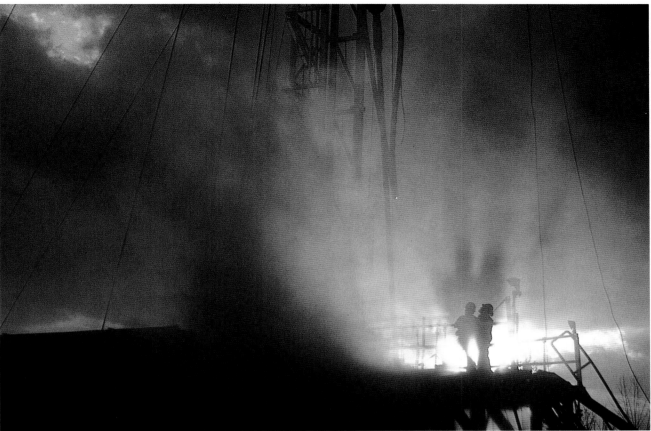

USING EXPOSURE METERS AND BRACKETING

Pros own quite sophisticated handheld meters and most often work with the meter in its incident-light mode, since that is least affected by subject tonalities and hot spots. They do not rely heavily on the camera's metering system, no matter how advanced. As a matter of fact, with few exceptions, the camera is used in manual metering mode, with its meter occasionally used as a check in questionable circumstances. And once the meter reading is taken, the pro makes his exposures at the meter's recommended reading—and brackets above and below.

Bracketing insures a usable transparency or negative—after all, after spending all those hours setting up, it takes only a few more minutes to shoot those brackets. Bracketing gives the client a choice, and more often than not, minor deviations from the "ideal" are corrected in printing and possibly with retouching beforehand.

Without intending to plug products but going strictly by what my survey has indicated, the majority of photographers preferred the top-of-the-line Minolta exposure meters. But these are among the most expensive and offer a number of bells and whistles that you may like but not need, especially if you're starting out on a low budget. Remember that you can start off with a less expensive meter, and when your financial situation changes, keep your original as a backup and go upscale.

The principal function that the meter has to offer is reliability, followed very closely by ease of use. Fortunately, the exposure meter of today that offers a liquid crystal display has proven reliability, especially if it is among the top three brands, namely Minolta, Gossen, and Sekonic. This is a microprocessor-driven machine that provides digital easy-to-read displays and in some cases comes with a plethora of functions. Essentially, the meter should have incident-light reading capability.

As late-day sun cast a shadow into the heavy cloud of dust generated by the drilling, it produced an eerie ghost image, captured for a Consolidated Natural Gas annual report. But the dust also made it necessary to have the camera overhauled.

READING FLASH EXPOSURES

The one thing your camera's metering system cannot do is read studio flash systems. Handheld meters can—if they are designed with that capability—and are consequently called flash meters. There are flash meters that read both flash and ambient light to an equal degree, but there are also flash meters that read only flash and ambient-light meters that read flash to a limited capacity.

The flash meter should be used for studio strobe and is generally not recommended for on-camera flash units operated in automatic. You can readily use a flash meter for on-camera strobes used in their manual mode, since the flash bursts are of longer duration than they would normally be in the automatic mode. (I've also heard of a stu-

dio strobe that offers automatic operation, and the same would apply here as well.)

If your exposure metering lies in reflected-light measurement, you can convert many of these handheld meters to this metering mode. Often that can readily be done, but an accessory finder may be required. If you favor reflected-light metering to the point where you prefer a spotmeter, Gossen, Minolta, and Sekonic are manufacturers that each offer spot meters that are capable of reading both ambient light and electronic flash. Their only drawback at the present time, and it's one shared with some of the smaller handheld flash meters, is that they only read flash in "cord" mode. Be sure to check your requirements.

The radar dishes on the left were shot with the available light of dusk, and then with the floods kicking in (right) on the support structure.

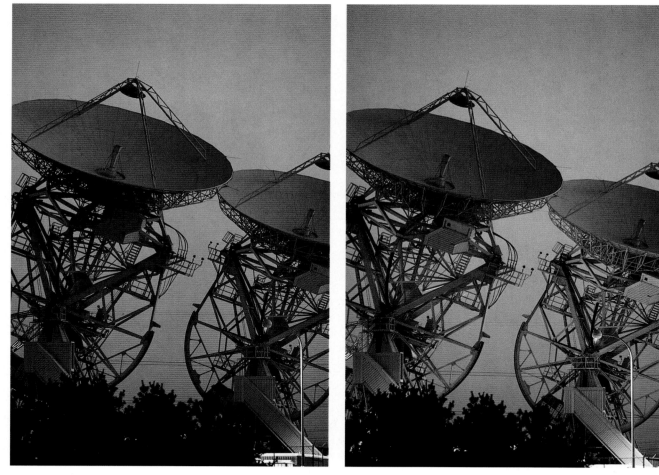

© Camille Vickers.

CORD OR CORDLESS MODE?

The flash meter can be connected to the flash directly with a standard sync cord or to both the camera and the flash via a Y-shaped, three-way sync cord. The cord, however, can only reach six feet or so and often your lights are placed well beyond that. Hooking up extension sync cords adds a bit of uncertainty to the equation, not to mention a lot of unnecessary clutter and wire that can get tangled up in something or other.

An infrared or radio remote can be used to trigger the flash while the meter is in its "cordless" mode. Once the meter is primed and as soon as its photocell senses the pulse of light, it produces a reading on the display. Here, pressing the meter's measurement button places it in a "ready" state, unlike cord mode, which triggers the flash as soon as the button is pushed.

The end result is that for this line of work, the meter should offer both possibilities, because you never know what situation is waiting for you.

You can, within reason, bypass the cord-only limitation by connecting your meter to a small flash that can be used to trigger the studio strobes off in the distance, assuming they are slave-synced.

COPING WITH AIRPORT INSPECTIONS OF FILM

Inherent in the field of industrial photography is location work to other cities and states and occasionally foreign countries—and that will inevitably mean flying to one destination or another. And you know what comes next.

In the United States, airport security stations are generally agreeable to hand-inspection of film. Boarding a plane in a foreign country, and that may even apply to foreign destinations from within the States, may subject your film to X-ray inspection—no ifs, ands, or buts. The only thing you can do is request a hand-inspection, and you can even try to be insistent.

Having the film shipped by air to your destination is no guarantee that it will not be X-rayed either. And even if you decide to buy your film when you land, you still have to worry about taking the exposed film back with you. (Remember that the potential for film fogging is exacerbated with cumulative exposure to X-rays.)

So, what's the solution? I would say that you should use lead-lined containers, and I know photographers who use them. But there's no telling that an overzealous security agent might not simply turn up the juice in an attempt to penetrate the shielding. My own experience here in the United States was interesting: I mentioned to the airport security agent that there was a lead-lined container with film in one bag, and upon seeing that container register on the screen, the agent pulled me aside and asked me to open each piece of luggage for a hand-inspection.

But to end this discussion on a positive note, Camille Vickers has this to say on the subject of problems with hand-inspections at airport security terminals. She noted that she's had problems "only in Europe. Occasionally they'll absolutely refuse to hand-check film and insist that it be X-rayed. Several times we've had security people say that the film had to go through X-ray and then when the film went through in the lead-lined bag, they didn't say anything."

LIGHTING TECHNIQUES OF THE PROS

There are inherent disadvantages in all sync systems, and you've got to find the one that will work for the situation you're in.

JEFF SMITH

Light is the photographer's greatest tool. Light, or the lack of it, controls the image exposed on a piece of film. And the photographer controls, to some degree, the light that forms that image. It is the right lighting that gives life to an image and poor lighting that saps the life out of it.

Lighting controls are often mechanical, placing one light here, another there, or involve the efficient use of reflector panels, umbrellas, or light banks—or any number of light-modulating devices, not least of which are the metal reflectors themselves.

The industrial photographer must also know when to use filtration on his lights to balance and neutralize what could prove to be a color cast, or when to add filters for color effects to liven up an otherwise drab image.

The controls at the photographer's disposal are numerous, but so are the variables—the shiny subjects, the facial features that need to be brought out or toned down, the contrasts of shadow and light strong enough to ruin the best planned image. The variables exist, but they rarely outnumber the controls and should never be permitted by the professional to overshadow or overwhelm those controls.

You begin by assessing the subject and the lighting that will produce the most effective photograph. The most intriguing facet to lighting is that you can take advantage of available light or combine ambient light with some degree of fill, such as from flash, or fully light a scene with any number of lights you feel are appropriate. Numerous situations led themselves to shooting by available light, but an equal number require expertise in setting up lights and correctly remote-syncing them to each other.

To illustrate the cover of a medical trade magazine required petri dishes, which the studio bought. A foamcore "ceiling" also contributed to the effectiveness of this shot.

The industrial photographer has a wide choice in light sources, including daylight, available interior and outdoor lighting, and systems he himself provides, namely quartz lights and electronic flash. Outdoor daylight, or daylight streaming in through windows or other apertures, can prove helpful and troublesome at the same time.

Light of the wrong color temperature, whether from daylight or artificial sources, can tinge parts or all of a picture, depending on the prevalent wavelengths present. An orange-red cast results from longer wavelengths (early morning, late afternoon/early evening sunlight; or incandescent lights), whereas shorter wavelength blue light plus ultraviolet radiation infusing the scene produces a bluish cast. Industrial light sources found on the scene will have similar effects. Sodium vapor lamps cast an amber/yellow tinge, whereas mercury vapor lights produce "industrial" blue-green or green that is often expected and may work to the advantage of the picture. Fluorescents are a hodgepodge of unknown variables that produce more or less greenish color casts, depending on the spectral quality of the lamp.

What every photographer appreciates most about studio lighting systems is that they are controllable to a considerable degree. While on-camera and handlemount/bracket-mount portable flash units do indeed offer several advantages and are modestly controllable, they are rarely the means of first resort in industrial lighting, at least not for the freelance photographer. The in-house photographer may use these compact flash sources more often on location than at his home base, but, either way, he does make considerable use of them. And there's nothing wrong with that, since much location work for the in-house photographer is done on the run, moving quickly from shot to shot, location to location.

Frankly, I was quite surprised to learn that industrial photographers still use tungsten lights. Some even prefer them over studio strobe systems, and many use them as an adjunct to their flash lighting. As Camille Vickers and Greg Beechler point out: "We don't very often do an entire shot with just the 'hot' lights, but we'll add them in for some warmth here and there, to create a nice feeling in a picture. A lot of times we don't use modeling lights, and the 'hot' lights give a better indication of the lighting we're using." That last comment especially holds true where gels are used.

Shooting for a Raytheon annual report, the photographer created the impression of a light rainfall by using red umbrellas and a fog machine, and by having the set wetted down. He used three orange-gelled 400 W/S strobes inside the fuselage and 800 W/S strobes underneath the fuselage and wing, on short stands, pointing toward the ground, with blue, green, and cyan gels to simulate mixed lighting. There was also a small 1600 W/S light bank a number of feet up, and farther away was a strobe rated at 3200 W/S.

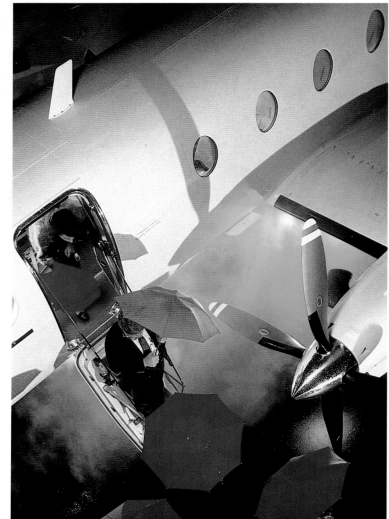

© Jeff Smith.

USING AMBIENT LIGHT

In theory, ambient light is the easiest tool for the photographer to work with. In practice, it is far from that. Bright days can present problems of excessive contrast that can blow away details in the extreme bright or dark areas of the picture, more so when using films that are inherently contrasty to begin with, such as Kodachrome or any high-speed chrome film or slow-speed black-and-white emulsions. Dull days may offer lackluster photo opportunities, but used judiciously can prove very effective.

One major difference between sunlit and overcast conditions, aside from contrast, is that bright days offer more saturated colors, whereas colors on cloudy days are muted, tainted by excessive ultraviolet radiation and short-wavelength blue light. With color films, a skylight filter or 81-series warming filter may be needed to restore the richness of color that would otherwise have been there.

Bright, contrasty days may also necessitate the application of flash-fill, that troublesome technique that softens the contrast or completely balances the brighter ambient light behind or to one side of the subject with a controlled burst of electronic flash light. Often associated with portraiture, flash-fill can be applied to any industrial subject within reach of a flash unit. Of course, reflectors may be used instead, but they may not provide the full degree of fill available with flash. Furthermore, a greater distance may be required, either for safety or owing to obstacles, that would reduce a reflector's effectiveness to next to nothing. On the other hand, reflectors take the place of flash in many situations where using additional flash heads is just not practical.

Ambient light is not merely daylight. As available, or existing, light it's a term often relegated to low-light situations, and many industrial photographs may be shot under these existing conditions often quite effectively.

LIGHTING CONTRAST AND FLASH-FILL

Flash-fill can be a cumbersome and time-consuming task if you're truly conscientious about achieving the best results through manual calculations. But you can achieve results of equal quality with less effort by using an exposure meter that provides this type of information, provided any flash you use is in its manual mode.

You can use any flash meter that reads both flash and ambient light, but even better is a meter that

features what some manufacturers call a daylight-to-flash "analyze" function. Simply stated, this shows you the difference between the exposure produced by the flash from that of the ambient light. From this data you can determine if the flash power must be boosted up or toned down, or, without that capability, if the flash need be moved closer to or farther away from the subject. You take a meter reading with each subsequent change and

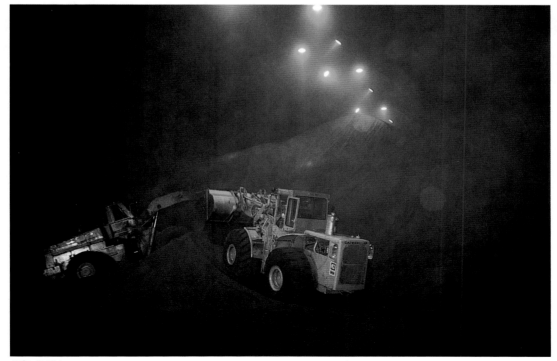

© Camille Vickers.

To capture an unblurred image of the bulldozers moving a mountain of coke at this California site required a small flash unit. The available mercury vapor illumination inside the facility required magenta filtration to partially correct for the color cast affecting the rest of the scene.

Beginning this series at about 15 minutes before sundown, the photographer first photographed the Linde truck by the fading available light. Subsequent exposures with a small flash unit for flash-fill proved most effective.

determine at which point you are satisfied.

Meter readings must be done in the incident-light mode, or failing that, using the equivalent in reflected-light mode by reading off an 18 percent neutral-gray card.

Generally speaking, reproducible lighting ratios should be kept to a range of between 2:1 and 3:1; higher ratios offer higher contrast, when measured by incident light. You can also balance the flash with the ambient light, but that may not work for many subjects, since it presents the subject in an unnatural manner. Balanced flash-fill often works better with people than with other subjects you would normally encounter. You'll have to be the judge of that.

The lighting ratio is a measure of contrast between a key (or key-plus-fill) light and a fill light depending on the lighting used. The flash-fill ratio, the ratio of ambient light to flash-fill, is in a sense a variation of the lighting ratio. A 2:1 ratio represents a difference of 1 EV, whereas 3:1 represents a 1.5 EV difference between the exposure readings your meter gives you for the two light sources. You have to remember here, as in any situation you light, that the process of reproducing the images in print form will affect contrasts one way or the other, and by controlling contrast, you limit the variables. (Just to clarify matters, if you take a reflected-light reading of a highlight and shadow value, you are taking a brightness ratio reading of scene contrast. A 16:1 (four-stop) brightness range should be considered the maximum, although the true range does exceed that, to ensure fully reproducible details in the key highlights and shadow values.)

CHOOSING STUDIO LIGHTING SYSTEMS

As we mentioned, industrial photographers do use tungsten lights, but far and away the most prevalent form of controllable lights they use is electronic flash; consequently we will focus on that.

Much of what is available for strobe systems finds its origins in the "hot" lights used in film-making. Chances are that there are accessories for these lights that will yield similar results.

Of course, where electronic flash and tungsten lights differ most is in the power source. All flash units require their own power source to convert the electricity from the AC source, or battery power, for use by the system's capacitors. Studio flash systems in particular are based around a power-pack. This may be a separate component that drives the system or integral with the flash head, called a monolight or monopack.

Depending on the number of lights you work with and the products you use, either powerpack-based systems or monolights may prove the lighter alternative. You can pack several lightweight monolights into your location outfit as easily as you can pack away one powerpack with several heads. The difference comes into play when you need a lot of juice. Heavy-duty monolights do add up, and can weigh more than a couple of powerpacks offering equal output with a contingent of four to six heads. It all depends on the systems you buy into. Furthermore, since monolights are generally heavier than conventional flash heads, it may not be advisable to hang these lights from the ceiling.

Another consideration is that many, though not all, powerpack systems let you split the output either symmetrically or asymmetrically among the heads attached. Asymmetric output distribution lets you bias output toward one or more lights, while drawing away from another that may be used simply for fill. Symmetric distribution places the load evenly on all the lights hooked up to the powerpack. One more essential feature is the power ratio per flash head or powerpack. Some units offer variable increments, while others are fixed, but increments of one-third are preferable over one-half, thereby providing greater control, and continuously variable output is better yet.

There are two principal ways to judge output. One is by the watt-second (W/S) rating, which directly indicates the power available. A 2,000 W/S unit produces more power than a 1,200 W/S pack. Yet the actual output, judged by the lens aperture you can effectively use, is a function of how much of that juice is poured into the individual light heads and the type of metal reflector—or none at all for bare bulb uses—controlling light dispersion. To that add other controlling devices, such as umbrellas or light banks. Each will affect the manufacturer's stated guide number for that particular lamphead. And the guide number alone will tell you how far a light will reach or how small your

f/stop can be. Higher watt-second ratings should not be your sole guide, since all units with similar ratings are not equally efficient in output, as measured by the guide number.

One reason for carrying a lot of lighting power on location revolves around the eventual use of filters on the lights. As Jeff Smith points out, that cuts back on the light available by as much as two stops in some instances, which is considerable.

Many names pop up when you ask industrial photographers what strobe lights they use—Balcar, Broncolor, Norman, Speedotron, and Dynalite, just to name a few. Many will have something good or bad to say about any system they've ever worked with, in a constant search for the perfect lighting system. A lighting system that is lightweight and compact, for example, may not offer the power or controllability of a heftier system, which might have its own drawbacks.

How deep in debt must you get to become a versatile industrial photographer capable of lighting most of your assignments? Not deep at all. Here's a lighting starter kit that Vickers and Beechler recommend: "At least one good powerpack, at least 800 W/S or more, a couple of flash heads, a couple of umbrellas, a few stands, a light bank, some gels and CC filters." Add to that a color temperature meter and an exposure meter. "Someone starting off could do pretty well with that. And having maybe one 'hot' light."

I've heard horror stories about what happens when the electricity is not voltage-stabilized. Peaks and surges in the system can blow your lights. On the other hand, your lights can blow a few fuses themselves.

It's one thing when you're in an industrial plant that's wired for heavy electrical loads. It's quite another when you're in an office building. There you have to gain access to the fuse box or circuit breakers to check which lines go where, then spread the lights around. If necessary, you may have to snake hundreds and hundreds of feet of extension cord all over the place to find separate lines, one for each powerpack, to prevent a drain on any one line. In such cases, it may be better to use monolights than to dedicate an entire powerpack to one light, unless you're hanging lights.

You can't always tell in advance when a problem will develop. Vickers and Beechler cite instances where the strobes have interfered with the operation of computers. The problem was easily corrected by using a different set of outlets in another room. And among the reasons they cite for using a specific powerpack system, they include compactness, good design, solid performance—and the fact that the "800 W/S packs don't draw that much electricity, so they aren't expected to interfere with line voltages."

© Jeff Smith.

UMBRELLAS AND LIGHT BANKS

With the advent of the commercially available light bank, photographers have shown a marked preference for these light diffusion boxes that attach to the flash head. These are often rectangular in design, with some offering a higher aspect ratio in the form of "strip" lights.

Umbrellas are usually used as bounce-light sources, usually silver or a more diffusive white, but they may be of the shoot-through type, acting somewhat like light banks. There are also gold-toned umbrellas that add a little warmth to the scene. Umbrellas come in a variety of sizes and shapes, and one type is a cross between an umbrella and a light bank.

Umbrellas are much less expensive and easier to set up in many cases than light banks. They also require less space when set up.

Owing to its construction, a light bank provides a more controllable diffusion pattern, since the light is enclosed on all sides. Some light banks do a better job than others at controlling spill light, but all are better in this regard than umbrellas. They are also often larger than umbrellas, which may be necessary where subjects of larger size are involved.

"The light banks are especially helpful in portraits and as fill lights," comments Robert Rathe. "For example, we were shooting some touch-screen computers recently. The operator simply touched the icon on the screen to input instructions. The client didn't want to strip in the screen or have to retouch. The art director wanted enough light on the front to see detail. So by putting a strip light out to one side, and a light bank carefully goboed, out to the other, we got enough soft lighting to show the hand at the computer screen, without reflections on the screen."

A combination of light banks at floor level, and lights suspended from the bannister above and bounced off the white walls of the stairwell yielded this effective group portrait for GE Credit Corp.

HANGING LIGHTS

"I'm a big believer in hanging lights from the ceiling, because it gets cords and light stands out of the way and it's a good way of illuminating a very broad area," says Jeff Smith. Basically, you bounce the lights off the ceiling. That bounced light can be used as fill light or as the main light, and other lights can be added to that to achieve the necessary effect. A commonly used device is a scissor clamp, but the ceiling or wall may not offer a good hold for such a clamp. You therefore need an alternative.

That alternative is a gadget Smith devised, which he calls the "Smith Hanger." He fashions it out of two basic parts: the Bogen stud and a socket extension.

The next photograph shows the essential components; electrical tape, socket, stud, A-clamp, and five-minute epoxy. You use the electrical tape on the stud to insulate and prevent against shock; you take the epoxy and pour it down into the female socket of the socket extender; use the A-clamp to hold the socket in an upright position; put the epoxy in and then put the taped stud in it and let it dry. And then you can screw that into a high-hat, which will give you a stud to hang your lights from.

Now, Smith warns, there are a couple of things to think about here. One is to make sure that there is no electrical connection into your stud that could result in a nasty or fatal shock, so make sure the device is well insulated. The other is that some high-hats are not put into the ceiling very securely, so you've got to put a little test weight on it to make sure that it will hold the weight of the light and cords. You can use gaffer tape to tape the high-hat to give it extra strength.

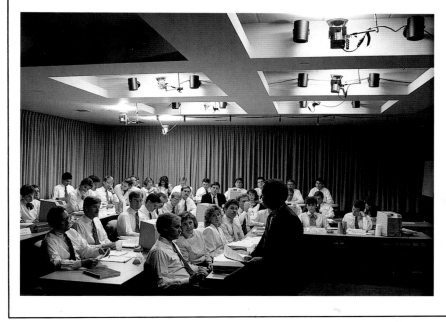

© Jeff Smith.

You can have the most expensive and most elaborate lighting systems available, but you have to know what purpose each light serves when applied to the subject. The key light may be your main light, but you have to understand that it's not the most important light just because it's the most powerful one in the system. It serves the purpose of illuminating principal features of the subject or even one small area, allowing other areas to go dark. It may be a conventional flash head—or a bitube or quad-head, requiring more juice to be pumped through that one light for a more powerful burst. This involves not only deciding whether or not to use umbrellas, light banks, or other diffusion devices, but which reflector to mount on the flash head as well to produce the best results. Sometimes bare-bulb will yield the quality of light you're after. However, any change in reflectors, or their removal, means that the head must be designed for that purpose. A number of flash heads do not offer that option.

There are numerous positions to put the lights in when lighting the subject and the foreground and background, along with supporting elements that, technically speaking, constitute "background materials." There are also considerations that involve the specular quality of the light, whether to make it hard or soft. And of course there is the spectral quality of the light, to correct for color balance, or distort the colors to add touches.

While the role of the key light is often self-evident, that of the hair light and back light requires more of a studied approach, knowing when to use them and where to place them.

The photograph on the opposite page started out as an art director's rough black-and-white comp. By viewing through the camera lens, the photographer was able to project onto a piece of paper the exact area the "city" of connectors would occupy, so that the model maker could be given exact specifications. This is a complex in-camera masking shot involving three cameras and no retouching.

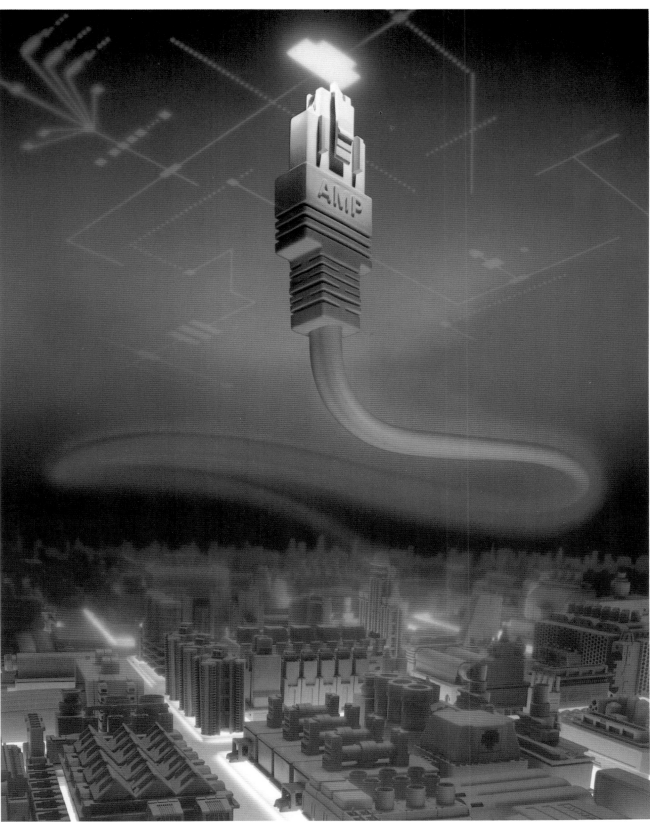

THE IMPORTANCE OF HAIR LIGHTS AND BACK LIGHTS

Backlighting adds a dimension of depth to an otherwise flat image. It also provides separation between the subject and its background. "I often believe that the first light I should set is my back light or my hair light," says Jeff Smith, "because it really draws the line of the image and the composition that you're trying to achieve.

"You've got to be careful about goboing that," Smith warns, emphasizing the proper placement of a card or any flat opaque material between the light source and the camera, "so you don't get any flare—using a back light can lead to flare if you're not careful."

One way to set up a back light or hair light is with a boom stand. To balance the boom arm, you use a counterweight, which can be a sandbag or a bag filled with miscellaneous hardware. Bags specially made for this purpose are available at shops catering to professional photographers and cinematographers. But because there may be a possi-

bility of someone bumping into a boom stand, alternatives should be considered, such as hanging lights from the ceiling or inside it. "Drop" ceilings have space that will hold a light bank, and all you need do is move the panels aside. You'll also notice that there are support rails, and these might be usable to hang lights from, as long as the heads are not too heavy and you've made sure that they will hang securely in place. Scissor clamps are often used for this purpose.

Another alternative Jeff Smith uses is what he calls the Smith Clamp (see page 99). This provides you with a stud from which you can hang lights that can be used as a hair light or backlight; the lights can also provide a diffused light source when bounced off the ceiling or wall, for a broader backlight or fill light. Be sure that the high-hat fixture the clamp will be joined to is secure before attaching the light.

LIGHTING ODDS AND ENDS

There are always little odds and ends that can make your lighting job easier. Here are a few.

Robert Rathe recommends duct tape as a cheaper alternative to gaffer tape when electrical wires and extension cords have to be taped down on carpets. Taping wires down is a prudent measure to prevent people from tripping over them.

Rathe, of course, carries gaffer tape, black and gray, because there are times when you need black tape to cut reflections or hide things. His location kit also consists of a custom-made 10 x 20-foot white rip-stop nylon sheet that folds up and fits into a pouch on the side of one of the carrying cases. He may use it as a large white wall or as a shoot-through diffuser. "Sometimes we'll put it behind blinds to cut the view outside but to allow light to

come through. We also have a black rip-stop nylon sheet that we may use as a backdrop or to wrap up emergency lights that can't be turned off," such as those that you may encounter in some computer rooms. "If we think we're going to need background paper on location—and we have to fly, I'll get it locally and have it shipped. We'll bring all the necessary hanging hardware.

"Radio slaves are something we wouldn't be without. Inevitably, the situations where you need it the most are where you'll get some interference from some source." Because polarity on some slaves may be questionable, Rathe recommends, for those slaves, that you put a drop of red nail polish on the right side to ensure that it is plugged in correctly. It's easy to remember: *Red on Right.*

DEALING WITH REFLECTIVE SURFACES

We've already seen how one industrial photographer effectively tackled a reflective surface. There are several approaches photographers take in working with shiny surfaces that can create glaring hot spots in the picture, aside from retouching the final image. If the subject is a small product, you can put it inside a light tent, which acts as a diffused light source that reduces glare. Usually, some surface sheen should remain, so don't dull the surface entirely; just eliminate the possibility of important subject areas burning out in the picture.

Light tents are often fabricated with materials available or brought along for such eventualities. You can surround the object with light diffusion panels on all sides, or just on two or three, depend-

ing on the effect you want to create. You can do the same thing with light banks.

But for very small objects, your best choice may be either a well-designed light tent you buy or make, with an aperture at the top for the lens to poke through. Here lights are placed outside the tent, and since they point downward, there is little, if any, fear of flare affecting the camera at the top. And still another approach would involve the use of special fiber-optics minilights.

When you've gone as far as you can practically go with the lighting and still encounter an obstinate hot spot, you may find that the only alternative is to use dulling spray.

There is one point to keep in mind whenever

you try to manipulate your lighting to overcome some obstacle or another. "It's important for a photographer to recognize when it's better to use the best means available to solve a problem," states Robert Rathe, "such as when it's better to leave something to a 10 minute retouching job versus four hours of your time manipulating lighting to get rid of a hot spot."

SLAVE SYNCING

"I use the GVI (Quantum) Master Slave. I've hard-wired my strobes on a number of occasions, but I've found that to be tremendously time-consuming and just as prone to glitches and failures as radio remotes and optical slaves.

"What I tend to do with lights that are considerable distances apart is run 100 feet of extension cord with the photo slave (taken to a place where it can see the light source). I've gone to the extent of taping a slave unit into the reflector of the primary strobe and then run 100 feet of cord to the next light. I generally travel with about 600 feet of extension cord. With these slaves, it's really just a matter of moving them, to a place where they can pick up the triggering pulse of light. I usually use a radio remote, most recently a GVI (Quantum) radio remote, to go to my main light source. Then I photoslave them from that.

"I did one job where I was shooting across Park Avenue (New York City) from the Waldorf towers into an office building, and I wanted to show two floors lit using strobes. I wanted to minimize the lighting from the other floors, which were lighted with fluorescents, to make it look like only those two floors had people working on them.

"I wanted to start wiring the strobes at noon, but I wasn't allowed to begin until about six in the evening. I had three assistants; we were communicating back and forth with walkie-talkies. My assistants were having a problem in that they couldn't make the hardwired connection between the two floors. We worked hours trying to hardwire all the lights. Meanwhile, we had 40 models, who are employees of this company, waiting around. (As far as keeping everyone happy, ordering out for pizza took care of that.)

"The reason, we found out, that we couldn't get the system to work was that the electrical cord we bought—we'd bought 1,000 feet of it—had a number of gaps in the copper wire, where there was only insulation. The solution to syncing was to run the Master Slave up a story with extension cord.

"With these Master Slaves, I can sync a system faster and with less fuss and frustration than I could with hardwiring." Smith noted that polarity adds to the problems encountered with hardwiring.

"On one shoot I was up in a crane, shooting straight down onto this radar array. It was a two light setup, with one bitube that cast a sharp-edged shadow from someone standing on top of the radar, and there was a fill light near the camera position and hooked up to the Master Slave. I had the hard light snooted to produce an even harder shadow, but because the light was snooted, it didn't see the Master Slave that was in the unit on the crane. I took a length of vacuum cleaner wire that we had bought and ran it six feet over the edge of the crane, so that it was dangling just about in front of the main light, and that worked like a charm."

Smith noted that problems with radio remotes include their limited range, the need for some to have the antenna pointed directly at the light, and interference from other sources emitting radio frequencies. "The GVI has two channels, so if there is any interference on one channel, you can switch over to the other and you might overcome the problem.

"I know that big electric motors, for instance, will emit radio-interference type patterns that can set off your strobes. One of the disadvantages, by the way, of photoelectric slaves in industrial applications is that a passing forklift truck with a stroboscopic warning light will trigger strobes once every half second—and you're in danger of burning out your power packs.

"There are inherent disadvantages in all sync systems and you've really got to find the one that will work in the situation you're in. I've even heard stories about photoelectric slaves being popped by reflections off chrome on a busy superhighway nearby.

"I've hardwired remote cameras using 1,000 feet of electrical cord to trigger a camera when I was shooting missile launches. I could get the camera close but I had to be inside a bunker. All that needed was a little triggering switch, and it's worked extremely well.

"One of the places where I've been doing a little more hardwiring than I used to is from camera to my master strobe. When I run into problems with my radios or with infrared, then I'll run 200 feet of extension cord to my first light, if that's necessary."

WORKING WITH COMPLEX LIGHTING SETUPS

Until now, you've read about different lighting systems and approaches to lighting various subjects. The following represent assignments that involve practical solutions to lighting relatively large areas and large products, a group of people gathered around a conference table, and various degrees of small-product setups.

Shooting for a Raytheon annual report, Jeff Smith created the impression of a light rainfall with the use of the red umbrellas and a fog machine, and by having the Beech commuter aircraft and the surrounding area wetted down. Smith was on a cherry picker, using strobes both outside and inside the plane, adding blue, green, and cyan gels over the lights (which were pointed at the ground) under the fuselage and wing to give the impression of mixed mercury vapor and fluorescent lighting. It was necessary to mount a red umbrella on a light stand to make it look like there were more models in the photograph than were actually present.

On another assignment, Jeff Smith photographed a conference room scene for a Mellon Bank annual report. For this overhead view, Smith employed three lights, with a bitube casting the striped shadow pattern through a specially designed scrim that was intended to simulate sunlight coming in through the window blinds. This scrim was made of diagonally stretched gaffer tape (with monofilament to keep the tape from sagging) and supported with the aid of light stands, stand extensions, and boom arms. Two light banks provided fill.

Moving from relatively large-area subjects to smaller-sized products, one and one-half million dollars worth of newly designed laser optics—102 pieces in all—was the focus of Lawrence Livermore National Lab photographer Jim Stoots's photograph for the Atomic Vapor Laser Isotope Separation Program. Lighting the subject was a complex process involving quartz lights, together with a number of white reflectors, including one 4 x 8-foot overhead reflector. Each of the side reflectors had a spot light bounced off it. For separation, Stoots set the optics off against a matte black cloth background.

On another occasion, Stoots had to photograph oil shale rock and a geologist's hammer as it came crashing down on the rock. Shooting for a poster and a multimedia production for use by Howard University's Geology Department and the Lawrence Livermore National Lab Equal Employment Opportunity Office, Stoots positioned two studio strobes, one at camera position, the other to the immediate left of the rock, adding fill where needed, and exposed at 1/500 sec. To minimize possible reflections in the rock and hammer, he placed polarizing filters over each of the lights, with a corresponding polarizer over the camera lens. The flash was triggered by the hammer coming down onto sync contacts hidden under crushed rock.

Assigned to produce a photograph for the cover of a Union Carbide house organ, to show that a book that was chemically treated by a proprietary company process could withstand moisture, Ken Graff set up a fish tank equipped with real fish

Lighting all these laser optics was a complex process. Each of the light gray reflectors at the ends of the table had a spot light bounced off it, while the other white reflectors bounced flood lights back onto the subject area. There was also one large overhead white reflector. The glass was set against a matte black cloth backdrop.

James E. Stoots, Jr., © LLNL.

To photograph this oil shale rock and a geologist's hammer, the photographer positioned two studio strobes, one at camera position, the other to the immediate left of the rock, and exposed at 1/500 sec. To minimize possible reflections in the rock and hammer, he placed polarizing filters over each of the lights, with a corresponding polarizer over the camera lens. The flash was triggered by the hammer crashing down onto sync contacts hidden under pieces of crushed rock.

For this Mellon Bank conference room scene, the photographer employed a high camera angle, three lights, and a specially-designed scrim. A bitube cast the striped shadow pattern through the scrim, which consisted of strips of gaffer tape in a support frame, to simulate sunlight coming in through window blinds.

The use of two different sets made it necessary to carefully light each so that the final combined image in this two-camera double exposure was credible. A total of two power packs and six flash heads were employed, together with fill cards. The photographer used an 81A warming filter on the lenses of his two 4 x 5 cameras to produce this photo for True Temper Corp.

© Bob Skalkowski.

(page 135). He had to anchor the book down to prevent it from floating to the top. He lighted the setup with one overhead small-sized strip light and added fill cards, one on each side. The toughest part, he notes, was getting the fish to pose in just the right spot in front of the open book.

For his assignment to depict the theme of desktop publishing for a Xerox Corporation in-house magazine cover, Paul Prosise put together a collection of old hand-etched woodcuts with lead type and other elements that related to the theme, most notably a computer mouse (page 139). To light the setup, Prosise used a spotlight and scrim opposite camera position, using paper cutouts and colored gels on the scrim to block light from hitting the paper pasteup at the left and the mouse at right. Another spotlight with an orange gel from the left added color and highlights to the paper and mouse, with fill provided by a 30 x 40-inch reflector positioned in front of the camera.

On one assignment for True Temper Corporation, Bob Skalkowski designed a shot using two cameras, two separate sets, and double exposure. The key element in the lighting, Skalkowski points out, is that, because two different sets were used, he had to be careful to light each component image so that the final combined image is credible, in terms of the direction and quality of the lighting.

The photograph involved a spray nozzle, pressure bottle, and fake foliage. The nozzle, the fake foliage, and the streaming water were shot on one camera, with the back removed to the second camera for the double exposure with the pressure bottle and handle. This produced adequate depth of field and allowed the nozzle, which was the key element here, to loom larger than the bottle. A total of two powerpacks and six flash heads were employed, together with fill cards. Skalkowski used an 81A warming filter as well on his lenses, which he notes were a 210mm and a 90mm on the first and second 4 x 5 cameras, respectively.

JEFF SMITH'S FILTER PACKS

In order to balance light sources of one color temperature with those of another, Jeff Smith has developed a system of filter packs that involves the use of one filter on the lens and one or a group of filters on the strobe heads being used in conjunction with other light sources. The filters on the strobe heads neutralize the color shift that would result when filtering on the camera for other light sources. For example, to filter for cool white fluorescents, you might use a CC40M (40CC magenta) on the lens. However, that would turn the strobe lighting magenta as well, so to neutralize the effect, you could take the expensive route of using CC40G (40CC green) camera-quality gels taped together or try the equivalent but economical alternative of a combination of Rosco 3304, Rosco 3316, Lee 191, and Lee 218 filters on the light heads. These filters can be bought in large sheets that can be cut up as needed.

Filter on Lens	Filter(s) on Strobe Head
85B	Lee 201 + 05C
81D	Two Lee 218 (or one Lee 203)
40M	Rosco 3304 + Rosco 3316 + Lee 191 + Lee 218
80A	Lee 204
82A	Lee 223
40R	Two Lee 191 + two 05C

These filter packs are provided as starting points for use with Fujichrome 100 and Kodachrome 64. Each film and emulsion batch should be tested for color balance, and strobe filters should be periodically tested for consistency as they fade with use. Color Polaroids are always recommended as an on-site test. If you have to shoot under unusual lighting conditions, such as mercury vapors or warm white fluorescents, if possible visit the location before the shoot and expose a test film with various marked filter packs, then have it developed and examine the results for color balance.

INDUSTRIAL PHOTOGRAPHY AS A

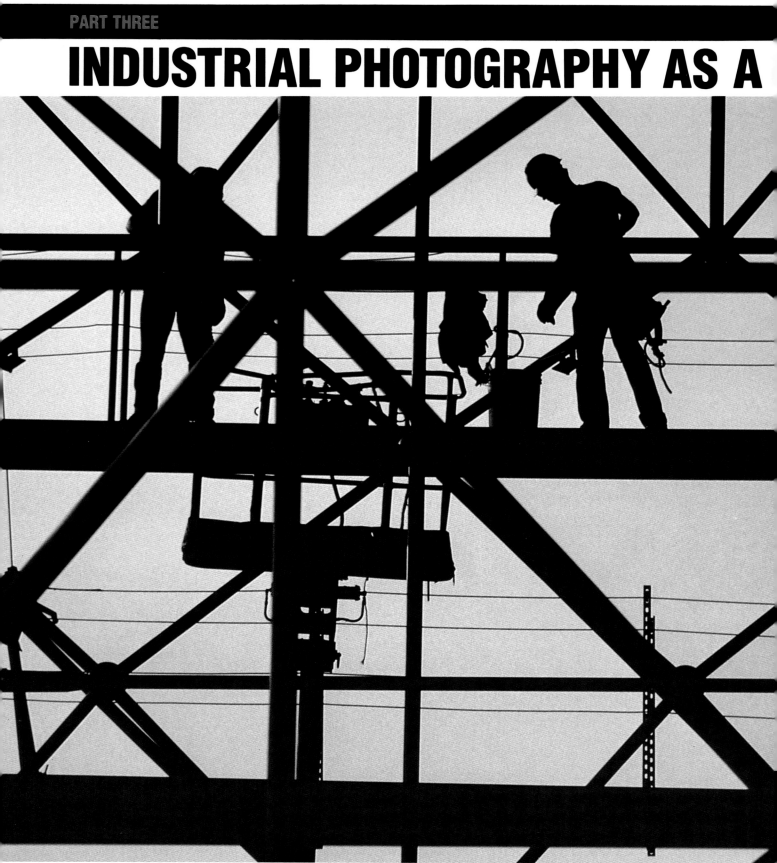

© Greg Beechler

CAREER AND BUSINESS

What does it take to be an industrial photographer? Industrial photographers are artists, technicians, and business-persons. They must express a unique visual sense in their photographs, and confidence in themselves—selling both their image and their images. They may be freelancers working alone or with considerable studio support. Or that support may be corporate, for the in-house photographer.

The professional industrial photographer understands that, to succeed in this business, every assignment must be a team effort. There is often a fine line between interjecting your personality into your shooting style, and rubbing people the wrong way. You have to know where to draw the line in this work.

The industrial photographer of tomorrow will find that a firm footing is obtained not only from simply striking out on one's own, but from working with, and learning from, experienced photographers in this field. Choices must be made as to whether one will work in the corporate environment or as a freelance; how to develop a winning portfolio; and, independent or corporate, the industrial photographer must follow procedures for business—billing and working with clients.

Most of all, the industrial photographer must understand what it means to be competitive and what should be offered to prospective clients in order to gain that competitive edge.

MAKING CAREER CHOICES

> *I always tell people that if this is not the most important thing in your life, then forget it. This business takes dedication.*
>
> — CAMILLE VICKERS

Choosing a career is never easy. And industrial photography is not an easy career to involve oneself in. It takes a strong constitution, good health, a willingness to work, and drive. The beginner in this field may already have a thorough working knowledge of the business of photography and may very well be an adept, if not master, technician with the camera and lighting.

Unfortunately, there are very few places that offer hands-on training, and sooner or later it comes down to immersing oneself in the real-life industrial and corporate environments, going into a factory or corporate facility to photograph industry at work. Even that may not suffice in this highly competitive field. Usually, the best way to achieve the kind of experience that will give you the competitive advantage is to work side by side with an experienced industrial photographer, as an assistant.

Probably the most important decision you will have to make is whether to enter the corporate milieu as an in-house photographer, knowing you'll receive a regular paycheck, or to strike out on your own in the freelance world, with all the uncertainties attached to this as to any form of business enterprise. As a freelancer, you do have the option of working out of your home and renting studio space only when necessary, which should lower your overhead. Don't be intimidated by the thought that you have to invest in studio space at the beginning—or at all.

No matter how long you've been in this profession, you will find that joining a professional organization will benefit you every step of the way. These organizations offer seminars and publications and provide services that you may not be able to get elsewhere or at comparable rates. This is just another step you can take to help your career along.

Intrigued by the patterns and textures, the photographer selected the appropriate color of hard hat and made this working portrait while on assignment at a paper mill for the Continental Group. Since this was at the end of the shoot, he had to set up his lights and make his exposures in a very short time.

"You put a few years in as an assistant and you'll pick up a tremendous knowledge of the business that would be very hard to learn on your own," observes Jeff Smith. Serving as an assistant may be a low-paying, back-breaking job, but it definitely has its rewards.

The assistant is a highly valued member of the team—and yes, assistant and photographer are a team. The photographer learns to depend on his assistant for many things. "I think it's important to have that sense of 'We're taking the photograph,'" says Robert Rathe of his assistants. "I always value that extra set of eyes. If you treat your assistants well, you're going to get a lot more from them and a lot better quality work."

As is more often the case, if he has not been dissuaded by the long hours and the tons of equip-

© Greg Beechler.

Working as an assistant may give you the opportunity to add to your portfolio or stock files. That was when this strange-looking assortment of hazard suits was photographed.

ment that had to be carried here and there, the assistant breaks new ground on his own, opening his own studio. Infrequently perhaps, but he can prove his worth to the point where he becomes a member of the team in every respect, joining the photographer he had been working for in the capacity of full partner.

The assistant is, in effect, in charge of the equipment maintaining it in good working order, keeping everything organized, keeping it from getting stolen. "They're also in charge of hanging, rigging, lighting—under my direction," notes Jeff Smith. "The better the assistant is, the less direction I have to give him. Most of the assistants I work with are those I've worked with for a long time. We go in there and I say, 'We're going to do the lighting like we did last week or like we did on such and such a shot a couple of months ago,' and the assistant knows from that how to set up, and we keep shooting Polaroids and try to refine the lighting and try to make it a little bit better. So, basically an assistant's job is to take care of the kit and keep me working efficiently—loading cameras, setting up tripods, running wires . . . whatever is necessary."

Of course, assistants don't grow on trees and photographers must find them, or as Lou Jones puts it, "Assistants find me. Good assistants I find." Jeff Smith adds that, "I get a half-dozen phone calls a week from people who want to be assistants for me. Who gets in and who doesn't depends on their perseverance, and then if I use them and like them, I continue to use them." Robert Rathe reports that the ASMP chapter in the Washington D.C./Virginia area is very active in making names of assistants available to photographers, and conversely, in making the names of photographers available to their prime employment target, the assistants.

"I generally work with one key assistant full time," says Rathe, "and may hire a second assistant on location, someone who knows the area and all the back roads, to make sure we don't run into rush-hour problems, to help get us around. The second assistant is hired in advance, based upon my assessment of the particular needs of the assignment." Rathe brings a list of possible assistants on location just in case the need arises.

If you're thinking about roughing it, without attaching yourself to a pro working in the field, heed Camille Vickers' advice. "I never worked as an assistant and had to learn a great deal on the job after taking it on and consequently I blew a few jobs at the beginning. I really didn't know what I was doing, but I was learning. I think it's a much better idea to start out as an assistant." Or as Lou Jones defines the need to work as an assistant, if you want to pave the way for yourself as an industrial photographer, "Today, that's virtually the only way."

Each assignment is a learning experience. These photographs by Jerry Poppenhouse represent assignments to photograph another plane over the Caicos Islands and an Alaskan rig in the frigid cold.

Jerry Poppenhouse, © Phillips Petroleum Co.

THE VALUE OF EDUCATION

No one will argue about the value of education. Again Jeff Smith: "It can't hurt, but I don't think you need to spend four years in college to learn photography—all that's in addition to being an assistant. A college education in any endeavor is important." Beyond college there are other educational opportunities. Lou Jones advises that "photo seminars give you a little enthusiasm and maybe introduce you to some new techniques."

Smith continues, "Basically, read as much as you can, look at as much photography as you can, shoot as much as you can, and be very self-critical. When you like a photograph, figure out what you like about it and how you can incorporate that into your own work." That's a part of education that many of us tend to overlook.

"Get as much experience as you can, wherever you can," advises Jerry Poppenhouse. "If you're going to school, work around photographers during vacations. Get as much exposure to creative thinking as you can. Expose yourself to the ballet and to opera and go to museums and look at how painters used light and communicated using the brush and the medium they worked with—that's what you're doing essentially. You're working with light and you have to be aware of light. So when you're watching television, be aware of lighting setups. You don't see the setups themselves, but you see the results. Look at good photography books and magazines and try to be well-rounded to the point where you're visually aware of things."

IN-HOUSE OR FREELANCE?

This shot of a new facility, for C&P Telephone, captures the ambient spaciousness of the interior with the use of a 16mm rectilinear fisheye lens on a 35mm camera. Getting the right angle required standing on a ladder and leaning way out over the railing.

Once you've set your mind to becoming an industrial photographer, you have to make a choice: work freelance, for yourself or in someone else's studio, or in-house, for a corporation or institution. Industrial photography has room for both, and often companies with in-house departments will hire freelancers.

It's an unfortunate fact of life that the in-house photographer, despite his talent and dedication to the job, does not gain the same recognition that the freelancer does. "The PR precedes him," says staff photographer Jerry Poppenhouse of the freelancer, "and so by the time he gets here, everybody expects great things from him." Contributing to those great expectations are the freelance photographer's reputation and price tag.

But Poppenhouse has a remedy for this situation. "I work on my own PR. I make sure the top executives see the publications where my photographs are featured. That helps to get me more respect in-house. You have to work at getting respect; you have to keep doing it over and over and over. If I can convince these people that I know what I'm doing, then I don't have all the little detours along the way that keep me from doing a good job. You try to pave the way for yourself."

Yet, there are decided advantages to being an in-house photographer. "I know that if I'm sent out to the North Sea, for example," cites Poppenhouse, "and I'm photographing for the annual report, those pictures are not going to be used just for the annual report. They're going to be used for wall decor, they're going to be used in Norwegian publications, they're going to be used in our UK office, they're going to be used in other types of publications. The engineers are going to use them and look at them to see where they can design a better mousetrap. So you have to shoot the assignment, taking all that into consideration. If you're in-house, you realize all these purposes without being told."

Of course, there are other advantages that come with being an in-house photographer, namely a steady paycheck, coverage for sick days, paid holidays, bonuses, and medical benefits, along with possibly the addition of dental and insurance benefits, and perhaps profit sharing. For the freelancer, each of these is a hard-earned privilege.

The in-house photographer also gets involved in what Poppenhouse calls "run-and-gun" photography, photographing company functions and even noncorporate events. Many corporations sponsor special groups and events, and they send their photographers to record all that. For Poppenhouse, that may include swim meets, the ballet, and even celebrities, all of which is a far cry from those nasty, wind-blown, sea-spray experiences on North Sea oil rigs.

As we said, corporations with in-house departments do hire outside photographers. There may be a sudden need to cover an event at a time when their staff photographer is away on assignment. Or, even with a number of photographers on staff, the corporate graphic designer may feel the freelancer can bring a certain viewpoint to bear on a situation. In the case of Phillips Petroleum, the need for an in-house staff is greater, according to Poppenhouse, than it would be in a large metropolitan area where freelancers abound. Yet, he does hire freelancers in his capacity as photographer and art director. He is also responsible for keeping his department well-staffed, and he periodically puts calls out for experienced photographers with impressive portfolios who are interested in chucking the uncertainty of the freelance life for the corporate lifestyle.

Some in-house photographers may find themselves involved in complex assignments at every turn. This one required the photographer to wear a clean-room suit and dark green safety goggles. The resulting image has been published around the globe, which proved ample compensation for the hours of discomfort and frustration.

The photograph on the opposite page involved a number of critical factors, not least of which was the lighting. Two strobes were directed from below a sheet of white translucent Plexiglas to light the beakers, with an additional light on the blue background. Part of the challenge was positioning the highlight on the upper lip of the central beaker just right.

The corporate lifestyle—that may be one factor that drives freelancers to operate as independent contractors. Unlike the in-house photographer, the freelancer is free to accept or refuse jobs, but like the staff photographer, he has an obligation to his client to deliver the best results he can—and on time. On these points, in-house and freelance industrial photographers are in full agreement.

One major difference between the two is that the freelancer might schedule one shot per day, possibly two or three if the locations and lighting requirements demand less time. The staff photographer will often spend less time per shot and do considerably more in a day.

The in-house person may also find himself in countless situations during the course of a week, all depending on the diversity of the company he works for. His schedule is often hectic. One in-house contributor to this book, Ken Graff with Union Carbide, once found himself on assignment in Soviet Armenia, documenting Union Carbide's contribution to the earthquake relief effort. In-house photographers may not universally have such experiences, but their days are never typical. As Poppenhouse comments, "Every day is different."

Freelance industrial photographers readily admit that this is a difficult, if not uncompromising business. Jeff Smith recognizes that "it's a very tough way to make a living, but it certainly does have its compensations, although they're a long time coming."

Ask freelance industrial photographers if they had it to do again would they follow the same profession and you hear Smith's words often echoed, "Yes, although there were plenty of times in my life when I said that if I had to do it again, I wouldn't touch it with a 10-foot pole. But yes, I would." "I'm very glad I stayed in this field," remarks Camille Vickers. "It's exciting to see your images in print, although they usually don't print the ones I like best. I wish I had more control over that end of it at times. I would certainly love to see things reproduced better. It can be kind of disappointing when you see things you've slaved over shown ¾ x ½ inch and badly printed. That's not rewarding. But to have someone come up and say, 'I know your work and it's really nice'—That's wonderful!"

Vickers emphasizes, "I always tell people that if this is not the most important thing in your life, then forget it, because that's the kind of dedication it takes to make it. Being a freelancer, you've got to be able to take rejection and uncertainty. You don't have a paycheck coming in every week. You've got to be adaptable and keep plugging at it. You can't ever just sit back and think, 'Oh, I've got clients, I've got it made.' You've always got to keep pushing yourself and promoting yourself and trying to do new and different things and not get into a rut in the way you handle work."

© Lou Jones.

SOMETIMES THE TWAIN DO MEET

One in-house photographer related how he'd had to show a freelancer around the facility he works in and instruct him in the techniques that he personally developed. He admitted to at first feeling awkward, if not aversive, to the idea of giving an outsider this information, but one lunch and several cups of coffee later, he began to sympathize with the other photographer and gladly helped him.

Freelancers sometimes find themselves in awkward positions when there's a photo staff at a facility that is perfectly capable of doing the job. In the situations that he's run into, Jeff Smith has found, as obviously the photographer referred to above did, that in-house people can be very helpful. "They generally realize, sometimes with a little resentment, the reason somebody from outside has been brought in is because they (the staff photographers) have a lot of constraints put upon them. They have to live with the executives and workers for the rest of their lives. I've got to live with them for that day, and I find that I can be a little bit more insistent—and sometimes generate a little bit more support—than the in-house photographer can because I've got corporate backing. I try to get myself a letter from the chairman of the board. Or at least the word comes down from the chairman to cooperate with this person; we're paying him too much money to waste his time. So I go in there with a great deal of clout, at least hopefully. I find the in-house photographers to be very helpful, and whenever I can, I share my thoughts and techniques. We talk shop a little bit if we've got the time to do it, and I try to be as helpful to those photographers as I hope they're going to be to me.

"Sometimes when they know I'm coming in," Smith continues, "and they know I'm going to need specialized things, they'll come over to me. Some in-house photographers know how to do stuff I don't know how to do, and it's very helpful to me to pick their brains. For example, when I was photographing a missile shoot, I was able to call upon the people who shoot these things all the time, and they helped me execute the shot successfully. That kind of help is very much appreciated, and since it's not something I do every day and they *do* do it every day, I find there's a lot of information to be learned from the in-house photographers."

JOINING A PROFESSIONAL ORGANIZATION

Professional organizations provide health-care benefits and insurance programs at somewhat reduced rates, compared with programs that you could get as an individual directly. But more important than that are the channels of dialogue that you open up with your fellow photographers. Members from one state or region can call fellow members in another area of the country when an assignment takes them into the other person's backyard. And the really nice thing about this business is a photographer's willingness to help other photographers. Sooner or later, you develop close personal ties with other photographers and you share information. When you need help with a certain technique, there is someone to turn to.

Membership organizations are also helpful for other reasons. They publish their own magazines, newsletters and other publications. They may even provide a legal and business hotline as a free service or for a nominal fee. They also have their own legal counsel whose fees may be more reasonable and the attorneys are certainly more knowledgeable about your business than most generalists or nonphotography-specialists.

There are several principal organizations that industrial photographers can join to help them in one way or another. Two are the ASMP, the American Society of Magazine Photographers, and PP of A, Professional Photographers of America. ASMP appears to have a stronger following among the freelance photographers I talked to, whereas the PP of A has an Industrial Division that is devoted to in-house photographers. PP of A Commercial Division also caters to freelance industrial photographers. Another organization, APA (Advertising Photographers of America), focuses on photographers shooting ads for the print media. Since freelance industrial photographers may find themselves doing such work, this may be an organization worth considering.

In addition to its national headquarters, each organization has local and regional chapters that you can join. It's often much easier to attend regular meetings held locally, or even regionally than at national headquarters, though special events may be held where the national office is located.

Each organization also has its protractors and detractors. Generally, because of the fees involved, and occasionally the time to participate in membership functions, it makes little business sense to join every organization, although some photographers may be active members in more than one. As with other areas related to your career as an industrial photographer, you should collect and read all the literature you can and talk to photographers, members and nonmembers alike. Look for differing opinions and make your choice for the potential benefits, not the stigma attached to one organization or the other. These and other organizations have made great strides toward promoting the welfare and improving the business climate of photographers and photography as an industry.

WOMEN AS INDUSTRIAL PHOTOGRAPHERS

In interviewing both freelance and in-house photographers about the question of why there were so few women in this business, the answer I received was pretty much the same. Women were excluded from various work environments as part of the labor force and were consequently excluded as part of the creative team that would be sent to those work environments. Undoubtedly, misguided opinion about a woman's ability to take pictures under the sometimes extremely harsh conditions that an industrial photographer encounters led corporate clients to shy away from women photographers.

But both the work place and people's opinions have changed. No, the work place is not necessarily less difficult to deal with, but the people working in or overseeing those areas have come to realize that a woman's place is as much in the industrial environment as it is any place else in the business world.

Prejudices against women industrial photographers did exist, as Camille Vickers will attest to. "I had designers, for instance, tell me that they wanted to use me on an assignment, but the client did not want a woman coming to photograph their factory, because it was out of the norm. But that has changed rapidly, because women have proven that they can do as good a job as men. There were some superstitions about women on drilling rigs and similar ideas in male-oriented industries."

As Greg Beechler points out, helping to overcome the negative stigma is the fact that there are also more women in the corporate structure. Moreover, there are more women in the graphic design field, and designers are the people to whom photographers often turn for work.

On assignment at a paper mill, the photographer was quick to realize the strong aesthetic value this image would make.

KEYS TO SUCCESS

The portfolio is proof both of your willingness to work and of your ability to deliver results.

Industrial photographers use a variety of means to get their names out to prospective clients. The portfolio is one, tear sheets are another. And both, whether submitted together or individually, can be effective. There are additional methods, which include custom-designed mailing pieces. But the approach that is almost invariably followed by the pro is advertising in any one of several source books that graphic designers, art directors, and corporate users of images refer to when looking for the right talent to portray their companies or clients.

Your first step is to get that capabilities statement across to your potential clients, just as your clients attempt to do in the print pieces they hire you to shoot. You've got to decide how the portfolio will look for presentations and how to present yourself, to give clients a reason to knock on your door and ask to see your portfolio or to invite you in to see them.

Of course, getting your own capabilities statement across to prospective clients may be easier said than done. If you're just starting out, you have to build up a body of work good enough to put in a portfolio. Then you have to decide how to shape that portfolio to give it a look that reflects experience and professionalism by editing the pictures and packaging them to advantage.

Finally, you have to recognize the resources available for you to promote your work. Some paths can take an expensive turn, but not all do. Find the ones that fit your budget. Winning competitions and getting your work published is a good start.

This started as a black-and-white photograph originally shot for a client. The screen was black for type to be dropped in. To make this a winning portfolio picture, the photographer added the computer face through in-camera masking.

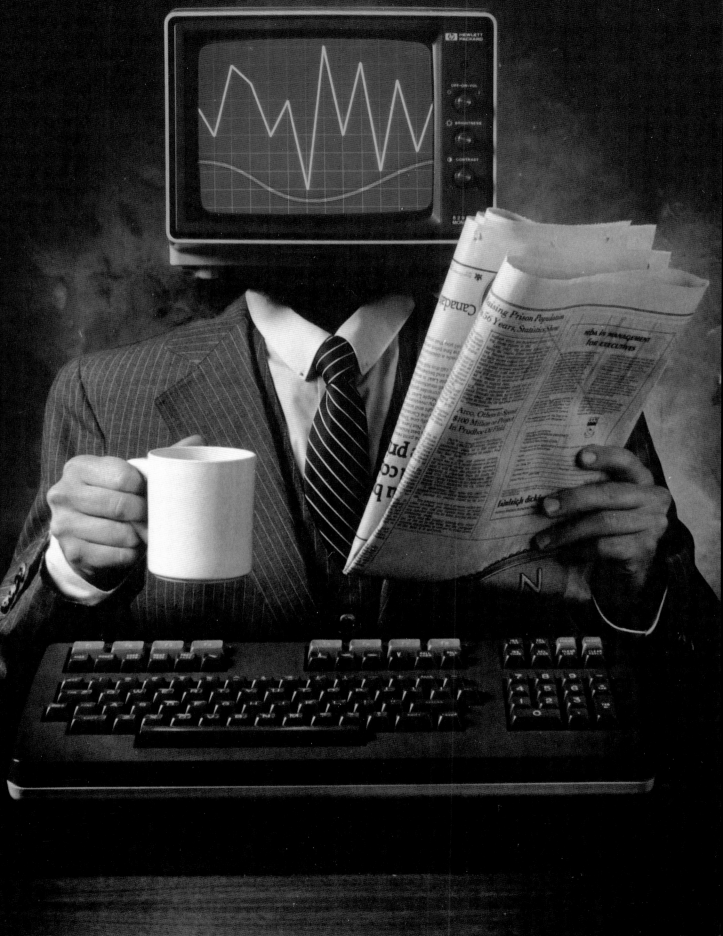

THE ALL-IMPORTANT PORTFOLIO

The photographer's portfolio of work is the key that unlocks the door to countless assignments. But winning portfolios are not found, they are made—with diligence, care, and a sense of perspective of what is relevant to the world of industrial photography.

But do pictures have to be strictly of industrial subjects to produce results? And what in particular should the portfolio look like? Most important, where do you go to take the pictures to put into that portfolio? The questions seem endless and the industrial photographer, whether he's got 15 years in the business or just starting out, does not take his portfolio lightly.

The portfolio weighs on the photographer's mind each time he goes out on a shoot, looking for more images—newer work to update that portfolio. He does not take for granted that just because he knows how to take pictures that someone will hire him on good faith.

The portfolio is more than just a collection of images: It's proof of a willingness to work, an ability to deliver results, and, when it includes published pieces, an affirmation that a prospective client is not alone in appreciating your good photographic eye.

Shot from a light plane, this aerial view depicts a coal tipple at a Wyoming mine. This photograph represents part of the diversity of images an industrial photographer may be required to shoot to successfully compete in this business.

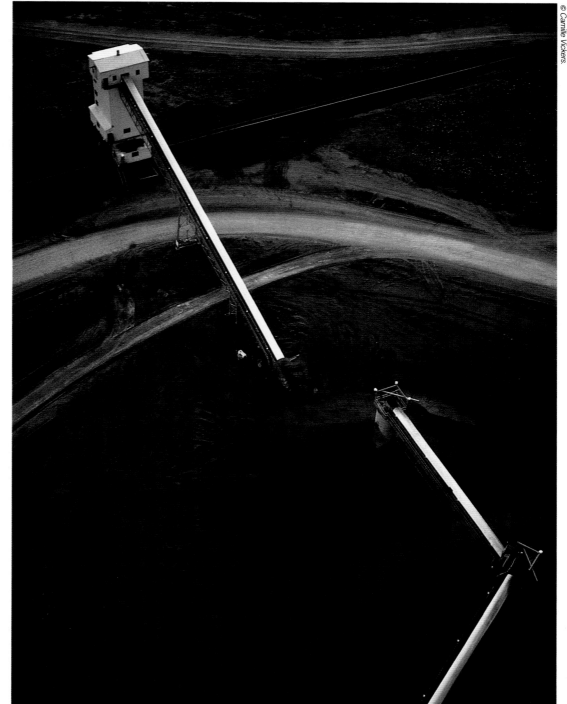

© Camille Vickers.

© Jeff Smith.

WHERE TO GO FOR PICTURES

The best advice is always the most direct and most practical. Jeff Smith suggests, "The best thing you can do is go to a local industrial facility and offer the public relations director (or someone in that capacity) that you'll shoot for expenses and that he'll get use of the photographs. Get as much co-operation as possible, even finance the job yourself, if necessary. Develop a very strong sense of composition and graphics. I think that in industrial photography, that's probably about the most important thing you can do."

Lou Jones adds that you should "shoot things that you like. I can't emphasize that enough. I take pictures that are from my own head and I make them work for me. That's what really makes the portfolio strong. If you have an editorial bent to your photographic style and you go out and take good editorial photographs, somebody will find a way to use that quality in an annual report or other industrial assignment some day. The worst mistake you can make is to try to shoot the standard things people think *belong* in a portfolio." Jones further recommends that photographers interested in this field do audiovisual work. "That gets you in touch with a lot of industrial situations on a faster, more prolific basis."

Opportunities to shoot for your portfolio arise at every turn. Camille Vickers believes that a good portfolio can be generated while studying photography in school. It involves "creating your own assignments, going out and doing things that aren't necessarily given to you—something you make up and follow through on your own." As we said at the outset, it takes initiative and drive.

The photographer took advantage of the direct sunlight and the shadow pattern it cast from the netting onto the men and the van to create this intriguing photograph for his client, Raytheon.

EDITING YOUR PORTFOLIO

The easy part is going out and shooting to your heart's content. The difficult part is to go through those photographs and decide which ones go into your portfolio and which ones do not. If you're pulling together pictures from jobs you've shot, you may want to include not only the most aesthetically pleasing compositions, but also the ones that were a "hitch" to light or that posed other photographic problems.

"I think a good portfolio has to show some kind of consistency," Camille Vickers recommends. "I don't think somebody starting out can show a portfolio that's got a tremendously wide range of things. I think it's important to keep it simple and short and to show very, very strong images of consistent quality, rather than show too much and too many weak images."

Build up your portfolio as gradually as you can with your best work and get advice from the professionals out there, advises Jerry Poppenhouse. "Weigh each photographer's opinion and put what you think is your best work in your portfolio. If you can only get a job for the summer with a newspaper, that's good experience and good exposure. Take the best things from that job and the best things from the people that you worked with and keep building on your portfolio."

The portfolio must go through a regular review process, about once every six months. You have to establish criteria, set standards for your work, learn when to say no to an image that may be a favorite but one that does nothing for your portfolio. You have to learn to be self-critical, to look deep down inside yourself and examine your motivations for putting a certain image into your portfolio. On this subject Jeff Smith observes that "some people make the mistake of showing too much mediocre stuff. I think that a very good guiding principle for any image in your portfolio is to ask: " 'Is it the best one I've ever seen, or is it better than any of my competitors have?' " And if you can get a portfolio filled with those types of images, you're going to get a lot of work." Makes sense to me.

Do you tailor a portfolio to impress a prospective client? The pros disagree on that point—to a degree. "If I have a client that I really want to work for and I know what kinds of things they do, I usually try to include something that is especially appropriate to them," says Lou Jones. But that does not mean that Jones will tailor his entire portfolio. "My feeling is that I show my best pictures. I show pictures of things I want to do, and, hopefully, a creative person will see that a picture of an orange will be appropriate for the apples that they're trying to sell. I find it very disturbing that people will put pictures of computers in a portfolio when they go to a computer company. I shoot probably 60 percent of my assignments for high-tech compa-

© Lou Jones.

Created in the studio for self-promotional use, this image required that the copper tubing be custom-fabricated. Careful lighting added to a carefully composed simulation of an industrial environment.

© Robert Rathe

While on assignment at this power plant, the photographer noticed two workers walking in the distance in the early morning light. He took the opportunity to make several exposures.

nies or companies that have computers involved in their operation. But I do not have a picture of a computer in my portfolio, and I refuse to put one in there because those pictures are rampant." And now here's the clincher: "I put in the work that I want to do, rather than what I think they want me to do. Because if I put pictures that they want me to do in my portfolio, that's what they're going to ask me to do." In other words, let your portfolio reflect your approach to photography. That's how the pros become known for their personal style.

That, however, doesn't mean that you can't tailor the portfolio to reflect the kinds of subjects your prospective client expects you to shoot. "We have different slide trays," Vickers notes. "We have trays that are mostly people or that are mostly scenic/travel-type images, or that are heavily industrial—because people usually want to see something more specific. I like to show just a general portfolio, but you can't get away with that all the time, especially if someone says they just want to see people.

"I agree that there is a danger in trying to be specific," Vickers continues. "It's a real Catch-22 situation: It works both ways. You show somebody great work, and if it's not *exactly* what they're looking for, then they won't hire you. If you show somebody *just* what they've asked to see and nothing else, then they think you don't do anything else and they won't hire you."

Jeff Smith doesn't agree that the portfolio should be tailored, at least not appreciably. "I figure that anything the client is going to want he's going to see in there, and he'll also see the versatility that I've got. If he indicates a need for executive portraits, I may add an extra 10 executive portraits to show my versatility in that area. But I believe in the general portfolio as opposed to the tailored portfolio, because you can sell to a broader range of clients. If you show the client the whole portfolio and you don't get the executive portraiture job today, he may say, 'I've got an industrial job next week, let's use him for that.'"

These are perspectives geared toward getting freelance assignments. The person applying for an in-house job doesn't show a portfolio as something that will simply get him an assignment from day to day, but to convince the person doing the hiring that he's the man for a full-time job. In that case, what do you need in your portfolio?

As head of his photography department, Jerry Poppenhouse must hire staff photographers when the need arises. "You're only going to see in the portfolios what the person trying for the job thinks his best work is. Here you don't see all the 'run-and-gun' shots that the in-house photographer has to do: the client handshake, the holding-the-plaque-up, the smiling faces, the retirement parties, the holding-the-wine-glass. That's all part of it. A great deal of our time is spent doing those kinds of shots or getting somebody else (a freelancer) to do them." If you've got any photojournalism experience, let your portfolio reflect that experience if you want a staff position.

PUTTING IT TOGETHER

Now that we've seen what kinds of pictures go into a professional portfolio, the next item on our agenda becomes putting the pieces together in an effective, attractive package. The physical makeup of the portfolio can make as big an impression as the pictures themselves. If your portfolio consists of pictures with bent corners, cardboard mounts with frayed edges, or too many or too few slides, these things will reflect negatively on your professionalism.

No one said you have to go out and buy an expensive portfolio case, but there are certain guidelines you should follow when deciding what goes inside whichever case you buy. As it turns out, different photographers approach the problem in different ways. Judge for yourself what works and what doesn't. All I can add is that the approaches outlined here do work, which is why these photographers are working.

To begin with, a portfolio usually consists of a slide tray of about fifty 35mm slides, dupes of course. There is, however, always the possibility that your prospective client doesn't have a projector, which means that a tray is useless. In that case laminated 11 x 14-in. or, better yet, 16 x 20-in. mounted prints, or prints in a vinyl-sleeved loose-leaf-type portfolio, and possibly 8 x 10-in. duplicate transparencies will be impressive enough. Graphic designers are the people who have projection facilities. Advertising agencies would rather look at the 8 x 10 dupes.

Portfolio cases can be bought in any art-supply store. Photo shops sometimes carry them, but they may not be as good as the ones you buy in art stores and might even cost you more. There are notable exceptions, however. I've seen a well-made nylon portfolio case made by a company specializing in photo luggage—and yes, photographers use it. The good thing about nylon is that it cleans easily and doesn't show wear the way even a good leather case can. Perhaps most important, it's highly protective of your precious work inside.

RESOURCES FOR PROMOTING YOUR WORK

"Generally I can figure on doing two to four really great annual reports a year. I send them out with a letter explaining what the objectives were and how they were achieved, the problems I ran into, what new techniques I used to execute them, and so forth. I try to inform people about the services I can provide for them." That's the approach that has worked for Jeff Smith, together with source book advertising. It's sound practice. Remember, never underestimate the value of promotion, and let your work speak for you.

There is an odd thing about showing portfolios to prospective clients though, as Robert Rathe explains. "You can go in to see somebody with your portfolio six months before they've got work, and they may really like your work; but in those six months, 50 other photographers have been in to see them, 40 of whom they've also liked." So your name slips through the cracks. But, just as in the rest of the job market, your "resume" may land on someone's desk just when discussions are being undertaken to shoot a brochure to promote a new facility. And all other things being equal, you may have just landed the assignment.

Getting as much good exposure as you can won't hurt in your endeavors to win over prospective clients. Obviously, word of mouth will precede you in many circles and having a professional attitude at all times is a step in the right direction. But beyond that, you should keep an eye toward any reasonable avenue of exposure. One of these is photo competitions.

Several of the photographers featured in this book brought attention to their work by successfully entering photo competitions. You submit your own work in a competition and hope that the judges agree with you that what you created deserves merit. The judges don't always agree with your opinion of your work, and sometimes inexplicably, but you press on to the next competition and the next. You don't do it merely because a graphic designer will pick up a copy of a photo magazine and see your winning entry but because that piece goes into your portfolio or becomes the focal point of a special mailing that goes out to graphic designers and other potential clients.

There are other competitions that you enter indirectly. Graphic arts magazines sponsor annual reports or other print media competitive events and here it is up to the individual graphic designer or design firm to submit samples of their best work. And if your photographs are part of that—and win—all the better: You've just added another piece to your portfolio.

Unlike competitions, which involve little cost outlay, print advertising in an annual, often called a "source book," is an expensive, albeit necessary, proposition. These can run several thousand dollars for a single page, and some photographers even go to the expense of buying two pages. But there is the added benefit that your money also pays for a limited, but sufficient, number of "tear sheets" from those ad pages. You can send these to clients or include them in your portfolio as what Lou Jones calls "leave behinds."

"I think they're valuable," remarks Jeff Smith. "If nothing else, they show the flag, they can help you sell stock, and there are clients who use them. I

find the *Black Book* to be the most valuable, and it's really the only one I'm advertising in these days."

There are several different source directories being published these days. The *Creative Black Book* that Smith referred to probably stands out in most people's minds, but volumes such as *American Showcase* and *Corporate Showcase* should not be overlooked. These two are less expensive to advertise in than the *Black Book* and reproduce your work in a larger format.

"Leave behinds," those tear sheets from source book ads, are the most effective business cards the pro can get working for him. Robert Rathe sent some to a magazine art director, and she recommended him for this book. Talk about effective tools! Camille Vickers also recommends adding a sampling of printed pieces, where her work is featured. She sent me a magazine where one article featured her work. I was sold. She also recommends including copies of brochures and annual reports, "which I like to get back, of course." These are all promotional tools that become part of your portfolio.

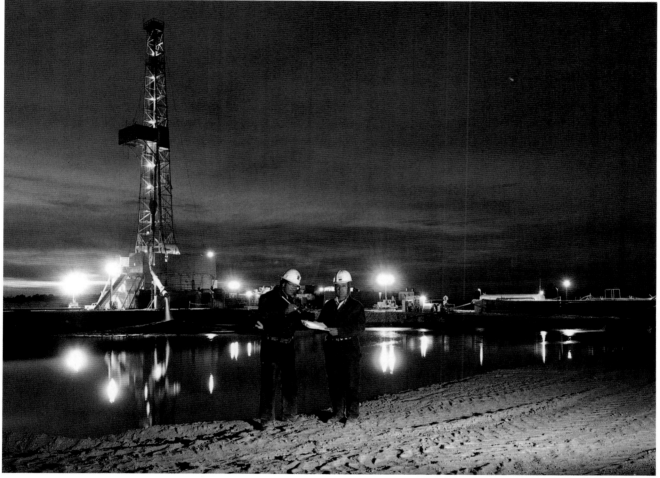

© James E. Stoots, Jr., © LLNL.

This is a good example of a portfolio photograph, since it represents the photographer's initiative in being able to go out to a site and photograph a single element that captures the essence of an industry.

Assigned to photograph this drilling rig at the Nevada Test Site, the photographer used a Hasselblad and a handheld Metz flash to combine available light and flash-fill.

ESTABLISHING A BUSINESS PROFILE

If you don't come out of an interview with a job, come out with names of people interested in seeing your work.

JEFF SMITH

The most difficult part of any business is finding the people to do business with. Industrial and corporate clients are all around you, but it's like a pilot flying an airplane. He may have all the expertise needed to fly the plane, but he still needs guidance for takeoff and landing. What follows, then, is not a flight plan. That was actually laid out to you in previous chapters. Here, instead, are instructions that will get you off the ground and land you the jobs necessary in your career as an industrial photographer.

There are, of course, no guarantees. You're the one sitting in the pilot's seat. If takeoff and landing are not as smooth as you may have wished, consider looking to yourself to see where the fault lies. Not every client will take to you and you won't take to every client, but if you find yourself losing out to your competitors too often, it may just be necessary to go back to flight school for a refresher course.

Whether you go into business on your own or work in-house, you have a responsibility to manage the studio or at least contribute toward its efficiency. All the takes from your most recent shoot must be promptly edited and sent to the client; the client must be invoiced and overdue accounts must be tracked. You have to keep records and maintain those records for any auditing procedures that may follow, whether your own, the company's internal audits, or tax-related. It's a potpourri of responsibilities, but the successful industrial photographer has all that under control. Business management comes with the territory, once you label yourself "professional."

The industrial photographer must understand his client's requirements to produce the most effective photograph. In this case, the client did not want an overly literal image to represent the chemical etching processes of one of its divisions.

Lou Jones summarizes the concept of the industrial photograph by noting that "it's a photograph that's usually used by someone who has an idea to sell or a product to sell or a process to sell. The end uses can be anything from hanging the picture on the CEO's wall to public relations and everything in between that."

For both the in-house and freelance photographer, the wide array of applications remains more or less the same. Each takes pictures for a purpose, to promote a positive image of the corporate employer/client. And those photographs will find their way to many print media, corporate and noncorporate.

One of the principal uses of photographs is the annual report. Perhaps nothing else provides the corporation with the opportunity to speak well of itself. The annual report is, after all, a statement of profits (losses aside) and a continuing update of the company's progress in existing and new fields of endeavor. And most, though not all, annual reports are visually supported with any number of photographs, most often in full color, but occasionally in black-and-white.

For a manufacturing enterprise, that annual report encompasses photographs of its array of products; a service facility may be more people-oriented. But for both there is considerable attention drawn to the executive body, with a focus on people alone, in groups, or in conjunction with a manufacturing site or product. And the images have to be on the money for them to repay the corporation's financial outlay, as well as its investment in time to hire a photographer or take time out of busy schedules to cooperate with shooting requirements.

Part of a corporation's positive image rests also with the work it does for its employees and the community—local, national, or global—it is part of and in many ways supports. Concomitant with that are house organs and newsletters and more globally publicity and public relations. These are often a function of the in-house photographer. Publications for employee relations may feature employee functions and sports activities, the employee of the month, or other meritorious events. Publicity and public relations photographs are similarly the domain of the in-house photographer.

But no one has exclusive rights. The corporation may feel that a freelance photographer, who is noted for his personal style, might benefit the corporate image if he interjects that style into those pictures for those purposes.

There are other in-house functions for industrial photographs. Personnel training is one. Here the corporate image gains indirectly from the photographs, which are used to educate workers in proper work procedures, often with an emphasis on safety. These photographs are less often striking images than they are functional images, designed to present a message.

Another in-house function is documentation. The audience for these photographs may be more selective and more limited, owing to the increasing sensitivity of the subject matter. Documentation may be used to present visual support for product failures, but it is just as routinely used simply to document a work in progress, for better or worse. Without this routine documentation, there may be little foundation to support or deny a claim that led to a project failure or to identify a possible structural flaw that would have otherwise gone unnoticed by observers.

Then there are also photographs made for audiovisual presentations and promotional materials, namely brochures and catalogs. Audiovisual presentations may serve an in-house function or they may be used to present the various aspects of the corporation, a new product or service, to those outside the corporate circle. Or these presentations may be used to educate, although film and videotape, at times encompassing elaborate multimedia productions, will more than likely be used for this purpose. And the staff photographer may be the one responsible for the cinematography or videography, if the job calls for either.

In the corporate and industrial milieu, one type of promotional brochure stands out: the capabilities brochure, which defines a product or service offered by a corporation and outlines its "capabilities," its benefits and applications for use in other industrial and business environments. These, along with annual reports, can be considered the creme de la creme of industrial photography assignments.

But there is a major difference between capabilities brochures and annual reports. A corporation is legally bound to publish an annual report; it is not legally bound to produce a brochure. That further means that once set in motion, the annual report must follow a schedule, since the law further requires that it meet specified deadlines. It also means that there are periods of the year that are ripe for annual reports, which generally come out in the middle of March.

"The peak season used to begin after Labor Day and would reach its peak between the end of September until mid-January," Jeff Smith notes. "Nowadays, the season has been pushed back and contracted, so the real trick in this business is to fill up the August through October months: Start the season early and end it late. Chances are very good that you're going to be working five or six days a week between November and January, except for the major holidays, periods which eat pretty heavily into this contracted schedule."

Another reason for the late start to the annual

report season is that printing technologies have improved to the point where less lead time is required to produce an annual report.

Unlike annual reports, capabilities brochures don't generally have a deadline, unless there's some kind of a sales meeting, so they may get pushed back. The chances of publication on a brochure are a little less than for an annual report.

There is even less of an obligation to produce photographs for interior decoration. Generally, photo decor is an incidental, where the corporation makes use of photographs already taken. Corporations use photo decor to line the walls of reception areas, meeting rooms, cafeterias, hallways—any place there is empty wall space where the corporation's image can be well represented.

The president or CEO may want some of these pictures for his office as well. Decor projects can be simple or extensive, relegated merely to framed photographs or more elaborately involving a complex array of large photographs specially mounted, or even wall-size photomurals. Prudent in-house photographers spread their work around a facility by recommending selected photographs for display. For that matter, the staff photographer will find, in particular, that his photographs can be used any number of times, with wall decor being one of those many uses. And, unless a freelance photographer is hired to shoot a display photograph, for trade booth usage, for example, photo decor projects generally fall upon the in-house photographer.

For this self-promotion piece that later sold as a stock photograph, the photographer combined a toy eye and a computer floppy disk in a double exposure with the text, shooting with a 4 x 5 camera. He lit the eye and floppy with a key light augmented by a spot to the right of the disk for an edge-lighted effect. The lettering was backlighted on a light box, taking on a neon-like appearance with the aid of a fog filter.

© Paul Prosise.

KNOW YOUR CLIENT

Whom are you working for? Whom do you identify as "the client?" The answer is not that simple. What complicates matters is that the client is often two firms that you're working for, one directly, the other indirectly.

Freelance industrial photographers may work directly for corporations or for graphic designers hired by the corporation. Or the corporation may have an in-house designer. When a freelance graphic design firm hires you, it's analogous to your hiring an assistant: The assistant works for you, but you're both serving the needs of your client. Similarly, it may be the independent designer or the art director assigned to the project whom you answer to directly, but your principal concern always lies with the corporation at the top of the pyramid.

Even in-house photographers will work for both in-house and freelance designers, whomever those in power decide upon for the present annual report, brochure, or other print media project.

There is one more avenue open to the industrial photographer: the ad agency. Industrial photographers shoot ads that may not be as glitzy or as gimmicky as those we see in many of the consumer magazines, but they are every bit as well conceptualized and executed. Robert Rathe comments that "lately, I'm doing a lot more work for business-to-business advertising. It's a similar look to corporate photography for collateral use and annual reports but is sometimes aimed at a slightly different audience. Sometimes it's a high-tech look for a trade ad that's being targeted at a specific audience, for example, users of computers."

THAT IMPORTANT FIRST CONTACT

The biggest obstacle to developing a successful career as an industrial photographer is finding and contacting clients. Oddly enough, clients almost do grow on trees, but you're never sure which are ripe for picking and which aren't, or which ones have already been picked.

But you have to start somewhere and the best starting place, once you've got your portfolio put together, is just to make cold calls. Start locally, in your city or in a neighboring city. Your first inclination may be to take small jobs and work your way up, but Lou Jones advises against that, because once you start doing low-budget work "you get typed doing that kind of work." Jeff Smith notes that "it depends on the area that you're in," adding, "but basically send out a mailer and then cold-call—or just cold-call."

One possible starting place is your own business telephone directory, for ad agencies and design studios. There are also magazines that cater to art directors and graphic designers, principal among these are *Print* and *Communication Arts*. The AIGA (American Institute of Graphic Arts) publishes lists of designers. There are annuals, there may be a local art director's club that lists art directors and the design firms they work for, there's the *Art Director's Annual* (Madison Square Press) now in its 67th edition, and then there are newspapers and magazines that list top corporations. There are also publications that feature the best published work during the preceding year. You can never know which designers are potential clients until you call to find out.

The key is to just pick up the phone and start calling people, asking for interviews, asking for an appointment to show your portfolio around to as many people as you can. Don't expect people to drop everything to make time for you, although some will. And learn to expect rejection. Don't forget that any creative endeavor has its followers and detractors. Some people will like your work, others will hate it. But show it around. Don't stop. "And talk to a lot of people, pick people's brains," advises Jeff Smith. "When you go in for an interview, if you don't come out with a job, at least come out with the names of four or five people who might be interested in seeing your work. Always, whenever you pitch somebody, always come back with something, even if it isn't the job." That's experience speaking. Camille Vickers agrees: "Constantly ask designers that you meet if there's someone else that you can show your portfolio to. There are always new people, always people breaking away from firms and starting their own.

"It's rare that I go directly to a company," Vickers continues. "I don't have the time to do that. I try to see all the designers that I've worked with, or want to work with, once a year, at least, or maybe call them one other time in the year. I think sending them things on a regular basis—copies of the ads we do, self-promotion pieces—helps. If we can get a couple of cases with copies of something we've done, like an annual report that turned out especially well, I might send them around to a selected group of designers."

Admittedly, going door-to-door, so to speak, from corporation to corporation can be fatiguing, and it is certainly time-consuming. Many pros, as Vickers has stated, don't have the time to do that. Instead, as the pro gets busier and busier he may, more and more, turn to designers, since designers have access to a wider number of open doors—and getting through theirs may open others for you as well. Another option, not necessarily mutually exclusive by any means, is to use a rep—a photographer's representative.

You can make a presentation to a client in several ways. "It depends on where the client is," says Jeff Smith. "I generally don't do my own presentations because I'm on the road a lot. My rep/business manager will often do it in person. Or if the person is a considerable distance away, we'll send the book (the portfolio consisting of tear sheets, a tray of 35mm slides, and printed samples) via Federal Express, and then if the person's interested, we'll talk more."

WORKING WITH CLIENTS

"I think that one of the most important things to understand is that the art director is your friend." Jeff Smith's words may be the most important you will read in this book. It is the art director that you work directly with in many, if not most, cases. He's the person who gives you the work, and if he's unhappy with your attitude, he goes somewhere else the next time. It is vital that you adopt an attitude that is friendly, cooperative, and most of all, professional if you want to stay in this business—or any business, for that matter. "It should be a team effort, where everyone is moving in the same direction to get the best results possible," Smith adds.

"Usually the client tells me what he wants to accomplish," Smith continues, "and then I try to make a shot for him that will accomplish it, and I try to take every shot 110 percent, time permitting. I try to give my clients more than they thought they could ever get out of any situation. I want to knock them dead. I want to go into a black hole and turn it into a palace, and often I do."

Jerry Poppenhouse, in his dual role as art director and photographer, observes that what is important to him when he sends photographers out on assignment is the versatility they give him, that and on-time performance. Out of seven photographers he sent out on one particular assignment, two went the extra mile, providing additional data surrounding each shot and producing various viewpoints, from different camera angles. What that tells Poppenhouse is that he doesn't have to worry about the client, in this case a division of Phillips Petroleum, complaining. "If the client, who's paying the bill, doesn't complain about the work, it makes my job easier." It also makes it easier to justify the freelancer's price tag the next time Poppenhouse decides to hire him for a job. "It gives me an added device to use to argue his case for him." What Poppenhouse the art director does not like is exemplified by this: "I had one photographer who just shot wide-angle views. Every shot looked like he'd just gotten a brand new wide-angle lens."

What it's like to work with clients can best be summed up by Lou Jones: "The nicest thing about this business is the association between a good art director and a good photographer and that unexpected quality that you get when you're dealing with each other."

© Ken Graff, © Union Carbide Corp.

To show that a chemically-treated book could withstand moisture, the photographer set up a fish tank in which he anchored the book. He lighted the setup with one small overhead strip light and added fill cards, one on each side. The toughest part was getting the fish to pose just right.

BILLING CLIENTS IN-HOUSE

In-house there's almost always a charge-back procedure that staff photographers follow. How this works can best be described by Jerry Poppenhouse: "We operate more or less like a freelance group. The department I'm in is called Corporate Affairs, and all the other departments in the company and subsidiaries are clients. All the other people that aren't even connected with Phillips are clients.

"Other departments submit a charge number and that is put on an invoice/photo work order, which has all the information we need to do the job. When the job is finished, all the expenses are charged back to that department."

All in-house photographers work within a budget. Ken Graff explains that charge-backs within the company are credited to his department's budget and that helps pay the rent, which is charged against the photo department's earnings within the company. Helping to keep the photo department profitable is the photo lab. As with any department, the photo department in a corporate facility has to justify its existence and support itself.

BILLING CLIENTS: FREELANCE

For the freelancer, procedures for billing the client are similar to those outlined by Poppenhouse, but because he is an independent contractor with his own overhead, things do get a little more complicated.

Jeff Smith advises that you ask for an advance of a third up front, before the job starts, and perhaps another bill halfway through the assignment, with final payment on completion—after there are no more expenses to be tacked onto the bill.

Some freelance photographers do not make it a practice of asking for advances. Others, such as Camille Vickers and Greg Beechler, qualify this practice of asking for an advance by noting that "it depends on the job. If it's going to be a lot of travel, a long job, a job where we'll have to buy a lot of supplies or pay models, then yes." Robert Rathe's own variation on this theme is to offer the client a choice: The client can pay an advance or he has the "option of a 10 percent markup on travel expenses instead. Some companies just don't have it within their accounting system to give you an advance."

There are options. Nothing is carved in stone, but consider what Lou Jones has to say on the matter: "If we have a new client, we're likely to get something up front, but for most people, we become the bank." But he adds, "We're very meticulous in our billing processes."

As a freelancer, you must determine your fee, making sure that it is competitive with other freelancers in your area. Fees by and large depend on experience and reputation. But your studio location may affect those rates, depending on your overhead at that location. And all other things being equal, locating your studio in a prime location such as New York City may produce rates higher than in other parts of the country. There's that stigma attached to this town that, to some eyes, can work for or against you, depending on a client's personal experiences or word of mouth.

Just starting out doesn't mean you have to charge outrageously low rates. If you stop and think about that for a moment, there's sound reasoning behind pricing yourself competitively instead of trying to underbid everyone around you. Look at it this way: If someone you didn't know offered you a brand new European sports car for half the market rate, would you jump at the opportunity, or would you stop and consider the matter, possibly shying away from a deal that "looks too good?" The same applies to the competitive marketplace in business. Sure, you may get some small jobs, but you may never land the ones that add punch to your photographic portfolio. Or to your financial portfolio.

There is, of course, the other side of the coin: Not every type of assignment is high-paying to begin with. There are the "glamour" assignments, principally annual reports and capabilities brochures, and there are the not so glamorous assignments, often for in-house publications or publicity portraits or audiovisual presentations. The greater the value the corporation places on the end use, the higher the price you can demand.

The big-money projects, in particular, are the annual reports that last from one to three weeks and more. But many shoots last only a day or two. "But you can't get by without all those little days here and there," Camille Vickers points out. That's especially true in light of the fact that the peak season for annual reports is so short.

A lot is riding on the client's budget, which is not always revealed to you up front. "Usually it's a funny kind of cat-and-mouse game," observes Lou Jones. "They should tell us what their budget is, but what they do is say, 'What is this job going to cost?' which is very reasonable. But what happens is that you go through a long, drawn-out process of figuring out how much the job should cost, and if you're not even in the ball park, you've just wasted a lot of time. So if they say, 'We want ten photographs and we only have a thousand dollars to spend,' I can say, 'Thank you, I'll keep you on my mailing list.' If they say, 'We want ten photographs and we have thirty thousand dollars to spend, then I'll happily consider the project. Very often a matter of a thousand dollars can make the difference. If they already know in advance what their budget is, it

makes a lot of sense for them to tell you, but very often they don't."

Your rates as a freelancer are in one sense fixed and in another negotiable. You have a daily, or per diem, rate that you quote to a client, but you can also quote the cost of the entire job. The market, more than the photographer, determines the rates, but photographers have levels below which they cannot, and *will not*, go.

Very often a shoot can be specified as to the number of days you expect it to take. But there are many exceptions. Vickers and Beechler bill their clients on a per diem basis most of the time, for as many days as the shoot takes, but they may occasionally take on a job quoting a job cost, rather than per diem. That enables them to stay at a location, even working on weekends and holidays if necessary, to complete the job in a shorter period of time than it might otherwise take.

But for each job there must be reasonable expectations. "If they tell us initially that they have three states they want to shoot in three days, we'll say that there's no way to do that," note Vickers and Beechler. "We like them to tell us up front what it is they expect and what kind of schedule they're on, and we'll tell them right then and there if that's feasible or not. When we do a package deal, where we've said we'll do so much for so much time and quote a fee, we stick to that fee, even if we finish early." As may occur on occasion, a shoot will take longer, and when that happens, they bill on a per diem basis for the excess.

There are other things to consider. Different photographers follow different practices, but generally speaking, you are licensing the photographs for limited usage. If you shoot for a brochure or annual report, for example, and the client also wants to use these photographs in an ad, you may be within your rights to charge extra for that usage. You can certainly charge a higher rate if the shoot is intended for an ad in the first place, as opposed to the lower rates which would apply to other uses.

Lou Jones observes that "a lot of industrial clients also have extended needs for the photographs. One photograph may have multiple uses. It might be for public relations, for the annual report, for trade advertising, and for trade shows." Some clients also like some sort of exclusivity on the photographs you shoot for them. After all, they don't want to see them go into stock and end up in a competitor's publication. This area of usage is a gray one and is certainly negotiable.

Photographers who have worked with one client for a number of years and developed a rock-solid relationship tend to be more lenient toward their client's requests. It all depends on the terms you establish from the beginning. If you immediately establish that you only grant usage for the publications outlined in your job contract or that you have the rights to use those photographs at any time, you could always modify that position later

© 1989 John Corcoran, courtesy AMP Inc.

In this shot for a capabilities brochure, the photographer had to show the "gripper" head of an industrial robot in motion. The multicolored motion effect was created through an in-camera multiple exposure.

on. However, if you act like a stone wall and balk at any reasonable request at the outset, you may not have a client to go back to the next time.

Finally, there is the matter of layovers and delays. They can make a mess of your entire schedule, and you may have to leave one job to fulfill a commitment to another client. However, pushing back the other client's schedule to continue with the first one may prove hazardous to your business and you may lose the other client in the end. So you have to carefully weigh the factors involved.

For the freelance photographer, time is money, no two ways about it. If you're socked in at the airport or are forced to postpone the shoot due to bad weather or because the client didn't get everything ready on time, that is billable time. Travel time is billable as well, and whether you charge half your day rate or your full per diem rate for these time-consumers depends on you. Some photographers feel that during peak shooting season, namely when the crush is on to shoot annual reports that have to be completed during a specified period, they have every right to charge the full day rate.

Scouting time is another consideration. That time may be subsumed under the time allotted to do the shoot, and is simply billed as a normal part of your per diem. On the other hand, you may have that rare luxury of being able to do advance scouting, which then becomes billable time, usually billed at half the day rate if it involves traveling to a location. When it's local, and within what you consider a reasonable distance from your studio, you may opt not to bill.

What it all comes down to, in Lou Jones' words, is that "rates vary tremendously with the kind of client and with the assignment. We know what to charge based purely on experience."

WHAT EXPENSES ARE BILLABLE?

You'll amass expenses left and right, and each expense must be recorded and receipts kept, copies of which must later be sent to the client together with a detailed expense report. Don't send out your original receipts because you'll need them come tax time.

Frankly speaking, virtually every expense is billable. "Certainly food, lodging, travel, film, Polaroids, filters if I ruin them; on a big shoot I'll even bill back gaffer tape and telephone calls," Jeff Smith informs us. Generally, what is not included is lost or damaged equipment.

As with any business, you have to concern yourself with insurance. "I think there are an awful lot of shoots where you need a million dollars of liability just to get on site," says Jeff Smith. "You can write a floater for a particular assignment and bill the client for the premium. But if you do a lot of them, it's worthwhile to get a general liability policy, but you can't bill the client for that."

Insurance, in general, is another matter. You should contact a qualified insurance agent, since you'll need not only liability insurance but worker's compensation, health insurance, and disability insurance—and if you use your car for business, business auto insurance. All these expenses fall under the category of operating expenses and are not billable to your client—directly. They are factored into the equation in your per diem rate.

There are generally two ways to bill for film and processing. One is a percentage markup, in the neighborhood of 15 percent, more or less, depending on what expenses and time are factored into that equation. Another approach is that described by Robert Rathe: "I don't have a specific percentage markup for film and processing. My price is based on the cost of the film, processing, fees for messengers to the lab, editing time, sleeving, stamping, and related expenses. I keep a price in the computer for each inventory item (film, prints, local messengers, etc.) that we bill out. This is usually based on the average list price of that item, not the specific cost at the time of purchase. Twice a year we review our costs to determine if the billing prices should be adjusted. So film costs quoted to the client, while not marked up per se, have a built in margin to reflect the film's cost plus processing and handling expenses. It makes life a lot simpler."

Different studios follow different procedures with regard to expenses when quoting a job cost. Expenses might not be part and parcel of the rate you quote: "Sometimes the client will request an estimate of expenses, how much film we'll shoot, rental cars and hotel costs," observes Greg Beechler.

Some photographers will include expenses as part of their fee, quoting the cost for the completed job. "Very often the expenses are far more than the initial fee," notes Lou Jones.

RESHOOTS: WHO PAYS?

No one likes to think about it, but sooner or later you may have to reshoot some part of an assignment. There are any number of things that can prevent you from achieving a successful conclusion to an assignment. The question is: Who pays for it?

As Camille Vickers points out, "In our standard assignment contract that we send out, we say that we will do reshoots where, if it's any fault of our own, we'll do it without charging a fee; but if it's a change in the assignment or something the client decides should be different, we will charge our full fee." Regardless of whose fault it is, the client still pays expenses.

Reshoots *are* rare, but they can happen for the strangest of reasons. Take these two experiences, related by Vickers and Beechler. "One time we shot a training manhole for Con Edison in New York and when the chairman found out it wasn't a real manhole, he insisted we photograph a real manhole, so we did. Another time we photographed a computer room, where we showed five people (in the picture). Then they insisted that we only show three, although we counted 18 people working there when we first got there. So we reshot it with three people."

Jerry Poppenhouse emphasized that "once in a while our processing machine will eat our film. That's the major cause for reshoots. You normally try to build in some safeguards by shooting more than one roll—but somehow the processor seems to know not only which roll but which frame is the best one and destroys just that frame. If it can happen, it will."

If you'd like guarantees, there is only this: reshoot insurance, but it is very expensive and must be purchased on a per shoot basis.

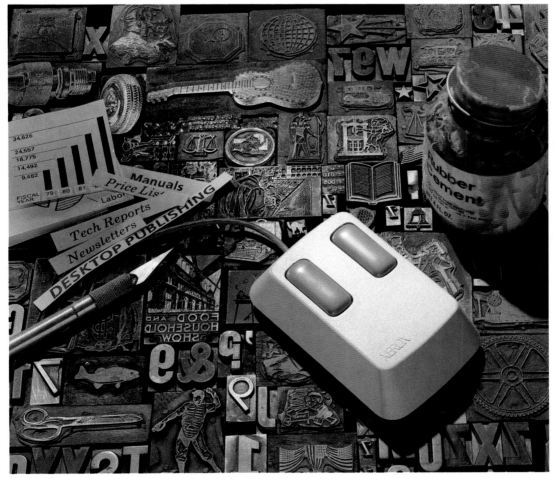

© Paul Prosise.

To light this still life illustrating the theme of desktop publishing, the photographer used a spotlight opposite the camera, positioning a specially modified 12 x 18-in. scrim between the light and the old type. Another spotlight with an orange gel added color from the left, as well as highlights, to the paper and mouse. Fill was provided by a 30 x 40-in. white reflector to the front of camera position.

CLOSING COMMENTS: THE COMPETITIVE EDGE

There are clients everywhere and there are jobs everywhere, within reach of an airport. There is no "right" location for a studio. If your studio is located outside New York City, it may require that you take a different approach to marketing than would a photographer whose studio is in the heart of Manhattan. The only "right" element should be the talent going into any assignment: you.

Running a successful studio puts you up against new talent arriving on the scene every day. "With a studio and full-time help, you have a certain amount in the way of fees to keep your business operating . . . You have to constantly be out there, marketing, getting your name around," observes Robert Rathe.

Success is not judged simply by your ability to pay your bills. "Your responsibility," Rathe reminds us, "is to present the corporation in the most favorable light that you can and to present their message in a way that is going to be effective for them. That's what you're being paid for."

One other approach involves offering both studio and location services—or having a larger studio capable of offering a greater range of services or being able to handle more kinds of location assignments. Or it may require you to do *the* kinds of work that others won't handle or executed in a way that is beyond the means of your competitors.

The competitive edge also means "having good pictures," Greg Beechler notes, "but it may be more a function of personality . . . Jump in the door and sell yourself—I would hope that in the end it comes down to having good work." Camille Vickers adds that, to a degree, appearance is also important.

"I think that if you can't do good pictures under adverse circumstances," Vickers continues, "then you're not going to make it. If you're a prima donna and can't get along with people, then you're not going to make it. If you don't have a very high energy level, you're not going to make it."

But what is most important? Vickers and Beechler concur: "The first thing would probably be competence, the second a good photographic eye, and the third personality. We don't think that even really great photographs are sometimes as important as just being able to get in there and get the job done. Just get a picture and don't let a lot of stumbling blocks stop you from coming back with something usable." But from the photographer's standpoint, they further agree that it would be photographic vision that ranks first. Either way, in the process of doing your job or getting it, they remind us, "Don't step on people's toes."

There's one more thing, as Lou Jones points out, and it goes hand in hand with competence: a proven track record. "People are more willing to give us those bigger jobs because they think we'll come through. We've done them before. If the portfolios are equal, they're usually going to go with experience."

There is yet another aspect to the competitive edge. "Whether you're in-house or freelance, you constantly have to sell yourself as an expert in the field," observes Jerry Poppenhouse. But it's not just selling your abilities as a pro, as a qualified industrial photographer. You also have to sell your photographs, even after they've been bought and paid for. "In the industrial world, you may be sent out to the North Sea and you may have a full week of hurricane-like conditions—50-foot waves, dark skies, blowing rain, cold, wind—and it never gets any better. You can't stay out there for ever and ever. So somewhere in your mind, you have to make what you've got work for you. And when you get back, you have to convince the people who sent you out there that these are the types of shots that they want to use . . . If these are the real conditions that exist, why not show this to the stockholders!"

Yet how do you define the competitive edge? How do you know that you've actually got it? The answer is not simple. An art director may say that a shot needs something more but doesn't clearly define what that "something" is; you have to "go deep inside yourself," in Lou Jones's words, "and pull out something that really makes the picture just a little better than you've ever done it before." That's the competitive edge.

Incorporating a photograph produced previously adds impact to this image of angiographic catheters for a sales brochure cover.

GREG BEECHLER

Freelance photographer Greg Beechler has worked independently and as an assistant to industrial photographers, assisting Camille Vickers before joining her to form New York City-based Vickers & Beechler Photography. A member of ASMP, Beechler specializes in location photography.

JOHN CORCORAN

President of New Cumberland, Pennsylvania-based Sterling Commercial Photography, John Corcoran has worked as a freelance industrial photographer for 19 years, having begun his career in-house. A member of ASMP and PP of A, Corcoran, who works both in the studio and on location, has been widely recognized for his in-camera masking techniques to illustrate small products.

KEN GRAFF

Ken Graff has served as in-house photographer with Union Carbide (Danbury, Connecticut) for 25 years. He currently holds the title of manager of photography and is in charge of a department that offers studio, location, and full photo lab services for clients in and out of the company. His photographic documentation of Union Carbide's relief efforts in earthquake-ravaged Soviet Armenia has received special recognition.

MARK GUBIN

Mark Gubin has operated Mark Gubin Photography in Milwaukee, Wisconsin for 26 years. A member of ASMP, Gubin specializes in location work, including architecture, and studio photography of both large and small products. His work has been honored with several awards.

LOU JONES

A national board member of ASMP and a member of APA, award-winning photographer Lou Jones offers studio and location services to a variety of corporate and industrial clients in the United States and overseas. Based in Boston, Massachusetts, Jones specializes in photo-illustration, still life, and people, having worked in this field for 18 years.

JERRY POPPENHOUSE

In-house photographer Jerry Poppenhouse is senior photo-designer for Phillips Petroleum Company (Bartlesville, Oklahoma) and has been with this multinational corporation for 22 years. He holds a BFA from the Kansas City Art Institute (Missouri) and has also studied at the Rochester Institute of Technology. A member of ASMP, Poppenhouse's work has been widely acclaimed.

PAUL PROSISE

Formerly an in-house photographer, Paul Prosise operates his studio, Paul Prosise Photography, in Gardena, California, specializing in studio, small-product, and location assignments. His work has been acknowledged by various organizations.

ROBERT RATHE

Corporate/industrial photographer Robert Rathe operates Robert Rathe Photography out of Fairfax, Virginia. Recognized for his corporate and advertising work, Rathe specializes in assignments in the studio and on location for major corporations around the country and focuses on the high-tech industries, people, and architecture. Currently serving as a national board member of ASMP, Rathe received a BFA from George Washington University.

BOB SKALKOWSKI

Bob Skalkowski is a freelance photographer with Sterling Commercial Photography, New Cumberland, Pennsylvania. A commercial/industrial photographer, Skalkowski had previously operated his own studio in Philadelphia.

JEFF SMITH

A freelance photographer for 20 years, Jeff Smith is based in New York City but travels nationwide and around the world on assignment for his corporate clients. The recipient of numerous awards, he is a member of ASMP and APA. His photographs are represented in several permanent collections, among them the International Museum of Photography, Rochester, NY. Smith specializes in executive portraiture and in the areas of high-technology and defense.

JAMES E. STOOTS JR.

A highly acclaimed photographer with Lawrence Livermore National Lab, Livermore, California for 15 years, and currently senior photographic technologist, James E. Stoots, Jr. first spent several years as a photographer in the air force. Stoots studied photography at Brooks Institute of Photography, where he acquired a BFA, and received additional photographic training at the Winona School of Professional Photography.

CAMILLE VICKERS

Camille Vickers has operated as a freelance corporate/industrial photographer out of New York City for over 15 years, currently working with Greg Beechler as Vickers & Beecher Photography. A member of ASMP, Vickers has received numerous awards for her location and aerial photography, as well as her photographs of people and architecture.